MONOLOGUE TO DIALOGUE

An Exploration of
Interpersonal Communication

CHARLES T. BROW ˙
Western Michigan U

PAUL W. KELLER
Manchester College

PRENTICE-HALL, INC., Englewood Cliffs, New Jersey

Library of Congress Cataloging in Publication Data

BROWN, CHARLES T
 Monologue to dialogue.

 (Prentice-Hall speech communication series)
 Bibliography: p.
 1. Communication. 2. Interpersonal relations.
3. Nonverbal communication. I. Keller, Paul W.,
joint author. II. Title.
HM258.B76 301.14 72–8518
ISBN 0–13–600791–0
ISBN 0–13–600783–X (pbk.)

PRENTICE-HALL SPEECH COMMUNICATION SERIES

Larry L. Barker and Robert J. Kibler, *Series Editors*

© 1973 by Prentice-Hall, Inc., Englewood Cliffs, New Jersey

Prentice-Hall International, Inc., *London*
Prentice-Hall of Australia, Pty. Ltd., *Sydney*
Prentice-Hall of Canada, Ltd., *Toronto*
Prentice-Hall of India Private Limited, *New Delhi*
Prentice-Hall of Japan, Inc., *Tokyo*

**To That Person
Who Understands You**

Contents

2
The Nature
of Communication 14

3
Meaning:
The Translation of Words 35

4
Meaning:
The Reading of
Nonverbal Cues 56

5

Emotion and Communication 73

6

The Role of Expectation 95

7

Environmental Impact 117

8
Judgment, Criticism, and Discrimination

140

9
Power in Communication

163

10
From Monologue to Dialogue

185

Selected Readings

209

Index

217

Preface

The traditional view holds that communication is the sending and receiving of messages, that the mouth pours messages into ears, and that the ears, performing something in the fashion of a funnel, channel the message to decoding centers. This understanding parallels, and is probably related to, the ancient concept of learning. The learner, according to that view, is a vessel who receives information from a person who knows. The "power" is in the "knower" who "commands" the attention of the less knowledgeable one. This view holds that the attention of the receiver is capricious and undisciplined. Thus, the speaker or teacher or leader is obliged to excite or command attention, and the listener, whose attention is arrested, opens himself to the word.

Traditionally, we have also conceived of "receiving information" as an act of a person in the subordinate position. "Now let me tell you," suggests that the speaker is in charge of the listener. So the teacher,

preacher, parent, advisor, employer, tells, and his subordinate listens. The view stands out clearly in the oft-repeated statement of victory when the tables are turned: "I'm telling you, I walked into the boss's office and did I give him an earful!"

However, perceptive and sensitive persons have always known there is something wrong in the above description of human communication, most particularly in its awareness of the nature and the power of listening. A listener is not passive. A person listening breathes faster than he does at rest. Any listener—psychiatrist or student or even television viewer—can be exhausted at the end of a day of listening. Listening is not a passive mood, but in truth a powerful and highly active process— a fully developed other half of the communication act. This book tries to describe the communication process as a dynamic interaction of speaking and listening.

Our approach, we are trying to say, is frankly interpersonal. What is the ultimate achievement in such communication? Is it not that which happens when one person comes to feel fully known and accepted by another? Sometimes when he tries for that kind of contact, says Dr. Carl Rogers, but is not understood, he has a fantasy of a boy, all alone in a cave, tapping out, day-after-day, in Morse Code, "Is anyone out there? Can anyone hear me?" And finally, one day, he hears a faint tapping from the outside spelling out, "Yes." That is the essence of interpersonal communication as we conceive it. To be involved in it is probably the most commanding, yet cohesive, experience available to man. This is an ancient wisdom, probably out of the East, which all the helping professions, each in its own way, try to institutionalize. The counselor, minister, and psychiatrist assume, as fundamental, the power of listening to change, to direct, or even to stop, speaking. Sensitivity training and encounter groups in education, business, industry, and governmental services have come into being in part because these institutions have recently sensed listening as the powerful act it is.

Yet there is still a gross gap between what we know about speaking and listening, and our practice of it. The research, as well as our everyday observations, shows that most men of power do not listen to negative responses from below in the chain of command, and most of them conceive of their role in large measure as that of sending statements, often critical, down the chain. Parents and teachers still rely more on talk than on listening, and more on talk that closes ears rather than talk that opens them. In short, we do not do as well as we know. Why?

The bulk of research on distortion and breakdown in communication shows anxiety as its basic ingredient. Few people learn how to speak and listen without feeling anxious, and without arousing anxiety in the other person. It is not that man is perverse. As we see it, the problems of hu-

man communication stem, in the main, from the ancient perception of speaking and listening which, learned early in life, fixes practice. We need a new perception of communication that fits the available research of the hour. This book tries for such a perception.

But in all modesty and some honesty let us say this: Our confidence in our descriptions of communication rests not so much on the data discussed as in our awareness of our own growth and power as we have unstably and inconsistently put our understandings to work in our own lives—as persons, teachers, and members of a family. We feel our observations about the communication act move in the direction of truth, but that they surely need refinement and eventually replacement. In his theory of meaning, J. R. Pierce discusses the difference between scientific fact and scientific ignorance. Obviously, the facts we deal with are neither as numerous nor as far beyond question as we would wish. The reader forewarned, the writers proceed in the pages ahead to commit the sin of certitude without further apology.

The essence of our perspective is spelled out in Chapter 2, "The Nature of Communication." The remainder of the book does two things. It tries to show the kinds of evidence, gleaned from both research and human experience, that speak for that opening description. And second, it tries to show how certain other phenomena like meaning, emotion, expectation, environmental impact, judgment, power, and dialogue take on particular and related form in the light of our fundamental points of view.

Our descriptions of the communication process, meaning in language, and the role of emotion, have directed the style of our discussion. Cold analysis, alone, is inert. Communication that makes a difference is immersed in feeling. People are aroused when they can see and feel the relationship between an abstract statement and their own behavior. Thus the book is a mixture of research, generalizations, and illustrative anecdotes, put together with the intent of fusing in the consciousness of the reader his meanings for "communication" and his understanding of "the quality of life." The medium is the message.

A list of all the persons whose thinking has influenced the book would probably lose focus. A few stand out. It is our feeling that the writings of Adelbert Ames, Martin Buber, Sigmund Freud, Alfred Adler, René Spitz, Hadley Cantril, Lev Vygotsky, George Herbert Mead, Carl Rogers, Abraham Maslow, Marshal McLuhan, John Bowlby, and Norbert Wiener have impressed us in ways that have had their observable impact on the thinking of the book. To these and our colleagues with whom we have discussed many of the ideas in this book we are indebted.

Anyone pondering the names we have just listed, and scanning the Bibliography at the end of the book, will be struck by the fact that we

have borrowed heavily from recent writings of psychotherapists. We agree with the view expressed by Floyd Matson and Ashley Montagu that this day finds itself involved in the third great revolution in communication—the dialogue revolution. And since, in that context, psychotherapy provides the meeting place for the efforts to communicate and the efforts to provide human growth, its literature seems significant to us. It does not lead us to a behaviorist or determinist view of what happens in the speech act. It does lead us to think of the human individual—once he has learned the communicative system of his culture—as existing in his own uniqueness, possessed of creative possibilities, and participating in the choice of values by which he will shape his life. It does nourish in us the conviction that communication is the tool with which man etches the poetry of his life, be it lyric or tragic.

We have been teaching the perceptions of this book for some years and have noted that our students have discovered new ways of seeing themselves and communicating with others, ways which have enriched their lives and increased their powers. We hope we may do the same for the reader.

CHARLES T. BROWN
PAUL W. KELLER

Introduction

A THESIS ON THE LEARNING OF COMMUNICATION SKILLS

In this book you are encouraged to understand how communication shapes a person. The book asks you to examine interaction, most particularly from the "receiving" point of view, since we are shaped by what we listen to—in our own speech and in the speech of others. But the book is designed to help you achieve improvement in interpersonal skills, not just the understanding of theory. So it explains the forces that shape a person, but it also suggests assignments designed to bring about the specific change under discussion. The assignments, as a group, are built on the assumption that communication growth emerges, in the main, from three activities: oral verbalizing, receiving "feedback" from others, and making written commentary on communication experience both in and out of the classroom (for example, in the form of a journal).

One other thing should be added here. At the end of each chapter is an "Evaluation" assignment to assess your learning from the chapter and the related assignments. For several chapters the procedure requires that you test yourself both before and after the reading, a pretest and a post-test. It will be necessary, then, for you to look at the evaluation proposal at the end of each chapter before you read the chapter, in order to determine whether you should do something before you read. This may seem something of a bother, but, if you do the evaluation, you gain the advantage of identifying your blind spots and knowing what and how much you are learning.

The central theme running through the book and assignments is the value of openness in verbalizing, listening, and making journal entries. Contrarily, we all know that language can be used to conceal as well as to reveal. Norbert Weiner, the late scholar on "self-governing machines," believed that secrecy is the measure of social illness, and thus openness, the opposite, is both the way to, and the measure of, social growth. Sensory deprivation experiments illustrate that when hearing, seeing, and touching are closed off, impairment of one's physical and psychological functioning begins to occur within two or three hours. There is no doubt that *completely closing off* our sense data makes us ill. This book makes a case for revealing speech.

Yet it is not so simple as all that. A completely open person makes little sense. Who would tell everyone where he hangs the key that opens his house? As open as the younger generation is in conversations about sex, a young man does not without risk reveal his sexual fantasies. The businessman may be unwise to tell his employees each other's salaries. The teacher cannot justify telling which students he likes and which he dislikes, or identifying those he thinks are bright and those he thinks are not so bright. The person who is indiscriminately open is naive and gullible, if not entirely unwise. As a thesis, openness, like closedness, ends in absurdity.

In this book we opt for an appropriate tension between openness and closedness. Somewhere between the extremes is that which is wise, and what is wise for one person is not wise for another. And what is wise at one point in one's life may be foolish at another point.

Most of us believe in freedom and dignity for the individual. Those who are freer are more open. Yet openness, as it reaches gullibility, is not dignified. Our dignity rests in our uniqueness in a variety of ways. If a person needs much approval from others, he tends to be less open about his unsociable attitudes and feelings, but very open about his love and affection. Those who are disposed to be aggressive can be open in argument but are less inclined to express their affections openly. Those

who fear and withdraw cannot argue or express approval with ease. It is probably best when we can argue, approve, and withdraw in our interaction as the situation dictates. But only those who are open enough to their experience to sense what the situation dictates can be this wise. So our stance throughout the assignments is to advocate the degree of openness (1) dictated by the situation which (2) one can tolerate. In short, you should feel comfortable with yourself after each assignment. You should choose among assignments with discrimination and execute them with the degree of openness appropriate to your experience.

1
Point of View

The longing for interpersonal intimacy
stays with every human being from infancy
throughout life; and there is no human
being who is not threatened by its loss.
*FRIEDA FROMM-REICHMANN**

To understand himself man needs to be
understood by another. To be understood by
another he needs to understand the other.
*THOMAS HORA***

Communication between people involves, in its essence, two things—relationship and information; the former determines the latter. A student detained us after class one day and said he was "uptight"—needed to talk. "I don't know whether I can go home at Christmas. I made up an excuse for not going at Thanksgiving. But Christmas is different. It's my dad. Now don't get me wrong; I love my dad. But he's got this thing about beards and long hair. I went home last June and soon as he saw me he said 'John, for God's sake, get upstairs after dinner and get rid of the beard. Your aunt is coming tomorrow and she'll make plenty of that. . . .' After dinner I went up and shaved. Then I felt this big." He held up his hand, thumb and forefinger an inch apart. "As soon as I came back to school this fall I let my beard grow again. But if I go home

**Frieda Fromm-Reichmann, "Loneliness," *Psychiatry* 22 (Feb., 1959), p. 3. By permission of William Alanson White Psychiatric Foundation, Inc.*

***Thomas Hora, "Tao, Zen and Existential Psychotherapy," *Psychologia* 2 (1959), pp. 236–242. By permission.*

at Christmas I know the first thing I'll hear and I'll be damned if I'll shave. . . ." The information in this exchange between father and son concerns a difference of opinion as to beards on young men in general and on one young man in particular. But the information is shaped and comes into existence by reason of the peculiar relationship between the father and son. As it turned out, they have an immense affection for each other, but the father is finding it difficult to allow his son to make his own decisions, and the son is reaching a point of open rebellion.

Any relationship between people, casual or important, always involves feelings of varying intensity—loving or hostile—as well as some sort of authority arrangement between them. At the heart of every relationship lie the self-images of the persons involved, each created by interaction with the other.

Machines do not have feelings, authority problems, or conflicts of self-image, or even images of any sort involved in their communication. If you tune your radio to a given frequency you get a given station. You can predict, with almost total accuracy, that whatever information is available on that carrier wave will come through. You do not have to worry that the station will sometimes be found at some other frequency. As long as you stay with that channel, the information of that channel comes through.

Not so with people. They are constantly shifting their carrier waves, their emotions, their attitudes toward authority, and their images of self and others—the stuff of a relationship. Sometimes they broadcast to one person in such a way as to exclude another. At other times they are preoccupied and thus indifferent to others, sending information only to themselves. Many times they are anxious in their relationship with the other person and, for that reason, distort both the information received and that sent. They may not even hear some information. Thus even two scientists differ in their reception of the information about, say, pollution, because their basic relationships, with persons, things, and ideas, built up over a lifetime of communication with other persons, things, and ideas, determine their interpretations of a given bit of data.

Though we might wish it otherwise, the most critical factor in human communication is the relationship produced by interaction. Say a committee is meeting in the Chicago offices of one of the nation's largest manufacturers of household appliances. The conference is called because each of the committee members has specialized knowledge the others do not have. The committee is to make recommendations for a more efficient design of one of the company products. At a crucial moment Mr. ———— does not tell his colleagues what he knows—knowledge that would save the company thousands of dollars.

What fails in this communicative exchange? The potential information is there. Mr. ———— listens accurately and speaks clearly. The com-

mittee is chaired efficiently. But something fails. A little history sheds light on what that is. Mr. ———— was passed over for promotion in a recent reorganization of the company. The dream he had of becoming a high-level executive has been shattered. He sees the company, now, as his enemy—one which does not deserve his expertise and loyalty. So change the relationship and you can change the information available to the meeting. The story, repeated daily in a million versions, is a parable of human interaction—information is dependent on relationship.

Every man's life, at all its depths, is a collage of his relationships. The picture of a life dulls or brightens in terms of the quality of those relationships. Socrates glowed, even in the face of death, because there were enlivening human beings with whom he shared the search for ultimate answers; Van Gogh watched his human ties disintegrate one by one —and yielded, finally, to the disintegration in himself.

Indeed, a person or personality is not some entity separate from his relationships with other people, but, rather, a self-picture and a set of associated behaviors determined by his relationships with the others in his life. Harry Stack Sullivan, the famous American psychiatrist, describes a person as the sum of his interpersonal behavior—his relationships with other people.[1] The sociologist George Herbert Mead, reasoning in much the same way, saw society as held together by the mirror image of the self each man must have and which is provided for each person by the others with whom he talks.[2] Each person he meets helps him shape his identity. Thus a person *is* and *behaves* as a consequence of his relationships with others, just as a planet is a ball of matter held together by the relationships with all the other planets for which it has gravity. Take Mars or Jupiter or another out of our planetary system, and Earth would fall apart or sail off into some other new orbit—we cannot predict. The Earth goes as it is inclined but also as governed by its attraction to all other planets and bodies that bear upon it. Like that planet, the person, as Harvard psychologist Henry A. Murray has observed, is also a compromise between its impulses and the demands of other people.[3]

But relationships do not occur capriciously, or mysteriously. They occur as the very process of communication. No communication; no relationship—and the reverse. To communicate is to make contact, to inspire and receive response. So the act of communication nurtures relationship and in turn, is fed by it. The study of communication leads of necessity into an examination of the maze of forces that sustain or corrupt human relationship. Until that journey into the recesses of the

[1]Calvin S. Hall and Gardner Lindzey, *Theories of Personality* (New York: John Wiley & Sons, Inc., 1957), p. 134.
[2]George Herbert Mead, *Mind, Self, and Society* (Chicago: University of Chicago Press, 1934).
[3]Hall and Lindzey, *op cit.*, p. 190.

human spirit has been made, whatever can be understood about the speech act must remain superficial.

Yet, in the main, the approach to examining speech communication has traveled quite another path.

THE HISTORICAL APPROACH

The study of speech has come down to us from the ancient Greek civilization. The inherited perspective is this: Human speech worthy of analysis is that which we do for the purpose of persuading an audience in the public speaking situation.

This focus is understandable and was inevitable, given the history of Athens. Exploding out of the chemistry of that city came the shape of man's magnificent urge to be free—and we are still working at that. Every freeman was given a voice in the government. And every freeman was his own lawyer. So the sons of freemen were obliged to learn how to state their views effectively, in the court and in the public forum. Thus, in Western culture, we have studied speech as the way the person who talks prevails upon the one who listens. Aristotle, the most famous of the ancient writers about speech, defined rhetoric as "the faculty of discovering in the particular case what are the available means of persuasion."[4]

As a consequence of these beginnings, speech has been primarily the study of one kind of relationship, *the controlling relationship*. It has been an examination of the means by which one human being could successfully influence another. If the potential speaker gave appropriate attention—as he did—to "audience analysis," he did so more out of his desire to get listeners to react as he wished than out of any impulse to establish or understand relationship.[5]

But this is not the Athens of the fifth century B.C. This is life on a crowded, planetary spaceship, to use Buckminster Fuller's phrase. This is the age of "the lonely crowd"—the age of inescapable elbow-rubbing. It is also the age when men do not know what to believe or why to live. And this is why we turn to each other and ask for an understanding of interpersonal communication.

The study and use of persuasion—the controlling relationship—is of

[4]Lane Cooper, *The Rhetoric of Aristotle*, (New York: D. Appleton-Century Co., 1932), p. 7.

[5]Beyond this, the study of speech *per se* is more involved in linguistics, phonetics, physiology, and neurology—all that goes into the production of communicative sound. It is the linguist and the speech correctionist of the present day who have been most interested in speech as such, and again understandably, for it is the linguist's task to study the nature of language and the correctionist's task to help the person whose speech has not developed normally. Speech education, in the main, has been more deeply involved in understanding listening in order to discover ways to control the listener.

enormous importance in the social order, and will be a significant part of the development of leaders into any future we foresee. But in our day it is too narrow a view to satisfy our needs and questions about human communication, too narrow in at least three ways.

First, it neglects the most common kind of communicating. Most human beings listen far more of the time in the interpersonal situation than as members of an audience. And this requires a significantly different analysis, because we do not listen in the same way in an audience as we do when we are conversing with one or several people. With the support of others—in the public speaking situation—we are more dependent and suggestible. Without the support of other listeners—listening alone—we are less carried away, more independent, and, thus, often more fearful and defensive. Listening fear is intensified in the private situation, or in small groups, for the speaker focuses upon the listener to a degree impossible in the public situation. The public speaker broadcasts; at best, he tunes in on one person and then another. When the speaker in interpersonal exchange is effective, he comes into closer and more constant ties with his listener. Therefore, this book, concerned with a more comprehensive perspective of the relationships inherent in interpersonal speech, is no less involved in speech than are speech books designed to teach one how to be an effective public speaker. But its emphases and probings are different, because its concerns rest more with the private than with the social impact of speech.

Second, the purposes of public and private speech, while overlapping, are considerably different, too. The traditional view, designed, as it has been, to teach the skill of reaching and persuading a mass audience, quite inevitably has been prescriptive in character. "This is the way to do it." In short, public speaking books concentrate on the strategies that work. When we concern ourselves with communicating in the interpersonal situation, it is appropriate to examine the interaction from a more descriptive point of view. "Here is what is involved." We, of course, *do* try to persuade each other privately (indeed, most proposals, honorable and dishonorable, are made in private), but when we do persuade in private (and the effort does not end in quarrel), it is done with considerably more sensitivity to the language and to the understandings of the relationship than could be expected in public discourse. We need to know more about what constitutes a person when we talk to just one other person than when we talk to an audience.

In public speech, which except for entertainment and transfer of information is intended to persuade, we want others to act or think or feel as we do. And there is nothing wrong or evil about this, especially when *we undergird that desire with the understandings of interpersonal speech*. Thus, as we shift from a study of the art and science of public speaking to an exploration of the art and science of interpersonal speech,

we move from a prescriptive statement of the way to control another to a descriptive statement of the way to understand the self and the other person.

Third, the traditional view of communication underestimates the significance of listening. As we move from a study of public speech and the formulation of messages to a study of interpersonal speech, we become more fully aware of the power of the listening act, even upon the very formulation of messages. The point comes to sharp focus if we will think for a moment about the problem of "stage fright," a phenomenon not reserved for the stage or public speaking platform. When we analyze it, we find that the fear is not of one's own speech, but of the response to it. The frightened speaker, especially the private speaker, is afraid not only of what he might hear in his own speech, but also what somebody else might hear in it. We do not fear to speak to a trusted friend or to any audience of more than one when we appreciate our own speech and when we are sure that the others will listen to us appreciatively. The fear centers on the listening of the listener. Analysis of the filtering system of our listening is to interpersonal speech study what analysis of strategy is to public speaking.

BOTH SIDES OF COMMUNICATION

One of the more important perspectives of the book, in addition, is this: to understand human communication one must erase the concepts of "speaking" and "listening" as separate or wholly different acts. We are trapped by our usual language into thinking that there is in the communicative act a speaker and a listener, and that the speaker speaks and the listener listens. But the stage-frightened "speaker," as we have cited, is listening as he speaks! And the significance of that fact, that the "speaker" and "listener" are the same person, as well as two separate individuals, brings us closer to the description of communication on which this book rests. Put in the form of a proposition, the view could be stated as follows:

> *Human communication revolves chiefly around two kinds of speech: silent speech (listening) and overt speech (talking). Silent speech is the necessary preliminary to overt speech, and the quality of overt speech cannot be better than the quality of the silent speech from which it springs. Overt speech can be understood only through the medium of the silent speech from which it emerges. One's expressive powers can never exceed his silent powers.*

Viewed this way, speech is the whole of communication. The flow of communication within a person and between people is an intricate, indivisible operation of listening—speaking—listening, and so on. And in it there are only listener-speakers interacting.

Consider the following exchange which one of the authors heard. An applicant for a teaching position at a university was talking, at his request, with a group of students. A part of the conversation went like this:

> Applicant: If I were to take the job here, do you think you could get along with me?
> Black Girl: Do you think you could deal with a class of black students?
> Applicant: I don't know whether I could do it alone, but having talked to you this past hour, I have the feeling we could do it together.

Our analysis is this: the bulk of that piece of communication is to be found in the realm of silent speech, and what you have in it is two listener-speakers interacting. Both before and after he arrived at the campus, the applicant must have said many things to himself which led him to feel he needed to test students' reactions. He apparently found himself silently raising questions about black students, and that subterranean flow built up until he felt he had to test it—whereupon he broke into overt speech. ". . . do you think you could get along with me?" The black girl, on her part, was saying things silently about this man, and his question elicited from her silent flow, not an answer, but the critical counter question, ". . . could you deal with a class of black students?"

A study of the speech act cannot lead to an understanding of communication—as an act of establishing and understanding relationship—unless it concentrates on silent speech, the source from which overt speech emerges. That is why this book spends its effort searching the dark domain of silent speech and examines overt speech as the product-producer of that silent world.

It may be worth saying that the authors have not always held this view. When we first began examining the listening act, we thought of it as discrete from the speaking act. We searched for the factors in it, for the "things a listener does." And for a time we were tempted to believe listening was a cluster of skills which, once identified, could be used as the basis for training an individual to be "a better listener."

In the process of that search it eventually became clear to us that (as explained and developed in the next chapter) "listening" is the act of silent speech, and that speaking aloud inevitably involves the speaker in listening to himself and to the other listener-speakers present.

THE IMPACT OF BOTH SIDES
OF SILENCE ON LIFE

Our other major discovery was that human growth depends on the listening-speaking cycle, that people are made or broken by the kind of relationships which evolve, and that both silent and overt cues shape

those relationships. If one acknowledges the centrality of communication in human life, he senses there are no "self-made men" who have grown by themselves into their potential. Students have been our teachers here. As they verbalized the forces that had shaped them, they shed eloquent light on their silent-overt worlds. Maybe the reader can best gain the "feel" for what we sensed if we share several of the many stories students have told us about the impact of a communication. As you examine these vignettes, you may find it difficult to determine whether you are being told a story about the power of listening or the power of speech. At moments, you may feel unsure as to whether you are being told a story about the impact of the speaker on the listener or on himself, or the impact of the listener on the speaker or on himself. In some instances, perhaps, all four of these things are at work. Let your picture of the vital features of the communication act come into focus as you explore what follows. Perhaps you can begin by taking note of the profound effect of silent speech in the lives of human beings, observing what they did with what they heard.

"IN A WAY I AM LIKE THAT OLD SHACK"

When I was a boy of about eleven or twelve, I had a strange urge to be alone. I just didn't want to be with anyone at times. Around our house there wasn't much of a chance of me being alone, so I had to go out and find a place. It was by accident that I found it. I was a paperboy. I walked down this highway named Woodward, which was made up of eight lanes. Just before I got where I picked up my papers on the left side of this block was—I even remember the name—the GMC Truck and Coach Warehouse. There were trucks coming in and out of that place all the time. Machines and men were working like crazy. Across the street was this huge block of rotting buildings. . . . And next to another trucking company was a lot full of brush. And to the back of this lot was an old shack. I guess it must have been an old railroad watchtower.

One day I went up to the door of the shack and pulled off the boards that were locking the door and walked in. It was dark, so I broke out all of the glass in the windows and pushed out all of the boards blocking the light. I picked up an old crate, placed it next to one of the windows and sat down. Then the funniest thing happened. With all the noise coming from the warehouse and the trucking company and cars passing on the highway, it was quiet. It is hard for me to explain, but with all the noise going on outside, it was really quiet here. I must have sat for two hours, and all I did was think. For a kid of eleven I thought of some of the weirdest things. I thought about if I would ever make it to college; if I would ever marry; I even thought about what I was going to do with my life. And while I was thinking about all of this, it was silent. I just couldn't hear a sound.

I must have gone to my place every few weeks for maybe two years, until the inevitable happened. A local businessman bought that sacred lot. He tore down the shack and he built a gas station.

In a way I am like that old shack. I am that person in the middle of all the noise and racket who just isn't noticed. I just sit back there and watch all that is going on. I sit back and think to myself. You know, I looked and looked for another place to go and think, but I guess that old shack was a one-in-a-lifetime thing for me.

"YOU'RE JUST LIKE YOUR MOTHER"

"You're just like your mother. She was no good and you'll grow up to be just like her." Repeated over and over, this phrase has done more to affect my personality than any other utterance I've ever heard. Along with that favorite of my grandmother's went such ego-building statements as "Nobody else wanted you, so I had to take you. Your father can't be bothered with you. He won't want anything to do with you until you're old enough to work."

Grandma Field wasn't really such a witch. She was basically a good Catholic woman who, at age 65, found herself burdened with the care of an active, troublesome four-year-old. This child was the product of a broken marriage of which grandma had thoroughly disapproved from the start but had no power to prevent. My parents were hastily and secretly married when my impending arrival was realized. Grandma learned of the marriage by reading it in the newspaper.

For all of this messy background, I had a very uncomplicated childhood. I remember feeling sorry for myself occasionally, but what child doesn't? I remember saying to a high school friend that, considering the crazy-mixed-up family life I'd had, I was a remarkably well-adjusted person. Perhaps I was, at that time, but I think that marriage and the responsibilities of a family were the catalysts of change. I was no longer responsible only for myself but for others. I had no emotional framework within which to react to this responsibility. After having three children in three years, I felt that I had to give up my religion in order to maintain my sanity. This was the turning point in my life. It's been downhill ever since. I started working in a bar and that was the beginning of my drinking problem and the marital problems that went along with the drinking.

Perhaps it was a curse, perhaps it was a prophecy, but my grandmother's repeated phrase did come true. I am just like my mother. She is fat; I am fat. She drinks too much; I am an alcoholic. We are both opinionated and argumentative. She was pregnant when she married and so was I. She has been married three times. I have only one husband, but there have been numerous emotional involvements with other men. My mother is a nervous person; so am I. My mother is oversensitive to criticism; so am I. I never really got to know my mother until I was fifteen, but we cannot get along together because we are too much alike.

Those two phrases echo in my mind as I think of listening experiences that shaped my life. "You're just like your mother." And, "Nobody wants you."

I am sure that unless I am strong enough, I am doomed to continue suffering the guilt of my birth. I have spent the adult years of my life in a frenzied effort to prove my grandmother right. When I look at myself now, all I see is a person without worth. A person nobody should want. A per-

son the world would never miss. Yet even as I write this, I know that through all of this pain and confusion, one person wants me and thinks me worthy. My husband has stayed with me when no other man would have. He has heard my inner screams for help. Maybe through this excruciating experience I can find the person within me that he thinks I am. Maybe I can find the person that I want to be.

THE MEANING OF THE STORIES

Hundreds of stories like these have come to us from students (the reader could probably add others of his own). What they tell us is (1) that human growth is closely tied to human speech, and (2) that to study only how messages are sent is to limit one's capacity to understand communication.

How is one to understand that boy sitting in the old railway shack except in terms of the way he listened to himself and to the others in his life? Somewhere, somehow, he had learned to make extensive private commentary on his experience. Clearly, that realm of silent speech is important to him, as is his comment about the value of telling his story to others—a matter of no small consequence as we shall see in the pages ahead.

It would be equally futile to try to understand speech in the life of the alcoholic woman by fastening onto the mechanics of her overt speech, her voice, and her organization of ideas. Overt speech has had and will have a controlling impact in her life, but this is so because of the echoes that keep reverberating in her silent world—the thousands of things she has said to herself as a consequence of those words she has heard far too often: "You are just like your mother."

SETTING THE DIRECTION

In this chapter we have tried to lay a foundation for what is to follow. We have suggested that a study of interpersonal speech involves dimensions beyond the confines of persuasion, for persuasion is but one kind of relationship, while communication is the fabric of a variety of relationships which make up our lives.

We have also said that to look at the communication act from the vantage point of silent speech (listening) is to increase our understanding of what is said aloud. Overt speech is like the visible fraction of the iceberg. It is also the more primitive, more ego-centered, and earlier developed part of our communication system. Listening is a social act, involving, at its best, the internalization of another person, and it becomes far

more sophisticated than talking as the human being develops.[6] So, ultimately, the listening side of silence illumines the speaking side. How that happens will, we hope, unfold as we explore the nature of communication in the next chapter.

OBJECTIVES

The discussion assignments in this chapter are designed to do three things:

I. To sharpen your awareness of the two language worlds that man lives in—the world of persuasion and the world of relationship.

II. To increase your capacity to talk about your alienation and your relationships.

III. To make you aware of the way alienation increases your knowledge of others and yourself.

EVALUATION

In order to understand how the assignments achieve the goals cited above you may write a statement of the meaning of "loneliness" or "alienation" or "relationship" now and then again after the class assignments have been completed. Then compare the two statements. The difference in perception measures your growth.

DISCUSSION QUESTIONS

1. *Objective I* Imagine and compare a speech class in ancient Athens with that of today.

2. *Objective II* Many people feel that failure in relationship is a mark of our time. Discuss human relationships in your generation as you see them today. Compare these with the relationships of your parents' generation.

[6]For a classic description of how language functions in the development of a child, see Jean Piaget, *The Language and Thought of the Child* (New York: Meridian Books, 1955).

3. *Objective II* Read again the story on page 1. Now consider these questions.

a. What is the connection between a relationship with a person and your emotional response to him?

b. What is the connection between a relationship and authority?

4. *Objectives I & II* Compare and contrast speaking and listening.

EXPLORATIONS

1. *Objectives I & II* Read aloud the story of the shack and silence. Discuss the perceptions you have of the boy's personality. Although you have no vocal or visual cues, you have in this story an extremely clear statement of a unique awareness of one's own speech to himself. Following are questions intended to direct your attention to the detail in the story.

Is the speaker male or female? Rich or poor? Foreign or native born? Lonely or well related? With purpose or a drifter?

Here is information known to the authors but not divulged, we think, in the story. See what you make of it. He says his most intense ambition is to be a millionaire. He deeply resented the students seeing him as a very sensitive person.

2. *Objectives I, II & III* Discuss the life of the alcoholic woman. What is basically the problem, as you see it, that drives her to alcohol? Do you sympathize? Why? What does your answer say about you? Having expressed your own feelings about yourself, what more do you understand about her?

Some specific questions: How old is she? How would you describe her husband? How do you predict her future?

Here is additional information. The woman had been under psychiatric care for a year or more. The psychiatrist had told her many times she was an alcoholic which she always denied in laughter, as she explained to us. In one class assignment each student wrote down twenty times "I am ——————," filling in the dash with what ever came to mind. On the twentieth one this woman wrote "I am an alcoholic." A few weeks later came the story written in a diary. What new thoughts does this stir?

3. *Objective 1* Give a speech on the difference between speech for persuasion and speech for relationship.

4. *Objective II* Discuss the basic social structure of a modern student party in an apartment. What values are expressed by this very structure?

5. *Objective II* Give a sample or an explanation of the characteristic talk between you and a person with whom you are well related. Discuss the relationship and its significance to you.

6. *Objective II* Break up into groups of four to six and discuss the meanings of the words "intimacy" and "loneliness." Come back to the large group and exchange the views of the smaller groups.

7. *Objective II* Play a two-minute excerpt from a musical recoridng that you deeply appreciate when you are lonely. Listen to the class discussion of the music and you.

8. *Objective II* Play an excerpt of a recording that you appreciate when you feel deeply related to others. Listen to the class discussion of the music and you.

9. *Objective III* Describe your father (mother). Then describe yourself. Indicate what you note about yourself by first describing a parent. Explain the significance of your observation. Explain where your parent's values and your values are the same, and where they are different.

10. *Objective III* Draw two circles, one representing your values, the other representing your parent's values, showing the amount of overlap of the circles. For example:

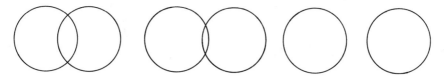

Have several other students do the same. Compare and discuss.

11. *Objective III* Bring to class two objects (pen, tie clip, beads, painting, watch, cup, briefcase, ring), one of which you feel very much related to, the other you feel very indifferent to. Tell how and why you feel as you do ·about the two things. Have the class tell you what they have learned about you as a consequence.

2
The Nature
of Communication

Mankind craves definition as he craves
lost innocence. He simply does not know what
his life means until he says it.
 *MELVIN MADDOCKS**

We need to discuss three things in this chapter: one, the nature of listening and its functions; two, the nature of speaking and its functions; and three, how the two work together to produce communication, and its functions.

THE SILENT SIDE
OF COMMUNICATION

No feature of everyday existence is more misunderstood than is listening. Common sense (which in this case is wrong) tells us that listening is the receiving of information by ear. We shout to a small boy as he crosses the street, "Watch out!" The boy looks up, jumps appropriately from the path of the automobile, and the age-old illusion is reinforced: a

*Melvin Maddocks, "The Limitation of Language," *Time* (March 8, 1971), pp. 36–37. Reprinted by permission from TIME, The Weekly Newsmagazine; Copyright Time Inc.

speaker sends a message; his listener receives the message; communication is a game of verbal *give and take*. Even sophisticated scholars use language that helps fix the misconception. J. P. Hughes, in his *Science of Language*, for instance, says that speech is a system of symbols "by which thought is *conveyed* from one person to another."[1] And M. Pei in his *Story of Language* says that speech is "produced by the human voice, received by the human ear, and interpreted by the human brain."[2] However, a second reading of this latter statement suggests the weakness in the "conveyed and received" view. If a message is conveyed, it arrives in its own right. Why must it be interpreted?

Even the popular communication models of the day help sustain the illusion that the speaker *sends* and the listener *receives*.

Encode———Transmit———Channel———Receive———Decode.

But such models contradict the overall conception of sending and receiving, too, for they entail *encoding* on the sending side and *decoding* on the receiving side, suggesting that the meaning, if received, is not necessarily the meaning sent. One may note that the act of assigning meaning to a "received" message is labeled *decoding*, not *re-encoding*.

What is listening then? Listening, or decoding, is speech, a verbal response to what is heard. It is, to put it another way, silent speech. Defined that way, there emerges an important distinction between hearing and listening. Hearing is the recording of sound waves and this, plus the memory of those recordings, allows us humans and several species of birds to repeat words and songs. But listening is not recording. Listening is the speech excited by that recording. Therefore, while the fundamental requisites for listening are hearing and memory, it does not follow that if a person can hear and remember he will listen. If no verbal response is made to what is registered in the ears there is no listening. And this happens. How often have you sat through a lecture to which you made no verbal response? You may have even repeated some of the words, or have taken notes. But the speech had no meaning for you because you did not listen; you did not say to yourself, "Now let me see; he says, 'History is the ethical struggle of man.' I thought history was a story of the past. Well, not all of the past or we couldn't study it all in one lifetime. History is selective—the selection of some men. Maybe he means it is the selection induced by the struggle of humans to conquer the evil in themselves." Now such an interpretation may not be what was meant by the speaker. And certainly a listening response is telegraphic, being developed into the communications of interpersonal statements, as above, only

[1] J. P. Hughes, *The Science of Language* (New York: Random House, 1962), p. 6. (Italics are ours.)

[2] M. Pei, *The Story of Language* (Philadelphia: Lippincott, 1949), p. 100.

as needed. But the point is that listening is a talking back to the recording that one hears and remembers. Listening is the response to reception.

The question still remains, "How do we gain any degree of commonality of meaning, which of course we do, when we cannot transmit meaning?"[3] How do we understand each other if we cannot receive meaning from each other? The answer is that we all live in the same physical universe with its common stimuli for sense organs. And although the studies in perception—the way we see and hear—do show that our personal needs often distort, the fact remains that we all are earthlings and thus we do have some commonality of basic experience. We walk, we eat, we joy, we pain, on the same earth, under the same sky. "Doth not a Jew bleed?" asks Shylock in his plea to be understood as a member of the human race, in the family of man. Much experience is common to all of us.

In addition, any social group whose members try to communicate has a common linguistic structure that allows its users to point to things in the physical world, to smile or frown, to shake their heads. In short, there is enough of the commonness of earth experience and similarity of basic design in all languages (which scholars like Noam Chomsky and others are trying to discover and describe) for even a German and a Chinese on their first meeting to achieve some identity of meaning at the more primitive levels. The commonness of experience breeds commonness of meaning.

The key fact remains, however, that so far as meaning is concerned, each of us is encapsulated in his own experience. We do not, because we cannot, transmit the meanings of our experience. Thus listening is the silent speech aroused by the words recorded on our brain cells when we hear.

Nature's Provisions for the Listening Act

Nature has provided at least three basic conditions for listening as here described.

Shift of Attention Attention is not a continuous thing, but broken. Research by the psychologists Woodworth, Pillsbury, and others, who followed up William James's emphasis upon consciousness and attention, has demonstrated that we can attend one source of stimuli for only a few seconds at a time. Apparently, attention is an on-off mechanism, which means that in our recording of a speaker we do not behave as the electrical tape recorder does, registering a continuous flow of the incoming words. Rather, we hear a discontinuous flow. So our hearing and recording of another is an alternating of recording and listening. We hear, we make comment, we hear, we make comment; thus nature's

[3]See Jon Eisenson, J. Jeffrey Auer, John V. Irwin, *The Psychology of Communication* (New York: Appleton-Century-Crofts, 1963), p. 118.

shift of attention provides the basic condition, the gaps needed for response.

Language and Attention Shifts But these shifts of attention alone would not be consequential in designing the character of listening as described above. Animals also demonstrate the shifts of attention, but, without language, their shifts are a series of diversions. Not so with man, for language, carrying the burden of past association, when excited generates new patterns of association. And so, we are induced, as soon as we learn to use language, to hear the other's speech, and in the gap of attention to comment, at first aloud, as children do, and then gradually to ourselves. Lev Vygotsky calls what we are talking about "inner-speech," a "fluttering between word and thought," or truncated speech. It is similar to making a note to remind yourself of something. Some speech professors call it self-talk. Laymen call it listening.

In large measure the speech–listening process may be explained in terms of social reinforcements received throughout a lifetime, beginning in infancy; the baby is loved and coddled as he exchanges nonsense sounds with his mother. As speech structure is learned it continues to be conditioned by interaction with other people. Thus children of five or six will verbalize six times as much in the presence of others as when alone.[4] Because of the gaps in attention and the impulse to verbalize, triggered by the speech of others, we learn to listen—to make commentary on what we hear.

The Linguistic Causal System Nature's third provision for inducing listening may be so deeply imbedded in the growth mysteries that we can never know the mechanism and how it works in full detail. But it is quite obvious from common experience that in the nature of man is some kind of energy that emerges in the response, "What does that mean?" and this is also basic to an understanding of listening as here described. The mockingbird sings only in deathless repetition; we humans translate, we say something else. It is as if each utterance heard arouses the commentary, "As the echo of that thought fades I am inclined to say. . . . And having said that I am reminded of this. . . ." A string of associations is unraveled until we hear or remember something unrelated, or perhaps something we cannot or will not associate with the words just released.

Self-Listening

Thus far we have discussed listening, in the main, as a verbal response to what is said by the other person. But we also hear, as we talk silently

[4]A. R. Luria and F. J. Yudovich, *Speech and the Development of Mental Processes* (London: Staples Press, 1959).

or aloud, our own speech, and so listening is also a response to ourselves. In truth, "self-understanding" depends upon developing the power to *explore the meaning of our own speech*. Indeed, all that we call well-organized speech, and more important, what we call wisdom, is the product of hearing our speech as we speak, assessing—saying to ourselves, "And what does that mean?", matching what we said with our purpose, and then proceeding.

We often call this the act of thinking, but it is profitable to conceive of the act as a self-conversation, an exchange between *called-up experiences and the commentary thereon*. Self-listening, like conversation with other people, is directed and determined by the feelings aroused in the exchange. And thus it is the feeling of freedom to call up thoughts, and the freedom to comment in new and often surprising ways on them, that shapes the character of our growth.

Of course, there is no good self-listening which does not also involve good listening to others. The two cannot, in fact, be separated. But this is all in the abstract. Let us examine the meaning of what we say here by looking at several lives that illustrate.

The Good Listener—to Both Self and Others

The life of an older student, among many that might have been chosen, illustrates the productive balance between listening to self and to others, a mixture that releases powers.

This man had lived, he said, on an Arkansas plantation the first fifteen years of his life. His recollection of those years was that it was like living in a prison. He was, in fact, a black youth trapped in a white society. But his parents, both very religious, taught him to accept the conditions of this life and to love all men, black or white. If he did that, they told him, he would get his reward in heaven.

So at that point the pressure to "listen" to the voices from outside the self was very strong. But silent speech, the voice of the self, was already stirring to restore the balance:

> I thought I loved everybody, but as I look back on it, I remember a mixture of hate and envy for the white man and his automobile and his big white house. And I hated my father's high laugh and loud talk in the presence of white men. When there were no white men around, he often sat silent and dejected or talked arrogantly to us children. I thought I loved my father, but actually I felt he was weak.

From age fifteen onward, the inner-outer mix of messages was vigorous, if often baffling:

When I was fifteen some relatives from the North came to visit and one uncle said, "There are no signs. You can eat where you want." The wildest statements came, however, from my peer group in Arkansas and my imagination led me to believe that Michigan was a heaven on earth. I went to Lansing, where I spent three miserable and confused years. I couldn't find out what to believe. Some people said you couldn't get served in that restaurant. So I would go in and order a meal and they would serve it to me. Then they would tell me, but you can't get fitted to a suit of clothes in that store. So I saved my money and went in there and they sold me a suit of clothes. But I'd often walk into an employment office and ask for a job, and they would say there was no work. They'd tell me to come back later. I would wait and watch and the next white man would get a job. I knew where I stood in the South and couldn't find out where I stood in the North. The northern white didn't play it straight with me, and my northern black peer in most ways was worse than the country hicks from the cotton sticks. I got full of hate and frustration. I got into fights. I spent much of my time complaining to friends who felt like I did.

Two of the most important things in my life happened the summer I was eighteen. I returned home and I found, for the first time, how deeply I loved my father and mother, my sisters and brothers. That was good to have the love wash through me. And the other thing: I had an aunt who I had never liked. She talked too much and too self-righteously. She said something one day and I spoke mean back to her. Then I heard myself say something I had never before said to anyone. I apologized. "I shouldn't have said that. I'm sorry. Forgive me." That was the first time in my life I had ever apologized to anybody. I don't know why, but I know that was the beginning of the most important change in my life. Gradually over the next ten years, at first dimly, I began to see the hate in me, and to see that the hate was eating me up. I'm 34. Three years ago I told my wife, "I've hated all my life. I'm done with that."

The revelations of profound internal changes taking place in this student's life appear to show him moving toward introspection, toward the painful effort to conquer a seemingly unconquerable feeling. But his final statement shows him still aware of the messages from outside, and still willing to accept them as part of his reality:

But I am still a frightened man. I am now a college senior. I am six-feet-five, weigh 220 pounds and quake inside with fear on examination days, like a boy. That's weakness. I don't want to be weak. I want to be counselor of the young. You aren't ready to counsel until you are strong.

Here then, is a man who has learned something about who he is, who has been able to stay tuned in to his silent messages even when they are frustrating, and who has made the invigorating discovery that he can sort out the worth of the messages he gets from the outside. He approaches the next stage in life with his eyes and ears open.

All sense of direction in life comes from remembrance of the imaginings of childhood.[5] In short, one can listen to himself only if he *has* listened to himself. And one can do nothing socially constructive with his self-awareness if he does not understand others. Self and other listening are appropriately balanced when the person grows and is productive.[6]

The Listener Who Hears Others
But Cannot Hear His Own Voice Sufficiently

A very different story emerges with the legendary Jimi Hendrix and Janis Joplin. Talented, charismatic, endlessly energetic, they both became singing stars—more than that—symbols of the "now" generation. There weren't enough superlatives to describe the musical magic they were able to work with the young.

Then, suddenly, they were dead—first Jimi (from too many sleeping pills); three weeks later Janis (from an overdose of drugs). Age for both —27. Why the passion, exhibited by both, for drugs? Why the readiness to quit, so soon, a life they seemed to love?

The answers can't be known with confidence, but much of the evidence adds up to something like this: Jimi Hendrix and Janis Joplin were tuned to the voices from outside themselves so completely they couldn't hear the inner messages which could have told them they were losing control of their lives. They were, from an early age, people who knew they had exceptional powers for entertainment. Someone noticed them. They got contracts. They got money. They made hit records. The voices from outside were strong and clear. Like moths drawn hypnotically toward the light, they were tuned to applause, recognition, reputation. And the more those messages flooded in, the more they gave. Toward the end they were performing with a transcendent kind of frenzy like few people had ever seen.

Then they were dead. At least one interpreter of their early deaths saw in them an inability to accept the reality of change that faced them, and to accept their limitations within that change. At the very least, we seem to see here two lives enslaved by the messages from without—shut off from the messages from within. They could communicate with thousands. They could not make sense to themselves.

Heard Who?

Intelligent speech depends upon intelligent listening, and listening is always a verbal response to what we hear from ourselves as well as from our conversant. Whether we focus on what we ourselves said or what the

[5]Best seen from the in-depth interviews with creative people.
[6]See Emil Ludwig, *Genius and Character* (New York: Harcourt, Brace and Co., 1927), for biographies illustrating this.

other person said—or both—is of critical concern. We have said that the energy which propels speech, whether it be silent or aloud, is, "and what does that mean?" That question, however, seldom stops with the word "mean," but is followed by "to him" and/or "to me." These differences in listening orientation are profound. Let us illustrate with an incident from one of our classes.

A young man, in fulfilling a communication assignment, took a book to the student center, sat down near people in conversation, opened his book, and proceeded to listen to the conversations. Two girls were talking and he tuned in. One was doing most of the talking and she was saying, according to his report,

> I don't know why I stay in school. I'm not getting anything out of my classes. I don't study. Last semester I almost dropped out. I don't know why I stay. I guess because I don't want to go home and I don't know where else to go. Nobody cares. Maybe I'll go away tomorrow. It really doesn't seem to matter. . . .
>
> The young man said:
>
> My commentary to myself at this point was, "An awful lot of people just let their speech be a funnel for their bad feelings. Listening to the girl I began to feel uncomfortable. I wanted her to quit talking. I decided I was not going to spend my life pouring my complaints into the ears of other people."
>
> In the class where the above report was made a girl said,
>
> I didn't hear the same thing in that story. I wish I knew the girl you refer to, her name and where she lives. I want to listen to her. I am pained too by what she said. But she is crying for help and I have the urge to sit down and listen to her. Somehow I know it would be good.

The point is this. The boy was *asking* as he heard, "What is the meaning of this girl's speech *to me?*" The girl in class was asking, "What is the meaning of that girl's speech *to her?*"

And if one follows through the implications of this story he sees that each of us makes the twists and turns of our growth in accordance with the questions we ask ourselves as we listen. The possibilities are as follows:

1. What does his comment mean to him?
2. What does his comment mean to me?
3. What does my comment mean to him?
4. What does my comment mean to me?

If we ask only what do his and my comments mean to *me*, our silent speech tends to make us highly egocentric, with several possible turns. We may withdraw from people if the meanings are generally painful. If we find great pleasure in the meanings for ourselves, we can grow narcissistic

as we study our mirror. If we are suspicious of others we become hostile as we listen to them. The results of finding only meanings for self in what we hear are many and varied.

On the other hand, there are some people who are incomplete because they respond almost exclusively to speech with the question, "What is the meaning of this to him?" While these listeners are always the more sensitive among us, they also include the conformists, the weak, the gullible, the purposeless, the celebrity lovers. Add to this second orientation a noncritical listening to one particular group and an occasional, "What is the meaning to me?" and we have the person with missionary zeal, driven to be the instrument of social change. Mix in hatred and you have those who like to do battle for great causes. As we increase self-hearing to meet the power of listening to others there comes a balance between listening to self and to others—a balance about which we know little—where the product is the evolution of the wise and calm person. Note the union of the two in Abraham Lincoln's description of his own evolvement.

In 1860, on a train near New Haven, Lincoln fell into conversation with a Rev. J. P. Gulliver of Norwich, Connecticut, who asked him how he got his talent for "putting things." Lincoln's reply is reported as follows:

> Well, as to education, the newspapers are correct—I never went to school more than six months in my life. But, as you say, this must be a product of culture in some form. I have been putting the question you ask me to myself while you have been talking. I say this, that among my earliest recollections, I remember how, when a mere child, I used to get irritated when anybody talked to me in a way I could not understand. I don't think I ever got angry at anything else in my life. But that always disturbed my temper and has ever since. I can remember going to my little bedroom, after hearing the neighbors talk of an evening with my father and spending no small part of the night walking up and down, trying to make out what was the exact meaning of some of their, to me, dark sayings. I could not sleep, though I often tried to, when I got on such a hunt after an idea, until I had repeated it over and over, until I had put it in language plain enough, as I thought, for any boy I knew to comprehend. This was a kind of passion with handling a thought, till I had bounded it north, and bounded it south, and bounded it east, and bounded it west. Perhaps that accounts for the characteristic you observe in my speeches, though I had not put the two things together before.[7]

Bounding a thought on all sides is saying the thought for oneself in ways meaningful to all concerned.[8]

[7]From: *New York Independent*, Sept. 1, 1864.

[8]The question quite naturally arises, "But what is the difference between listening and thought?" The answer we offer is this: listening is verbal thought, but not all thought, for the human thinks in nonverbal symbol systems too. People count, sing,

The Functions of Listening

What then are the contributions of the listening act to the communication process? Essentially, listening serves two purposes: one, to establish empathy; and two, to acquire information. Each is important, though they operate together and have little meaning independently. We are aware that other writers describe listening functions more exclusively as listening for information. We feel, however, that the functions of empathy and information acquisition work together in the priority given here.

Empathy Empathy is the act of imagining the universe of thoughts and feelings out of which a statement emerges. In short, it is the ability to perceive from the standpoint of the speaker, and it is probably the most sophisticated and the most imaginative skill a person performs. The effect is something like the reperception of instant replay on television, *experienced* (as it usually is) *from a different camera position.* One senses he sees the same action and interaction that he just experienced and yet it is different, seen as it is from a second cameraman's "point of view." Empathy thus provides the perspective of two or more observations of an interaction. In the end, it is this that provides the data necessary to internalize the whole of a communication exchange. Thus empathy is the basic ingredient of what we call understanding.

The way language permits us to empathize and to get meaning is the burden of the next chapter. Here it is perhaps enough to note that understanding springs from the ability to speak for two people at once. As we become the other, as well as the self, three things happen: relationships with the other improve, understandings about others increase, and remarkably, self-understanding, the sense of identity, increases. In understanding how empathy works we learn why we have to lose ourselves to find ourselves. Empathy is, thus, the central skill in growth. In large measure this book is designed to increase the perspectives achieved by empathic response.

Acquiring Information The second function of listening is to recognize and to acquire information. As we hear words and later state

dance, paint, sculpture, make homes, public buildings, and cities. And then there is body English—the skills of the athlete, the automobile driver, the mechanic. Thinking goes on in many language systems. But the mother tongue, which Pavlov significantly called the secondary signal system, is the one kind that is self-reflective. By the association of person with person and the language symbols that attend these human relationships each of us has learned to use language as a mirror of others and of ourselves. Thus, while verbal language is not the only symbol system, and therefore is not the only kind of thought, it is the most important one to personal evolvement, and thus the most important of all symbol systems.

and restate them in different words, we are trying to isolate the significant points. In a previous story Lincoln reflects on the boy of his past who paced the floor trying to probe the dark sayings of the older people, searching for the basic information in their interaction. In order to know what they said he had to remember how they spoke, too. One must remember the stammerings, the tonal quality of a critical word, the expression of the face, the tension of the body, a constellation of detail discussed in the chapter on the nonverbal code. Lifting out the important information is the ultimate test of our listening, for this, as Lincoln suggests, is the way we develop our thinking powers. Nobody can reach beyond his ability to select a perspective in his listening and to store the pertinent detail accurately. Even if we listen just to enrich our relationship with another, it is what we listen to that makes the difference.

Yet we shall not analyze the information gaining and storing process as the central focus. We do not because it is our view, as cited in Chapter 1, that the dynamics of information acquisition rest in the factors that shape our relationships. One perceives, accurately or inaccurately, what he must in order to satisfy his needs. Thus that which bears upon relationship is central to understanding the role of listening. While we do not study the acquisition and storage of information in a book concerned with the dynamics of interpersonal communication, we should recognize the importance of acquiring information, for this is usually if not always the ultimate purpose of listening.

The contributions of listening to the communication act are empathy and the acquisition of information.

THE OVERT SIDE OF COMMUNICATION

Communication takes place between people—as well as within them. It thus requires overt speech as well as silent listening. And while no one can speak more intelligently than he can listen, yet overt talk is different from silent talk and has functions that the latter cannot serve.

The Functions of Speech

First, it is by talk that we may be transparent to each other. "A penny for your thoughts" says "I know something about you as a consequence of your nonverbal behavior. I sense you are experiencing thought that is deeply significant to you. Tell me about it." Speech is the window that reveals the person within. By speech we can be transparent to one another. That is its first function.

Second, speech permits us to test the accuracy and reasonableness of

our silent, and more telegraphic, speech. Only as we openly say what we think can we find out if we believe what we think.

Thus overt speech is a test of covert speech. The therapy session is probably our most dramatic example. But business conferences, family discussions, and the pervasive bull session, or "rap" as it is called today, to mention a few speech situations, all illustrate the testing function of speech. Most of the decisions and plans of action in this world are hammered out in the speech exchange.

As egocentric individuals we are likely to see group decision-making as a personal sacrifice of truth, not a test of truth, especially if we are emotionally involved. But group judgments in distinguishing small differences in objective things like weights or sizes of objects tend to turn out to be more accurate than individual judgments. Although there is no objective measure of what is true socially and morally, that very fact makes the decision of the group, arrived at by talk, the only socially acceptable position. So talk is a test of truth—as well as the way we may reveal ourselves to each other.

Common Resistance
to Verbalizing Our Listening

In spite of, or perhaps because of, the values of overt speech many college students resist the translation of experience into verbal terms, at least for the ears of others. Instructors know well that vacant look and passive attitude of a class the moment the lights are turned on after an emotionally packed film. An attempt is made to arouse the class to discussion. "Why do we have to talk about it?" one will ask and the rest will join him. They are saying there is a world beyond words that words profane.

We can in part appreciate this view. Much of our most delightful experience is like the whisper of the wind on our cheek, or the tingling sensation when music surges gently over our being. If the very words just written are a poor translation of some experience deeply moving to you, you can only resent the author. Who wants to hear, "Now ain't that pretty," as he grasps his first view of the Grand Canyon? Bad commentary upon peak experience is an abomination. Better depend upon imagery and sensations, and just say to oneself, "I'll do this again." But we will try to win the argument by saying this, that at least you have to listen that much; that is, verbalize to yourself, "I'll do that again." Long-term meaning is verbal.

Humans simply cannot build a unified and powerful life without words. Words must be found for gem experience, or the experience soon dies within us as does the very process of giving our life meaning. We

build into our lives a quality equal to the words that form the commentary on experience. That is to say, all experience is best when turned to the verbal, at least to the self.

Consider the words of Gibran on that miserable word "work":

> Often have I heard you say, as if speaking in sleep, "He who works in marble, and finds the shape of his own soul in stone is nobler than he who ploughs the soil . . . I say, not in sleep but in the overwakefulness of noontide, that the wind speaks not more sweetly to the giant oaks than to the least of all the blades of grass; And he alone is great who turns the voice of the wind into a song made sweeter by his own loving . . .[9]

To make no commentary—at least to self—is to be empty. In the end, escape from comment to others is an escape from the opportunity to make ourselves available to ourselves and others, and to test our listening.

In reflecting upon the analysis of these pages one will note that the line between the functions of overt speech and silent speech is as faded as the hour between day and night. But the fact remains that the difference is real. He who listens and will not talk is an enigma and seldom finds his greatest powers. And he who talks and will not listen seldom makes sense. It takes both silent and overt speech in union to produce the effective communicator.

COMMUNICATION: THE INTERACTIVE RESULTS OF LISTENING AND SPEAKING

The bulk of writing in humanistic psychology, psychotherapy, religion, and sociology in our times has led us, and many others, to place communication at the center of human concerns. The role of communication is seen for what it is if we note the matching functions of speech and listening. The two together produce our capacity to know ourselves and to think through our problems as suggested in Figure 1.

Open talk and empathic listening establish mutually trusting relationships. As we shall see, out of such talk and listening a person grows to understand and to accept his identity. The testing function of honest speech is matched with the urge of the listener to discover the pertinent information. Thus thought in both speaking and listening remains fluid and subject to change. These are the functions of communication—to enhance a sense of identity and to maintain an evolving flow of creative thought. Of course we can conceal and fail to test; we can reject the

[9]Kahlil Gibran, *The Prophet* (New York: Alfred A. Knopf, 1968), p. 27.

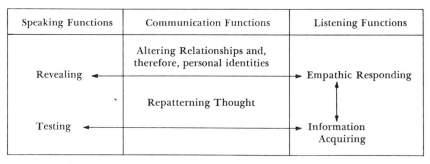

Speaking Functions	Communication Functions	Listening Functions
Revealing ◄────	Altering Relationships and, therefore, personal identities	────► Empathic Responding
Testing ◄────	Repatterning Thought	────► Information Acquiring

FIGURE 1

imaginative use of the ears of others, and even our own. Many people are confused about themselves and cannot think clearly.

Communication Functions:
(1) To Produce Identity in Relationships

Many of us would like to know our identity. By identity we refer to the need to feel some sense of direction in our lives, to make sense of our experience. And this is the primary function of the relationships which evolve out of our speaking and listening.

How does the open and empathic relationship between people carve out their identity? Each person is caught behind his own eyes, in his own bag of skin, looking out on others. By ourselves we cannot see and hear and know ourselves. Even that loner, Thoreau, intimated his dependence upon others for capturing a concept of himself, saying, "It is as hard to see oneself as to look backwards without turning round." To know himself, a person "turns around" and perceives himself in the responses of others. As his central theme, Sidney Jourard in *The Transparent Self* crystallizes this point: one must openly reveal himself to at least one other person if he is to gain any semblance of self-knowledge.

Actually, more than one person is needed if one is going to gain a direction unique to his talents, for others are not accurate mirrors, but reflectors that respond not only to us but also to their own needs. It is best, then, that we all have many reflectors from which we select that which designs our own pattern and course. At this juncture it becomes increasingly clear why our speech should be open—so that we may have many mirrors and that we may not arouse the defensive needs of our "mirrors." Otherwise we blemish the very source we must have to know ourselves. Moreover, only as we learn to listen to that other person empathically can we learn to separate out from his responses that which

tells us accurately about ourselves, and that which tells us more particularly about him.[10]

The haunting search for identity, always the basic concern of men who have the courage to explore their directions, values, and behaviors, is achieved in the communication act above explained.

Unirelationship and Its Consequences

The significant awareness we need to gain here is that a relationship between two people that produces the information for identity for them depends upon the open speaking and empathic listening of both persons. It is not enough that one person speak and the other listen. The meaning of this can be made sharper by examining the interactions of a unirelationship such as we have in mass media communication.

Let us look at this, first, from the standpoint of the newscaster's search for his identity as a newscaster. Each evening he speaks to his audience. He does not know who he is or what he is doing, save for feedback, which is not directly accessible to him from his audiences. Essentially, this media personality becomes believable, as a person, only as his colleagues, family, and friends react to him after his performances, or preferably as he performs. And indeed he can best be, on media, something of the real dimensions of the person he is when he interacts with another person. If he had to depend upon us, his unseen audience, he would have no way of knowing himself as a professional communicator at all.

But if the one-way relationship of television limits the self-awareness of the performer, think of the identity problem for us, who, though we respond internally to the message, as we watch, have no corrective response from the performer. Let us go to an example in fantasy. A person who could know other persons only by watching them on television would be destined to non-identity. The unseen, therefore the unspeaking, watcher is therefore actually the unreal man, known to nobody.

The importance of the act of speaking to our sense of identity may best be seen by looking at the strange world of the autistic child, who listens but does not speak. He develops this self-imposed mutism because in his earliest efforts to interact with others he has been punished traumatically, usually by an unpredictable mother. Not knowing what to expect when he cried as a baby, he gradually ceases to cry or to use voice—and therefore to learn to speak. Indeed, he learns to cut off all expressive communication and this includes the nonverbal too. But he listens, and in listening without the correction of speech, he builds a world of fantasy. A report by Dr. Richard D'Ambrosio describing his efforts to teach a

[10]This is feedback theory, translated from its mechanical model into humanistic terms.

twelve year old girl to talk, gives a vivid picture of what it means to speak.[11] Wan, weak, and without any sense of direction, the girl had learned to dress and eat. She could be led from place to place, but she did not initiate any behavior except to cry silently upon occasion, unpredictably, and usually at night when alone. She gave no sign of being aware of the world of things or people around her.

In their weekly meetings the therapist spoke kindly and intimately about the flowers and toys they both could see in the immediate surroundings, working for hours to prove he could share and be trusted. Her first response, an isolated one, came one day as they were walking together. A group of hilarious children on roller skates came rushing upon them and Laura, in terror, threw her arms about the doctor.

Over the subsequent months he became aware that she was gradually and occasionally responding internally to his talk. An idea occurred to him. He built a house of blocks as he talked about it and its decorations and the people who would live there. One session, as he fumbled in trying to arrange the furniture she reached out and arranged some pieces, then retreated to complete passiveness again, for weeks.

Knowing the story of her life, the doctor placed a father and a mother and a baby in the house and developed a quarrel between the parents that ended in a vicious beating of the child. As the story developed he sensed the girl's intense watching and heavy breathing. When he reached the climax, where the parents turned upon the crying baby, she screamed "No! No! No!" grasped the parent dolls, beat them furiously, and tore the house apart. At length she fell into convulsive sobbing as the therapist comforted her. All this pent-up terror, hostility, and revulsion was understood. This child had literally been fried in a frying-pan by drunken and psychotic parents.

For a week Laura retreated again to silence and despair. But, and here is the significant perception for us, as she began to talk (for the first time in her life) to the doctor in their next session she grew confused and lost orientation. She could not remember whether she had ever met him, whether she had ever been in the room before—though they had been meeting there weekly for years.

Her world of awareness was so shocked by overt speech that her perceptions became strange and unreal to her. Her previous world had been one touched and stirred by the words of others, but never tested in the crucible of her own spoken language.

We who have had our mouths open most of our waking hours probably can understand this by alerting ourselves to the way we react in coming out of a good novel in which we have been buried for half a day.

[11]"No Language But A Cry," *Good Housekeeping*, August, 1970, p. 64.

As we leave the book and take up life at the dinner table we may feel like strangers to the persons beside us. So Laura felt, most shockingly, as for the first time she entered the world where she heard her own voice.

We have been discussing the functions of speech and listening in forming the way we feel and relate to ourselves and others. And we have been saying that the critical thing for each person is this, that in these relationships, he finds his identity. Speech and listening together, two-way communication, produce relationship. Out of our relationships emerges our identity—limited only by our ability to make sense to ourselves.

Communication Functions:
(2) To Repattern Thought From New Information

Just as the physical person is something in process, so the cognitive person is something in process. Children think and speak as children. As they pass through the seven stages of life, from the "mewling and puking" infant to the old one whose very senses fade, the ways of thinking also change gradually. In the changing patterns it is basically the self-perceptions and the relationships with others that produce the new forms. Thus, when people are open and accepting with each other, they test what they think against the responses of each other and thus produce self-changing awareness. As they change in their perceptions of themselves they see and hear new and different things. The creative re-patterning of the virile mind is the product of eyes and ears that remain open, seeing and hearing as freshly as the child does.

Until recent years, the educational system has operated on the assumption that its province is the dispensing of information and the training of rational processes, as if the very emphasis upon intellectual processes would free the learner's thought from wants, feelings, authority struggles, self, and other perceptions. But that is not the way it works. We all think as our ego needs direct us to think. We are as intelligent as the stuff that builds our relationships will let us be. Thus we are as intelligent as our listening and speaking is responsive to the new information that our constantly changing environment provides.

SUMMATION

The essence of the chapter is this: we speak, we hear, we listen. Listening is silent telegraphic speech. Interactive *open* speech and *empathic* listening together produce relationships that allow an exchange of accurate information, the results of which are a clearer identity and more creative thought for the participants involved.

One of the things we must explore to understand these things better is the very nature of language, and this we do in the next chapter.

OBJECTIVES

The purposes of chapter 2 are:

I. To make clear a basic thesis of the book, that listening is inner speech, and to dispel the notion that listening is passive reception.

II. To explain the unity of speech and listening in the communication act.

III. To help you sense the significance of communication (identity search and pattern making) in our lives.

EVALUATION

Before reading the chapter write one paragraph on each of the following words: "speech," "listening," and "communication." After reading the chapter do the same thing. Compare the two papers.

DISCUSSION QUESTIONS

1. *Objective I* Discuss listening as it is defined and described in this chapter.

2. *Objectives II & III* In *The Merchant of Venice* Shakespeare says that justice will save the soul of no man, and only in charity or love can we hope to be saved. Discuss this idea in the light of the "Forgive Me" story of the chapter.

3. *Objective III* Discuss salvation as the preservation of one's dignity and freedom.

EXPLORATIONS

1. *Objective I* Read a poem, or display an art piece, or play a musical selection that is likely to have little or no meaning to others. Give an explanation of the way this particular message came to make sense to you.

2. *Objective I* Try the exercise on simultaneous feedback. On television you may have seen a person who can speak in unison with another person no matter what the person says. It involves an uncanny ability to anticipate the speech of another.

Give a slow short speech to the class instructing everybody to silently say the same thing with you as you go. Give a short listening test to the class over the material to see how much they remember and their understanding of the speech. Discuss with the class the results.

How does this demonstrate that listening is not passive reception, but active response?

How does it demonstrate the shift of attention?

3. *Objective I* Tell the class a fascinating story. Have it understood that a colleague without notice will ring a bell and you will stop talking. Everybody is to write down what he was thinking just as the bell sounded. Compare the responses.

What conclusion does the data support?

4. *Objective I* Keep a journal of your responses (1) to yourself and (2) to what other people say that impresses you. Write in the journal three times a week.

Write the thing you are going to respond to, then respond. As the weeks pass note that gradually you learn not only to respond but also to respond to your response, then respond to that response. On a good day there is no end except in exhaustion.

This is the essense of the process of creative thought.

What conclusion does it support?

5. *Objective II* This is a zero feedback exercise. Have a person go to the blackboard and draw a geometrical figure which you describe to him. Pass out to the class the figure. Without any questions from the person at the board, sentence by sentence, tell him what to draw. Compare his figure on the board with that of the one the students have at their seats.

6. *Objective II* Go to the back of the room or get behind a screen (the latter is better) and give a short speech to the class. Come before the class and tell them the difference in talking "behind their backs" and to them face to face.

7. *Objective II* Study an hour with earplugs in your ears. Then study for an hour without them. Report to the class the difference in your comprehension and productivity.

8. *Objectives I & II* Arrange to have a person in the class be interviewed twice for positions, say as a high school teacher. He will be interviewed by two superintendents. One is secretly told he is to feel superior to the candidate and to conduct himself as the superior one. The other "superintendent" is told he is to feel the candidate is a very superior person and to conduct himself respectfully.

9. *Objective III* Have your fellow students write down on a sheet of pa-

per twenty times "I am ———." Each blank is to be filled with the first thought that comes to mind. Ask the class to write or to think about a description of the person suggested by these twenty statements—the central characteristics of such a person. Choose several to tell what they have thought or written. Discuss.

10. *Objective III* Go as long as you can without talking or listening to anybody. Note your feelings and thoughts. Report the experience to the class.

11. *Objective III* Go away for twenty-four hours to a place where you do not speak to anybody. Report to the class what happened to you internally.

12. *Objective III* If available take and have scored the Everett Shostrom Personality Orientation Inventory. One of the most important items is the support index. It tells how much you are "inner" and "other" directed, relatively how much you listen to yourself and to others.

Report to the class or write a paper on your interpretations of the score.

13. *Objective III* Tell about a person you know who had to have approval from others so much he became confused, not knowing his own private needs.

What conclusions do you draw from this that relate to the chapter? State these conclusions.

14. *Objective III* Tell about a person you know who is so self-absorbed he does not listen to others. Discuss his personality and his impact on you.

What conclusions do you draw from this that relate to the chapter? State these conclusions.

15. *Objectives II & III* All of us who have prepared speeches carefully, especially in our early training, have been shocked by the difference between the prepared speech and the one given, even if memorized.

Prepare a speech carefully, recording it at least once.

——Now give the speech to the class, recording it.

——Compare the two recordings and report the difference to the class.

——What conclusions do you draw from this experiment?

16. *Objectives I, II, & III* For twenty minutes talk to a person in the class you have not previously known—on any subject.

Then, either by guess or actual data that came out, let each of you fill out the following form on the other person:

 a. His (her) age ———.

 b. He (she) is one of ——— children.

 c. He (she) is ——— in the order of siblings.

 d. He (she) comes from a community of ——— number of people.

 e. He (she) is closer to his father, mother. (circle one)

 f. His (her) father had ——— years of education.

 g. His (her) mother ——— years of education.

 h. His (her) political sympathies lie with the ——— party.

i. He (she) is a liberal, conservative, reactionary in social issues. (circle one)

j. He (she) is 1 2 3 4 5 6 7

 relaxed tense

 in social situations. (encircle one number)

k. He (she) is usually 1 2 3 4 5 6 7

 moody cheerful

l. He is emotionally 1 2 3 4 5 6 7

 stable unstable

m. He is athletically 1 2 3 4 5 6 7

 inclined not inclined

n. He is interested in:

Athletics 1 2 3 4 5 6 7

 very much not much

Art 1 2 3 4 5 6 7

 very much not much

Music 1 2 3 4 5 6 7

 very much not much

Drama 1 2 3 4 5 6 7

 very much not much

Philosophy 1 2 3 4 5 6 7

 very much not much

Religion 1 2 3 4 5 6 7

 very much not much

Travel 1 2 3 4 5 6 7

 very much not much

People 1 2 3 4 5 6 7

 very much not much

Our conversation 1 2 3 4 5 6 7

 very much not much

Having made out this form, now have the other person correct it. The fewer the corrections the more perceptive a listener you are.

From your own correction of the other person's awareness of you what do you learn? How revealing are you? How hard are you to read?

Write a short paper on what you have learned or make an entry in your journal, if you are keeping one.

3
Meaning:
The Translation of Words

Thus far we have seen that any communication that makes a difference hinges on a relationship between people. And we have also noted that the work of communication rests significantly in the listening act, and that listening is a truncated speaking act. We have said nothing yet about the verbal instrument we use in communication—the scribbles on this page, the words that race through your brain and drop from your lips intermittently most of your waking hours. It is in language we get our sense of meaning, our sense that what we are doing makes sense.

Basic experience is sensory. We see, we hear, we touch. And this is automatic and direct—it is the primary signal system. But language, the secondary signal system, as Pavlov called it, is a feedback system for primary experience. Its basic utility derives from the fact that it is an echo of direct experience. It is this feedback to experience that we call con-

*From the book LUDWIG WITTGENSTEIN: An Introduction to His Philosophy by C. A. Van Peursen. Copyright © 1971 by Faber & Faber Limited. Published by E. P. Dutton & Co., Inc. and used with their permission.

sciousness, awareness. Thus awareness is verbal behavior—the workings of language. The sense that we make sense is the function of language.

The challenge of this chapter is to try to unravel the nature of language, that thing that most makes us so human and gives us the power to describe and to evaluate—and thus to alter the approach to the upcoming moment. How does language work in providing this great power, this freedom to be responsible for our approach to experience, this capacity to know the great joys of existence as well as its deep sorrows?

To examine the nature of language is a difficult task, inevitably involving the frustrating feeling that we hold empty words just at the very moment that we think we are about to understand. The reason for this is clear. In order to study something, one has to get away from it so as to observe it. It is difficult to know how one looks in his new pair of pants if he has no mirror. What is the mirror of language? If awareness is verbal behavior, how can one get outside of words in order to discover how words provide him his awareness? He can't. But he can use his imagination, just as he can look at the pants on the rack and decide how he might look in them. Imagination, which is seeing that which is not, is one of the most significant functions of words, providing us our capacity to understand how we understand. The perspectives the above statement suggests are necessary if we are to understand the most profound impact of language in human life—the hypnotic power of words over the man who says them. The world is what we say it is. And although each man may admit this, he likes to think that the words he uses are but the symbols of an independent truth. He finds it hard to accept the fact that in the very process of formulating sentences he creates the world of his reality. It is our purpose in this chapter to bring the reader so close to his own basic experience that he senses this meaning-making process.

TRANSLATION AND MEANING

We have discussed listening as silent speech, truncated as compared to overt speech, often telegraphic. A single word or phrase may carry the essence of a lengthy statement. It is in that which trips off a word or phrase that we discover the dynamics of meaning. Meaning is achieved in the response act, in listening. The response may be to what we ourselves have said or to what another has said. It is this responding act which we must examine if we are to comprehend comprehension. We shall call this act translation.[1]

[1]For those who have studied language in some depth, the chapter deals with our comprehension of the nature of *reference* as discussed by Ogden and Richards and the term *mediation* as discussed by Charles Osgood and others.

Between Statements

First, consider this: The experience of feeling we understand some-thing, that a statement makes sense, is not to be found *in* the statement itself. Working in a tantalizing way, meaning is outside of the statements to which it belongs. More specifically, meaning is that which happens between two statements. It is a kind of sensing of the identity between different statements. Meaning is the recognition of relationship. Let us illustrate:

Statement	*Translation*	*Listening Response*
(Child speaking) "All gone boat."		"Boats of greater weight than water sink."
"That's the way the ball bounces."		"It is foolish to buck the inevitable."
"Mike is not serious."		"Mike is avoiding an examination of this thing. Maybe he's frightened."

Neither the statement nor the restatement alone has meaning. It is that silence turned to awareness, the thing that takes place as we move from statement to statement, that constitutes meaning.[2] "That's it." It is that awareness which Charles Osgood's semantic differential points to: this which I contemplate is alive, compelling, and right. We are looking at a psychic process as simple and primal as the osmotic flow of solution in plant life or the bird's "awareness" of the lengthening day that sends it on its northern flight. Simple, basic to survival, difficult to understand because it is the essence of our psychic being.

Here is another way of examining the phenomenon. The feeling that what I am experiencing makes sense is a perception of the relationship between foreground and background. "All gone boat," is the *foreground* which really has no meaning except as seen in conjunction with the *back-ground*: for the adult, "Boats of greater weight than water sink." And the difference between the child speaking the original statement and the adult with his response is the difference in the "backgrounds" of the two. Further, the child's own background response to "All gone boat" is, if Piaget is correct, "Magic!" Things come into existence and go into nothing at will. It is like closing and opening your eyes. The adult who

[2]This is probably what Ruth Anshen alludes to in the statement, "Meaning is what silence does when it gets into words." From *Language: An Inquiry Into Its Meaning and Function* (New York: Harper and Brothers, 1957).

does not know the difference between his response and the child's response simply cannot talk and listen to a child.

As a consequence of self-talk or conversation with another, meaning is the perception which takes place when we capture the relationship between two statements. In everyday reference to this translation process, we often say of a person who is having difficulty understanding something, "He doesn't see the meaning behind the words," or "He takes things too literally." He cannot "speak back to a statement" and gain the perception of sensing foreground against background. He cannot translate. Meaning exists in the relationship felt in the perception of difference.

In an effort to control our listener's translations of what we say we keep making statement after statement—until we finally conclude that we have "bounded" our intended meaning. Successful or unsuccessful in the end, the ongoing feeling while en route is one of endless misunderstanding.[3] And the consequence of getting anything out of the confusions en route is a concluding sigh, "Oh, I see." We have performed the miracle act of translation. As Susanne Langer points out, understanding or comprehension is basically emotional; first, anxiety, and finally a feeling of satisfaction or dissatisfaction with the chosen response.

Translation Within and Between Language Levels

An understanding of the way translation works is confounded by the fact that our mental gymnastics allow us to make statements at one of six levels of "reality." Let us create a visual model (Figure 2) that may help us grasp an overall view of the way translation operates to give us meaning.

First, as sensual animals, our primary reality is physical action. We eat, sleep, anger, laugh, make love. Physical experience is our first-order experience, and the language of first-order experience is composed of emotional grunts, curses, weepings, ejaculations of glee, and our commands, what B. F. Skinner calls *mands*—"move over," "Quit," "kiss me, honey." One can and often does, of course, put the emotional response and the command together—"Damn it, get out!" The important thing to note is this: the language of first-order experience is that *of* action and interaction, and thus *has no subject, no actor expressed*. It is a distinctly different experience to say "Stop, right there," from that of saying "*I say,* stop, right there." The first is an unconscious or at least subconscious

[3]Susanne Langer, *Philosophy in a New Key* (New York: The New American Library, 1948), p. 123.

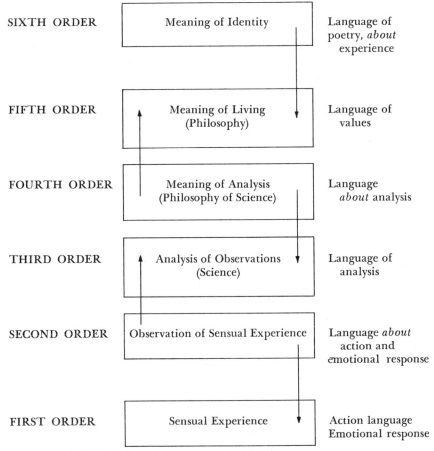

SIXTH ORDER	Meaning of Identity	Language of poetry, *about* experience
FIFTH ORDER	Meaning of Living (Philosophy)	Language of values
FOURTH ORDER	Meaning of Analysis (Philosophy of Science)	Language *about* analysis
THIRD ORDER	Analysis of Observations (Science)	Language of analysis
SECOND ORDER	Observation of Sensual Experience	Language *about* action and emotional response
FIRST ORDER	Sensual Experience	Action language Emotional response

FIGURE 2 Translation and language levels

command; the second is a command and a conscious statement—"*I* say . . ." In first-order language, there is no "I."[4] Emerging from feeling vocal expression is as automatic as seeing and hearing. First order language reveals our feelings and urges. But of itself, it has no awareness.

As noted above, we do have an "I" available. Its use introduces us into the world of second-order language. The pronoun "I" is our doorway to awareness, and all the god-like experience of the human emerges from the capacity of the "I" to make the "I" an object unto itself. Helen Keller, stricken blind and deaf at nineteen months, learned language

[4]First-order language expresses, but does not describe, action, and is thus very much like other animal and insect language.

more painfully than most of us and thus achieved a peculiar perspective about that learning. She reports that she was a confused combination of irritations until she gained the concept of "I," the self as an entity separate from all other things. It was, she said, in the gaining of a concept of self arising from the word "I" that she began to know the power of thought, of awareness. In speech that begins with "I" or any *subject* that *refers to* action or interaction, the perception of the speaker moves outside of first-order experience—like getting outside of a fence that surrounds a field—and he now talks about emotional expression and commands.[5] Second-order language makes comments on first-order experience. Here are some examples: "I feel good," "It is snowing again," "I wish that kid down the hall would turn his record player down." Each of these statements makes a comment about the self and/or other things observed. Note that the *tact*, as Skinner calls the language of commentary, shifts emphasis from action to things observed, by means of not only labeling a thing to be observed, but also by replacing a strong verb of command such as "give," "stop," "strike" with some form of the intransitive verb "to be."

Second-order language *translates* action and emotional response into concerns for study, and the translation process here is a capturing of the perception that takes place when one says, for instance, "Ah, nuts" (foreground) and then, to himself perhaps, "I'm provoked" (background). The translation of the language of experience into the language of commentary on experience provides the barest rudiments of awareness, knowledge, or consciousness of experience. It is the beginning of the building of reality in abstraction and the beginning of making "I know" compete with doing. In essence, once again, it is achieved by creating a subject for a sentence, thus shifting the speaker from being an experience to being a commentator on experience.

Third, as creatures with the capacity to create worlds to explore within the frame of a language system, we have the capacity to talk of awareness, the very thing we are doing in this chapter. In this language, no translation is made from the language of action to the language of observation, but rather, within the language system of awareness itself. To illustrate, here is a continuous flow of third level language: "The paper of this book is made of pine wood and the ink is an indigo which is made of herbs grown in India." And here is an example, without tangible references, but still within the frame of the third order. "College students today are trying to put together freedom, authority, responsibility, commit-

[5] Most of this explanation is similar to the reasoning of and the references in the following: Paul Watzlawick, Janet Helmick Beavin, Don D. Jackson, *Pragmatics of Human Communication* (New York: W. W. Norton & Company, Inc., 1967).

ment, and love in a way that makes sense in their lives." Or, "A checking of differences in the positions of distant stars in subsequent photos suggests lines of force which, in turn, suggests that the universe is expanding."

Third-level language is the language of analysis. It takes things and ideas apart and puts them back together again, achieved by developing a vocabulary that labels details and relationships. The language *of* knowledge is the beginning of the designing of the world in words. The translation process in this language, as in the primary language *of* experience, is simply the foreground-background insight caught as one statement flows out of the one just made.[6] The peculiar perceptions we gain from analysis come from a verb change, from the verb "to be" to the verbs "to have," or "to be made of." In short, analysis is the achievement of observing what *has* what, what belongs to what among our abstractions. Such is analysis, the language of science.

Fourth, in the order of man's ability to escape from sensation into flights of abstraction, is his ability to create what we call a philosophical view, a structuring of the way the world works *for* him. In contrast, the scientist, as suggested, is concerned to make statements about the structure of the physical universe. The physical philosopher goes further and says, "In the light of what we know, here is what *I believe* we *can believe* about our experience." The translation is between the language of physical relationships (to have) and a language motivated by the urge to say "I believe." Its purpose? The philosopher is searching in his knowledge for a mirror for man. He wants to talk *about* the significance of the structures noted in scientific exploration. Just as language level two constructs the rudiments *of* knowledge, so language level four establishes the rudiments of a philosophy of human existence. It is the language of *awareness* of scientific thought, but it does not yet internalize that information and help man decide what to live for or how to establish purpose. That function is reserved for language level five. Language level four talks *about* scientific fact and organizes data amassed by the analysis of level three, which simply observes what happens. When we think and talk about "how things work out there" we are more than we were as collectors of data and less than we are yet to become when we abstract from the data some values by which to gauge our living.

[6]At this point, this analysis parts company with Watzlawick, *et al.*, because of a somewhat different conceptualization of the linguistic character of identification. We conceive of identification as the phenomenon of translation between any two statements, whether within a language level or between language levels. And, as we proceed, it should become clear that we conceive of the greatest insights as the achievement of the greatest leaps of identification between the most different levels of language. The ultimate achievement: The listening of Emerson to the sermon of a stone.

Semantic Meaning Plus Existential Meaning

Fifth, in man's climb into a world of labels, is the language *of* values. In it man assembles his beliefs into categories and arranges the categories into some rank order. As man leaves his sensory world and climbs the abstraction ladder, which he does when he is not hungry or driven by sex or anger or hate or any emotion that induces him to physical action, he falls to examining his belief world, himself. He asks what he wants, and what he wants for tomorrow, and what, in the end, is the end of wants. He asks "Why?" He asks the "why" of his existence—and thus beliefs give way to values, and with this change, a whole new concept of the word "meaning" emerges. When we think in response to a "why?" the search for meaning goes beyond asking what goes with what to a search for the meaning of existence or, if you like, the meaning of meaning.

To restate, we have been talking up to this point about semantic meaning—how we make sense with language, and more importantly, how the translation process allows us to construct a world within a world within a world. But at the point where the semantic structuring begins to complete itself into a universe, we begin to ask the "why" of it all. We sense we have built a world of symbols. But, like a man who works all his life to make a fortune, the main thing we have learned is the need to press on. We are forced to ask "And now what? Where does it all lead?" A man with many beliefs is a man of many planets without a universe, and he unites his beliefs by composing a cosmos of values. "Above all else," said Albert Schweitzer, "is reverence for life." Each of us evolves his holy of holies, and the statement which expresses it forms the center of his existence.

To repeat, at the fifth order of experience, the peculiar thing about the language is that it asks the "why" of existence. All the "whys" in the lower orders are actually "hows"—how does something work? But at language level five, one is searching for a reason to justify his existence. Such talk is aroused when great tragedy falls upon us—a loved one dies, a marriage or love affair goes on the rocks, we are caught in self-delusion or infidelity, we lose an eye or a leg. Something happens that severs *relationships* with former behavior or persons, and our daily existence is altered so radically we question life—why live?

Probably, no man has ever built a philosophy to justify his existence without contemplating suicide—why exist? And the forming of a set of values that in some degree affirms life involves a translation process within the fifth language structure; that is, one puts his values in clear order, so that he knows what price he will pay for what when calamity strikes.

Victor Frankl, in *Man's Search for Meaning*, talks of the way he and

others learned to survive in a Nazi concentration camp. In story upon story, he shows that endurance depends upon a "why" for existence, reaching Nietzsche's conclusion—that a life with a "why" can endure any "how." A physician, Frankl observed that many of the prisoners with the strongest physical constitutions withered and died with little resistance and that often the frail people, like himself, who could verbalize at least to themselves some great meaning for their lives, persisted, despite the horror and the toll of their daily experience. A "why" for existence, a religion, is not, it would seem, a luxurious fantasy, but a basic need for human survival. It may be orthodox or unorthodox.

Let it be said this way. The common downgrading of abstract talk is based on an inadequate understanding of the nature of the levels of language and their roles in life. Abstraction at language level five designs for a person his value scheme, which, if well built, maintains meaning for him when tragedy strikes. A strong back and concrete talk is good only for sunny days. Hastily we concede that abstract language gives man the freedom to talk foolishly, too, but he who does not enthusiastically take that chance does not build a value scheme to preserve him in his hour of darkness.

Basically, it is our belief in a myth that gives us the code by which we put "our stuff together." And as Rollo May points out, civilizations are poised and the lives of the individuals in those civilizations purposeful when the whole social order is directed by common myths.[7] The ages when man rises to great heights, such as the creative fifth century b.c. in Athens, or the seventeenth century in Europe which gave rise to the American Dream, are ages when a hopeful myth dominates the communication of the people. When such a common myth dies, despair, alienation, search for the doctor sets in. As May points out, the listening professions are in great demand during those periods, as they are now. The death of a myth constitutes the death of a capacity to communicate adequately in language level five (and above) and thus denies the power to become a whole human being. "Without myth we listen like a race of brain-injured people, unable to go behind the word and hear the person speaking," May said. "There can be no stronger proof of the impoverishment of our culture than the popular—though profoundly mistaken—definition of myth as falsehood."

The myth is the story by which we interpret all that happens to us. The myth shapes our values and designs our responses to the messages that come our way. Myth is the master code that helps us translate. It is one thing to respond out of myth, "It is God's will." It is quite another—without myth—to respond "God, what a mess!"

[7] Rollo May, "Reality Beyond Rationalism," a speech at the Concurrent General Session II of the 24th National Conference on Higher Education, sponsored by the American Association for Higher Education, Chicago, March 3, 1969.

In the shadows of the mind that hangs together is a myth.

Sixth and last, man, the symbol builder, reaches his highest level of existence and becomes completely organized only when his talk gives him identity with many or all forms of existence. Lovers experience this ecstasy of identification, perhaps the most important contribution of the romantic experience—except for babies. A quarrel between people who eventually find the language "to comprehend" each other ends with words that permit a moment of identification, each with the other. Parents are likely to have this sense of at-oneness with life mysteries the instant they first behold their newborn baby. The second of awakening, having slept *on* the earth *under* the stars, or walking alone at the edge of the sea, sometimes will produce a moment of identification with seemingly everything. A man who ultimately arrives at reverence for all forms of life, as Schweitzer did, must ultimately feel his identification with a grain of wheat, and a snail, and the earth, as he did. Such a man cannot eat without ritual in which he offers up prayers of thanksgiving with feelings for the food that nurtures him similar to those for another person who has saved his life. With these feelings, he nurtures life and in so doing *becomes* life itself. At this language level, we lose the sense of meaning as "out there" and separate from us. "For all intents and purposes, our subjective experience of existence is reality—reality is our patterning of something that most probably is totally beyond objective human verification."[8]

Let us illustrate by using two stories from Frankl. He talks of attending a woman dying of diseases of malnutrition in a small hut in the camp. Though she knew she was dying, she was cheerful and peaceful; and she persisted even when he was sure she would be dead before his next visit. (The Nazis, having learned Frankl was a physician, had put him to work in that capacity.) Just before the end, he asked her how it was that life was obviously sweet to her despite the horrid living conditions and the imminence of death.

> "I am grateful that fate has hit me so hard," she told me. "In my former life I was spoiled and did not take spiritual accomplishments seriously." Pointing through the window of the hut, she said, "This tree here is the only friend I have in my loneliness." Through that window she could see just one branch of a chestnut tree, and on the branch were two blossoms. "I often talk to this tree."[9]

Frankl's first silent response was, "She is probably delirious." But further probing indicated that in the long hours of waiting for the end, she

[8]Watzlawick, Beavin, Jackson, *op. cit.*, p. 264.

[9]Victor E. Frankl, *Man's Search for Meaning* (New York: Washington Square Press, Inc., 1963), p. 109.

had seen the twigs and fluttering green leaves as symbols of life. They became exquisite to her and, in something of a trancelike state, she had felt her union with them and all that grows.

Frankl tells a story about his own experience which illustrates in a strikingly different way this phenomenon of identification and its resultant impact. He was marching in the snow to a work camp. His feet, clothed in rags, were swollen, wet, and bleeding. In his excruciating pain, his sense of immediate awareness gradually clouded, then faded. At that moment his consciousness (verbal behavior) was "transported" to a lecture hall in a medical school in Vienna where he delivered in fantasy a brilliant explanation of the nature of his emerging theory of the significance of identification with one's experience, documented by his very experience in the concentration camp. And when he ceased his translation and fell back into a consciousness of his marching, he reports the fatigue and aching were within bounds of endurance.

Language that performs the action of "peak moments"[10] in experience, as Abraham Maslow calls these ultimate reaches of awareness, is achieved by a translation between the emotional expression of first order sensual language and the value scheme of the sixth order of experience.[11] The language is poetic, for identities "I am (whatever it may be)" are not logical and therefore amenable to the treatment of semantic analysis. It is a transportment of the self to something other than the self. This is the essence of all ecstatic experience, and is achieved by the identity of "I" with something else beyond the physical self, achieved by the verb "to be." Said Wittgenstein, "The subject (I) does not belong to the world, but it is a limit of the world."[12] The language of identification is poetry, is *analogical*, not analytical and logical. For the self "to be" something else other than itself is pure nonsense, except that it happens—and it happens because "being" is awareness, and awareness is the language we are using at that moment. "Primary words do not describe something that might exist independently of them; but, being spoken, they bring out existence."[13]

The capacities to emote, command, comment, analyze, believe, value, and transcend develop early in life.[14] The brain doubles in size the first

[10]Abraham H. Maslow, *Values, Religion and Peak Experiences* (Columbus, Ohio: Ohio State University Press, 1964).

[11]Helen Nierrell Lynd, *On Shame and the Search for Identity* (New York: Science Editions, Inc., 1965), pp. 179–180.

[12]Ludwig Wittgenstein, *Tractotus Logico–Philosophicus* (New York: Humanities Press, 1951), p. 151.

[13]Martin Buber, *I and Thou* (New York: Scribner's, 1958), p. 1.

[14]For those who want to see the interlocking of the levels this may be noted: In the languages of levels one, three, and five, experience is examined for the purposes of power and control. All things become an extension of the self. A command conceives of the other person as one's legs or hands. The ultimate purpose of science is to control physical nature or other people. A value scheme is designed in order to control

six months after birth and doubles again by age four. Psychologist Jerome Bruner believes his research shows that the child can be taught any concept, as soon as he speaks in sentences, as long as the concept is taught in his vocabulary. We once heard a four-year-old tell how he shot a bird with a wooden gun, stuck the bird on the end of the gun and roasted it over a star. That takes some doing. Even more remarkable, we heard a five-year-old exclaim as he stood in awe of a fiery sky early one morning, "Nothing like that could be unless there was God," and then mumble seconds later, "But that doesn't make sense. Who made God?" The capacity to deal with questions of knowledge, value, and even existence are available to the child as soon as he has command of the syntax that does the job.

But, again the cruel paradox, man's very power to build a universe in language is, at the same time, his power to fool himself. By the verb "to be" he glues together whatever he says.[15] The conceptualization of the self-image including the value scheme, and one's image of the world are dependent, in the last analysis, upon these identifications of the self with all sorts of things, only some of which need work to our advantage. The Who Am I? test illustrates. One is asked to complete usually twenty, "I am ———" statements. "I am brave." "I am nervous." "I am sarcastic." "I am a poor speller." "I am afraid of the older generation." "I am loved." Anything is anything I say it is.[16] It may well be that today's generation has sensed both the power and the danger in the identification experience. Says nineteen-year-old James Kunen, "We youths say 'like' all the time because we mistrust reality. It takes a certain commitment to say something *is*. Inserting 'like' gives you a bit more running room."[17]

The Role of Feedback
in Translation at All Levels

As we note above, self-talk, self-persuasion, and self-feedback are crucial in the reach for meaning. But so are the vibrations fed back to us by those who listen. We scan both our own words and our impacts on

oneself. Expression *of* and analysis *of* are made for "calculating" purposes. Conversely, the languages of self-awareness, belief, and transcendental experience in varying ways lose the power of being responsive to the physical reality of the moment for the achievement of insight gained by the quick shift of identifications with that reality.

[15]For additional insights see Watzlawick, Beavin, Jackson, *op. cit.*, Chapter 6.

[16]See Charles T. Brown, "An Experimental Diagnosis of Thinking on Controversial Issues," *Speech Monographs*, 17 (1950), 370–77. A simple assertion, "A thing is true because I say it is true," proved to be the second most attractive form of evidence to college students from freshman through graduate school.

[17]James Simon Kunen, *The Strawberry Statement: Notes of a College Revolutionary* (New York: Avon, 1968), pp. 101–102.

others for the assessment of meaning. In saying something we scarcely know what we are going to say until we hear ourselves saying it, and we search for its validity by looking into the eyes of our listener. The significance of feedback to meaning-making is seen in international conferences where the person speaking is the only person, other than the interpreter, who knows his language. The meaning of his statements is registered in a delayed translation and, for the speaker, a delayed feedback. As communicator he is crippled because immediate feedback, so necessary to the effort to make sense, is denied him. Alex Bavelas suggests that in the future we consider a "member" of an international committee to be a pair of persons speaking the same language—in order to assure that the speaker has at least one person besides himself to provide the dual feedback system so necessary to the functioning of a speaker.[18]

Here is another way of grasping the significance of feedback in the language process. In thinking to ourselves or talking with others, it is as if we were in a dark room with a flashlight, searching for the wall switch by which to illuminate the whole room. Failing in our searching, we recognize that we are dependent upon the small amount of data fed back from the focus of the light at the moment; and that if we are to conceptualize the whole room, we must remember, store away, and relate the information gained by the light as we move about.

Language is linear; words come one at a time. Attention is verbal awareness, and words are variable pinpoints of light, seldom global.

As you sit in your chair and read this, you are surrounded by objects and your ears are focal points in a sea of sound. You are aware of what you are aware of only in terms of the words that flash into existence. When your verbal response is reflecting details of sensory experience of color, size, weight, heat, intensity, distance awareness is a sharp pinpoint of light in a relatively darkened room. But words and the combinations thereof shift from one language level to another. When your language shifts to levels five and six—when you are sorting out the meaning of your existence or are identifying, in some transcendent moment, with a loved one, thing, place, or life itself—your language seems for the second to diffuse light so as to illumine your whole internal being.[19] It is this momentarily diffused "comprehending" light that constitutes deepest insight. And it is probably the feedback both within and between language levels that does the mechanical work for what we have been calling the translation process.

[18]Mary Capes, ed., *Communication or Conflict* (New York: Association Press, 1960), p. 129.

[19]The catatonic is probably the example of pathological fixation of the identification experience. He cannot accommodate new information and so freezes on some comfortable identity, thus eliminating the data input of the scanning experience.

*Confidence to Listen
and Feedback Among All Levels*

Only as we translate lower-order experiences into higher-order ones, and occasionally complete the cycle of translations by identifying our "why" of existence with first-order experience do we gain the confidence to listen to new information without anxiety. Again, as language is linear, it picks up awareness in pieces. But we cannot tolerate a world in pieces. A world is one. Here we must resort to analogy, again, as always when we want to ensure new comprehension. The operation of language is very much like watching life through a slit in a solid board fence—words and sentences coming one at a time. If a cat on the other side of the fence walks by the slit, we see his head first, then his body, and finally his tail. Only by "comprehending" that this is *one* thing, not a series of *unrelated* things can we make sense of it. And we translate the parts into the whole with the word "cat"—the symbol encompasses all the separately perceived parts.

If the separate messages remain separate they create great fear as to their meaning. Lacking sophisticated scientific data at language level three, primitive man lives in terrible fear when the sky flashes fire and roars its thunder. Quaking, he identifies his own fear and anger with the violence of the cosmos and thus imbues the universe with a personality very much like his own distraught self. In confusion he asks, "Why is God vengeful? What have I done?" Even the father of the writer, far removed from man in the cave, was distressed by contemplations such as these we put here on this page. "It is dangerous to explore these things," he said. "We should have faith without question." Which, translated, says, "To ask about the nature of the abstract language we use to design and maintain our world in one piece is to look God in the face—and that might make Him angry."

Only as we create a God of our value scheme who engenders basic feelings of security can we permit any and all messages to be listened to. Thus the open mind must imagine the unknown plan, if plan it is, to be safe. Ultimately, it comes to this: the person who can listen fearlessly lives joyously in ambiguity, knowing that our lives are in a world where all is in flux—that each is a particle among particles forming a changing wave of particles in time. Learning to listen is like learning to feel safe in the womb of a ship which plunges, and rolls, and rumbles, through the endless sea in the black night. It is this identification with the powers beyond ken or control that lowers anxiety and permits one to sense the verbal cues that lead into new states of awareness.

An Examination of
the Language of Beliefs and Values

Most of the listening-to-each-other-problems of the human race in-volve the languages of beliefs and values—for here are the levels at which we create the verbal designs that hold us intact and steer our course.[20] If awareness is verbal behavior, then the "I" we are so fond of and about whom we each talk so much is a verbal image, a dual one, involving the person I am, and the one I want to be. The basic tensions we feel con-cern the disparity between the perceived self and the ideal future self—and these tensions are aroused or allayed by our translations between the languages of belief and value.

It should be noted, as the diagrammatic scheme (Figure 3) suggests, that what a person calls a belief is an abstraction that he feels he com-mands, whereas a value is something he wishes to attain. The statement, "I believe in education," has a considerably different meaning than, "I place a high value on education," for while the former says "education

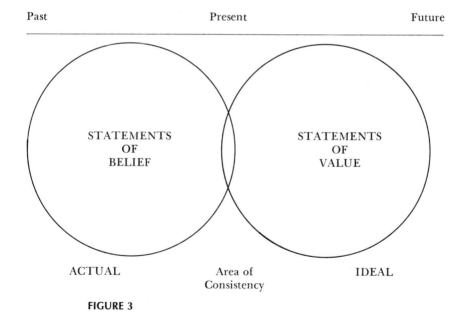

Past	Present	Future

STATEMENTS OF BELIEF

STATEMENTS OF VALUE

ACTUAL Area of Consistency IDEAL

FIGURE 3

[20]Much of the thinking in this section has been stirred by the works of Milton Rokeach, most particularly his *Beliefs, Values, and Attitudes* (San Francisco: Jossey-Bass Publishers, 1968).

is indispensable," the latter suggests a priority and the willingness to pay a price for that priority. It sets the stage for decision behavior. Where there is differentiation, there is value, the instrument of choice—and choice shapes the future.

We are most shaken when the value scheme by which we govern our lives is reordered. Little wonder. Without this we are blown hither and yon by contradictory messages. It is not strange that the studies of the self-concept demonstrate time and again that the value scheme of a person remains relatively fixed as he moves through life.[21] And the scheme of values stands firm when it is intimately related to the person's basic feelings. Sensual experience is always valid.[22] We can communicate without fear when "we've got our stuff together."

And, therefore, the most critical thing we do when we communicate is to check the incoming data against both our feeling world and our value world. If it fits both we take it. If it fits one but not the other we weigh it. If we take it something has to give.

We suffer intense stress when a message fits our feelings but upsets our value world. Tolstoi tells of his terrible urge to seduce a servant girl in his home after he had adopted the life of celibacy. If he gives in his value world is shaken and he experiences deep emotions of confusion until some kind of value order is restored. It is just as bad if the message fits the value world, but not the feelings. Consider the millions in "the economic rat race" who do what they hate to do because they value riches, position, or whatever. In the poem "Richard Cory," everybody in town admired and envied Mr. Cory, who went home one night and put a bullet through his head.

The value scheme is amenable to change without disintegration, but it will always be accompanied by great upheaval. When this happens the value that falls apart gives way to a more life-affirming one. *The Doll-maker* is a magnificent story of such a conversion. Gertie, a simple woman from the hills of Kentucky, deeply in love with the earth, reluctantly goes to Detroit with her family. She is estranged and in great poverty during a strike. The move to Detroit had been an economic mistake but now

[21]Richard Dieker, Loren Crane, and Charles T. Brown, "The Effect of Repeated Self-viewing on Closed-Circuit Television, or Changes in the Self-concept," (Washington: U.S. Dept. of Health, Education, and Welfare; Office of Education, Bureau of Research), Final Report, Project No. 7-E-198, Contract No. OEC-0-8-070198-2807, September, 1968. Carl Rogers, *On Becoming a Person* (Boston: Houghton-Mifflin Co., 1961); Ruth Wylie, *The Self Concept* (Lincoln, Nebraska: The Nebraska University Press, 1961); Dean Barnlund, *Interpersonal Communication* (Boston: Houghton-Mifflin Co., 1968), p. 635.

[22]Richard S. Crutchfield, "Conformity and Character," *American Psychologist*, 10 (1955), 91–98.

there is no land to return to nor money to make the return. She carves dolls of wood and sells them to supplement the family income. Guided by intense needs, she buys an expensive block of wood and carves a human form from it, except for the face. As she works the wood feverishly she has mixed feelings as to whom she is creating, maybe Judas. She is not sure. The winter is setting in when she receives an order for Christmas dolls, and she is advanced fifty desperately needed dollars for the wood. That night she works in exhaustion until dawn, finishing the upturned hand of her sculpture, and after feeding the children their breakfast puts the wooden form on a child's wagon and pulls it to the lumber yard. The scrap-wood man

> studied it, and shook his head. 'It's too big,' he said. 'Th way it is, yu'll hafta split ut.'
> 'Oh,' she said, and the 'oh' like the beginning of a cry, but smothered at once, and she was still, considering; while the children, troubled, gathered round, and looked first at the wood and then at her. She was so still; it was as if by steadfastly looking at the wood, she, too, had changed into wood.

Trembling, sickened inside yet determined, she raised the ax and split the sculpture.

> A great shout went up from the children.
> The man reached for the fallen face, righted it so that she might strike the head again, but his hand did not immediately come away. He touched the wood where the face should have been, and nodded. 'Christ yu meant it tu be—butcha couldn't find no face fu him.'
> She shook her head below the lifted ax. 'No. They was so many would ha done; they's millions an millions a faces plenty fine enough—fer him.'
> She pondered, then slowly lifted her glance from the block of wood, and wonder seemed mixed in with the pain. 'Why, some a my neighbors down there in th alley—they would ha done.'[23]

This simple woman who had formed her peace in the quiet of the hills, discovered her greater depths in the noisy city.

In either case, whether the impelling message arouses emotions which have to be put to rest in order to preserve our values or the values transcended to fit our basic feelings, in the process of putting oneself back together again, deep eruption is felt.

[23]Harriette Arnow, *The Dollmaker* (New York: Collier Books, 1954), pp. 570–71. Copyright 1954 by Harriette Simpson Arnow. Reprinted by permission.

There is one escape. It's called rationalization and is achieved by discovering words that fit our values into our incompatible feelings. Wars are usually justified by the most profound need for a lasting peace. As a consequence, we have lasting wars without accepting the responsibility for our feelings. How many angry fathers have spanked their children, exclaiming at once in deep feeling, "Son, this hurts me more than it does you." In a way he's right. But he does not know the way in which it hurt him. Rationalization is the identification process turned to deceive

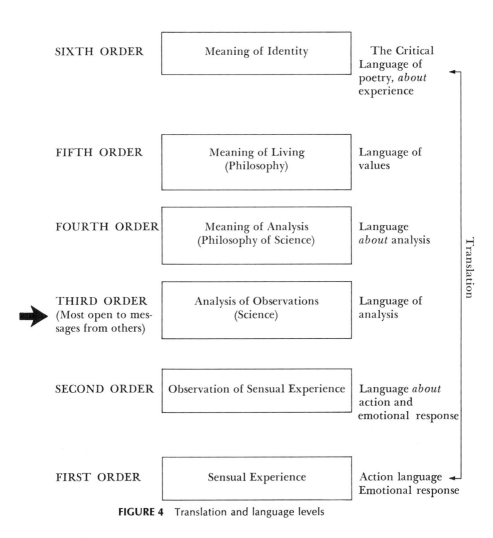

FIGURE 4 Translation and language levels

the self, always involving indulgence in a desired act which we do not honor. Coherency is maintained, at least temporarily by conceiving of the act as a self-sacrifice. "Son, it hurts me . . ." As a way of life rationalizations make it harder and harder to hear things as they are.

Given these basic facts it is obvious that the message we listen to most easily comes to us with low emotional upheaval and without violence to our value scheme. In short, we can all handle information, and thus we are most open at language level three. Light travels at 186,000 miles per second, we are told. And probably not even a physical scientist would be disturbed at the prospect of finding out it might be something different. What we cannot tolerate, without great confusion, is the likelihood of discovering that life is something different from what we imagine it to be —that either our basic feelings or the values that form our identity must change.

Each man lives within his own Tower of Babel. Forming the highest reaches is the myth through which he looks out on life. To evolve into something near his potential he must interlace this myth with the feelings which are his foundation—to let things reveal themselves to him, to "talk of their nature, and be able to respond to them, to answer."[24] Yet he cannot do this alone. To know what he means he must talk and listen to others whose revelations are different. It is therefore the lot of man to live in doubt, which is good—if matched with courage. Said Tennyson, "There lies more faith in honest doubt . . . than in all your creeds." Existential anxiety is every man's problem in every age. In the search for meaning it is man's everlasting first order of business.

OBJECTIVES

The purpose of this chapter is to help you:

I. Understand that meaning is the translation one senses when he recognizes the differences between two statements.

II. Recognize the levels of meaning.

III. Understand and experience the integration of information at emotional and abstract levels of language.

[24]From "A Conversation With Wedard Boss," *Psychology Today* (December, 1968), p. 63.

EVALUATION

Before you read the chapter write a paragraph on each of the following terms: translation, language levels, and language integration. Read the chapter and again write your understanding of the three terms. Compare.

DISCUSSION QUESTIONS

1. *Objectives I & II* When a person talks about himself it takes considerable effort to understand. We have concluded the speaker is usually too abstract, not specific enough about his experience. There are a number of reasons for this. What might they be?

2. *Objective I* A common experience in education is this. The instructor assigns the reading of a chapter for a given day for discussion. As it turns out usually the instructor talks about the chapter, and the students begin to understand the chapter as they had not when they read it. Explain this in terms of the translation process.

3. *Objective III* A statement of admiration among students is this: "he's got his stuff together." Explain the meaning of this in terms of the latter part of the chapter.

EXPLORATIONS

1. *Objective I* The humanistic psychologist Carl Rogers places emphasis upon listening as an instrument, both for clarification of communication and for the resolving of conflict. As a chief device he suggests the listener state and restate what the other person has said to the person's satisfaction. In effect what happens is that clarity of meaning is achieved by the translation of two adjacent statements.

Listen to a classmate talk about something that is a source of confusion (anxiety, anger, enjoyment) and say back to him, to his satisfaction, what you think he has said.

Note what you have learned.

2. *Objective II* Watch a movie or listen to a speech in your class. Write a one sentence comment about it. Classify it into one of the six language levels. Discuss it with the class.

Write six statements related to the movie or speech, one at each of the six language levels.

3. *Objective III* Arrange in order of importance (from one to seventeen) the following values as you perceive them. Discuss differences among your classmates.

	In the life of the average American adult	In the life of the average college student	In your life now
Helping others	()	()	()
Fame	()	()	()
Food	()	()	()
Wealth	()	()	()
Self-esteem	()	()	()
Love and affection	()	()	()
Achievement	()	()	()
Security	()	()	()
Possessions	()	()	()
Your potentials	()	()	()
Reputation	()	()	()
Status	()	()	()
Self-understanding	()	()	()
Emotional stability	()	()	()
Making creative things	()	()	()
Being ethical	()	()	()
Competition	()	()	()

4. In order to make sense of our lives it is necessary to keep all abstractions well related to experience. The following game illustrates this. Have all your classmates write an abstract noun (beauty, honesty, justice, etc.) on a slip of paper. Collect the slips. From the slips randomly fill in the blanks in the following statements:

 a. Where ——— begins ——— ends.
 b. If ——— leads to ——— you may expect ——— to follow.
 c. Greater than ——— is ———.
 d. When a man achieves ——— he reveals ———.
 e. ———, ———, and ——— are the essence of ———.
 How can you determine the sense in any of these statements?

5. *Objective III* Explain an intrapersonal conflict you have, showing how it is a struggle between feelings and conflicting values. If this is unclear reread pages 49–53.

6. *Objective III* Tell about a peak or transcendent experience.

7. Discuss your peak experience with people, things, nature, ideas.

8. *Objectives II & III* Listen to "the thousand voices" of the river. As you listen to the river (lake, rain) how does your experience change? At what language levels do you translate the experience for your understanding?

4
Meaning:
The Reading of
Nonverbal Cues

A man does not lay down his hat . . . or
take it up . . . but something escapes,
which discovers him.
 LAURENCE STERNE

Given what we have said to this point, the question arises, on what do
we depend in order to interpret what another person says? How do we
know the other person knows what he is talking about? Or that he is be-
ing honest? What do we use to guide our listening and our resultant
communication? The answer is that we make these decisions on the basis
of our interpretation of the nonverbal cues. "It's not what you do but the
way that you do it," blatted a popular song of the author's youth. Physi-
cal appearance, the physical distance between two communicators, their
relative position, time factors in their interaction, the posture, hands,
face, eyes, and voice—these are the things that guide our interpretation
of each other's words. We mention in a number of places throughout the
book the commonly believed misconception that, "If I do not say any-
thing I do not communicate." "Although an individual may stop talk-

ing," says Goffman, "he cannot stop communicating through body idiom. . . . He cannot say nothing."[1] Indeed, it is the nonverbal communication that guides, as we have said, the interpretation of the verbal code; guides, at least in part, because it is the more important part of the source of information. Surprising as that may be, according to Ray Birdwhistell, an authority on nonverbal communication, 65 percent of the social meaning in a two-person communication is carried by the nonverbal band, only 35 percent by the words spoken. The previous chapter discussed the role and operation of verbal language in communication. This chapter concerns the role of nonverbal communication and the way *it* works.

THE ROLE OF NONVERBAL COMMUNICATION

At the close of Michael Argyle's summation of the psychology of communication, based on some 120 pieces of research, he concludes:

> Not only public speakers, and professional social-skill performers, but anyone who takes part in social encounters, must present some kind of 'face' or self-image. If he does not the others will have difficulty in behaving towards him. It does not help for him to be obsequious and self-effacing. On the other hand the image presented should be realistic or there is a danger of it collapsing, which is one of the main causes of embarrassment. He should not be primarily concerned about the image-projection and its success, but about creating the responses he desires on the part of others.[2]

No matter how little or how much we respect the integrity of our respondent the fact is we do not communicate without the urge to make impact. The basic question of every listening act is "What does that message mean?" How much of the message tells me about the image making of the other person? What in the message reveals something about myself? These taken together, what does the message tell me about the *facts* being talked about?

The salesman says to a potential buyer:

> I would say the land at present is worth $250 per acre. In fifteen years it will go for $1,000 an acre. I don't know how to evaluate the house. At the going cost of $20 per foot it cannot be replaced for $60,000. But few people today would build a house like that. What do you think it is worth?

[1]Erving Goffman, *Behavior in Public Places* (New York: Macmillan Co., 1963), p. 35.

[2]Michael Argyle, *The Psychology of Interpersonal Behavior* (Baltimore: Penguin Books, 1967), p. 204.

The client stammers "I don't know." He does so because he cannot determine whether the salesman has lapsed into an economic question: "Let us try to decide in this unusual situation how to set a value on that place." Or is he asking, "What is it worth to you?" Or is he asking "How much are you attracted to a bargain?" Or something else? The words themselves are a constant, no matter how they are translated. But the listener cannot translate them without placing an interpretation upon the nonverbal cues. The question in the interpretation is "What does the salesman want me to say to him? What feelings is he trying to induce in me? What are we talking about that we are not talking about?"

The role of the nonverbal communication is to supplement the verbal in such a way as to answer several questions which are aroused by verbal interaction:

1. How should I go about translating the statement? That is the concern of this chapter.

2. What kind of feelings are involved in this interaction? Chapter 5 explores this element of communication.

3. What can I expect of my conversant? Chapter 6 goes into that question.

4. In what environment does this communication proceed? And this is very much determined by the environments from which the communicants have emerged. This is the province of Chapter 7.

5. How can I evaluate the person speaking to me? This peculiar aspect of communication is dealt with in Chapter 8.

6. What kind of relationship between us is being developed by this conversation? What kind of power is involved in that relationship? Are we in agreement about the uses of that power? These questions are explored in Chapter 9.

7. At what level of involvement with each other are we engaged? What faith do we have in each other? This is the world of concern in the last chapter.

A survey of the scope of these questions suggests the importance of the nonverbal part of a communication. It is the key to interpreting a message.

If the nonverbal is compatible with what is said we take the message as an honest one. We may or may not agree with it. If the nonverbal cues conflict with what the words seem to say, we do not know what to believe about the message because we do not trust the motives of the other person. The sender lacks credibility. Why is he hiding? Does he distrust me, or is he trying to persuade me without telling me what I ought to know?

If the nonverbal cues are uninterpretable, then the response is the same as above. Some people are highly mannered in their speech, and thus tell little about themselves. They speak in appropriate ways for the

culture but they do not let themselves show through. They have learned to play a game in communication. But the players of communication games usually become very confused. Not knowing the true feelings of his conversant, the other person is not sure how to respond. Not knowing how to interpret that unclear response, the player is unclear about how to proceed, and therefore unclear about himself.

Let us think a moment about what has just been said and relate it to the significance of openness in communication. When we are open the nonverbal cues we send are not only congruent with the verbal message but supplement it in such a way as to make it clear and powerful. For the receiver of the message it is his study of the nonverbal cues that directs his interpretation of the message he is receiving. The role of nonverbal communication is to provide the key for decoding. Or, if you like, it provides the information for getting inside the sender of a message and knowing the message as it is known by the sender.

THE LANGUAGES OF NONVERBAL COMMUNICATION

There are a variety of nonverbal languages. We shall discuss in brief the nine most important ones. Some tell about a unique aspect of the sender of the message. Some duplicate the message of another code and thus ensure appropriate interpretation. Both have their value.

1. Physical Appearance

One of the more obvious nonverbal codes is the physical appearance of the person, most particularly important upon initial contact. Size and weight have something to say. Several researchers tentatively conclude that physical attractiveness seems to have something to do with one's initial credibility.[3] And the studies suggest that most of the attitude change in the public speaking situation, at least, takes place in the first few minutes of the speech. Bigness and tallness do not seem to be plus factors in the influence of a person. Yet as one's status goes up so does the perceived size of his person.

It is almost impossible to separate out dress and grooming from physical appearance.[4] And again, the research shows that the importance of these, as with physical size, is greater when the person is relatively unknown to the rater or is socially distant from him.

[3] J. Mills and E. Aronson, "Opinion Change as a Function of the Communicator's Attractiveness and Desire to Influence," *Journal of Personality and Social Psychology*, 1 (1965), 173–77; F. S. Haiman, "An Experimental Study of the Effects of Ethos in Public Speaking," *Speech Monographs*, 19 (1949), 190–202.

[4] R. Houth, "Experimental Measurement of Clothing as a Factor in Some Social Ratings of Selected Men," *American Sociological Review*, 19 (1954), 324–28.

One study showed the intense relationship between dress attitudes of females and their score in selected measures of personality.[5] The girls rated themselves into one of five categories of dress attitudes: Decoration in Dress, Interest in Dress, Comfort in Dress, Economy in Dress, and Conformity in Dress. Girls who ranked high in conformity of dress also ranked high in the conformity variable in the personality tests. Those who ranked high in Interest in Dress and Decoration in Dress showed up as uncomplicated personalities. The ones who scored high in Interest in Dress showed considerable social stress and insecurity. Those interested in Economy of Dress scored high in intelligence and efficiency. All this suggests what we all privately know, that the way we feel about our bodies is directly related to the way we groom and dress. For the perceptive person this is an important piece of nonverbal communication.

2. Physical Distance

When we talk to people we seek a distance from them that tells the degree of affiliation that is desired. Rosenfeld found that in American culture a person wishing to be affiliated in a warm relationship with his conversant pulled his chair to about four and a half feet from the chair of his discussant.[6] Conversely, if he did not care to relate closely with the other person he pulled away to about eight feet. Edward T. Hall's anthropological studies compare the distance factor from culture to culture.[7] In the Latin cultures, famous for intimacy as well as explosive temper, people get closer together in conversation. The more formal and less expressive cultures are marked by people who stand at greater distances from each other. Within our own relatively cool culture, intimacy can be induced by crowding people into small rooms or pulling the chairs together, for instance in the circle of a class discussion. Again, in recent years, Hall has done research with the factor of distance to measure the violent urge of criminals. A violent person seems to be less able to tolerate having another person close to him than a nonviolent one.

A movement within the encounter or sensitivity training development that has spread over America in recent years emphasizes touch in order to produce an awareness of one's relative resistance to close affiliation. One has only once to experience the blindfold exercise where people crowd and mingle, touching whoever comes in contact with them to sense revulsion, or sexual stimulation, or an urge to identify with and belong

[5]L. Aiken, "Relationships of Dress to Selected Measures of Personality in Undergraduate Women," *Journal of Social Psychology*, 59 (1963), 119–28.

[6]H. Rosenfeld, "Effect of Approval-Seeking Induction on Interpersonal Proximity," *Psychological Reports*, 17 (1965), 120–22.

[7]Edward T. Hall, *The Silent Language* (Greenwich, Conn.: Fawcet Publications, Inc., 1959).

to all mankind. As we have indicated elsewhere, babies who are held by loving mothers of low anxiety grow into affectionate adults of low anxiety. And the zero distance in human relations is the sex act, out of which peculiar affiliation the children of the race emerge.

3. Relative Position

If distance is a measure of affiliation, then relative position is a measure of the quality of the intimacy.[8] Chairs placed at an angle to each others suggest cooperative interacting. If we are hostile or angry with a person we are likely to select a position directly opposite him, at a distance. Opposite, but not more than three feet apart, seems to be a comfortable positioning for people in our culture, in mutually cooperative attitude. Observers have noted that people opposite each other are more likely to dominate the interaction of a group of people than those who sit side by side.[9] Silent intimacy is suggested and aroused by sitting beside a person. If an executive wants to maintain an authoritative relationship he will likely place his desk between himself and his subordinate or client. In more democratic relationships chairs at a roundtable or just chairs in a circle are often arranged to establish the desired atmosphere.

4. The Communication of Time

Time acts jointly with distance and relative position to communicate both affiliation and the quality of the relation. The less often we see a person the less the affiliation. Lovers, conversely, are together all the time. If we want to insult or indicate neglect we simply do not arrive for the appointment or fail to answer the R.S.V.P. It is not fashionable to arrive at a party exactly on time, or early. But one is "rightly embarrassed" if he arrives late for dinner. Those who can stand considerable group involvement have their date books filled weeks in advance. But those who require individual freedom and privacy do not know whether they are going to the movie until it is time to go. Hall, again, has made extensive study of the communication of time across the cultures. A party is a three-day affair in some parts of the world. An hour late, or two, for an appointment is standard practice in some societies.

It is, however, not our concern to discuss nonverbal communication from the anthropological point of view, but to sensitize the reader to the fact that the nonverbal cue, in this case, time, is important for understanding a message. One of the more sensitive cues to affiliation and its

[8]Robert Sommer, "Further Studies of Small Group Ecology," *Sociometry*, 28 (1965), 337–48.

[9]B. Steinzor, "The Spatial Factor in Face to Face Discussion Groups," *Journal of Abnormal and Social Psychology*, 45 (1950), 552–55.

quality is measured by the mutual agreement between two conversants as to who is going to speak when and how long. If interruptions mark a conversation, the communication is, in turn, marked with conflict or in-difference and both persons feel irritated. If one wants to talk and can't get a word in edgewise, he grows frustrated and feels demeaned. Thus timing in interaction tells us how to interpret the spoken words.

5. Posture

One's posture is a self-reflexive statement. When determined we lean into our task. Drooping shoulders indicate resignation. Standing tall suggests pride. Going limp indicates exhaustion. Researchers note that everybody has a characteristic posture "at rest to which he returns when-ever he had deviated from it."[10] The word "return" is important here, for posture is not a static thing. And when the movement is restless, or tense, or deviates radically from its central tendency the person reveals conflict and anxiety. Much of the research on posture is old; the most extensive work was done by the psychologist William James early in the century. This is what he concluded from his work:

> The posture as a whole is an ensemble or constellation of different parts. Of these the head and trunk are, as we have seen, the most significant for the generic expression of the total posture, and the hands and arms most important for the specification of the posture. The distribution of the weight of the body, the expansion or contraction of the chest, the raised or dropped shoulders are other factors which, each in its own setting, are important. Every one of these has in any particular position its own ex-pression.[11]

He noted four postural attitudes: approach, withdrawal, expansion, and contraction. A second look at these categories indicates James is talk-ing about posture as an index of relationship. We approach or avoid—a person, a task, or ourselves—and we do so with assurance or a fear of defeat.

6. The Hands

Dean C. Barnlund says, "Next to the face, the hands are probably the most expressive part of the human body, largely because of their ma-neuverability and their involvement in so many instrumental activities."[12] Two studies of the hands of actors expressing a variety of emotions were

[10]F. Deutsch, "Analysis of Postural Behavior," *Psychoanalytic Quarterly*, 16 (1947), 211.

[11]Dean C. Barnlund, *Interpersonal Communication: Survey and Studies* (Boston: Houghton Mifflin Company, 1968), p. 520.

[12]*Ibid.*, p. 521.

interpreted by a group of subjects and they agreed substantially in their interpretations. The agreement was slightly higher when moving pictures, rather than photographs, were used. "Prayer, pleading, thoughtfulness, surprise, and fear were judged best in the first experiment; these plus determination, anxiety, warning, and satisfaction were judged best in the second."[13] The hands say very much the same thing as the posture.

7. The Face

The most expressive part of the body is the face. This general knowledge is symbolized by the way we use the word "face" as an idiom: "let's face it," "he lost a lot of face," "facing the west . . . ," "on the face of it . . ." If you ask a child to draw a picture of himself he is likely to draw only his full face, and if the body is added it will be much the smaller part, perhaps just hands and feet extending from the face.

A person's smile tells much about his inner state. Among other things, it tells whether he is tense, reflecting upon the self, or suggesting relationship with the other person. The mechanical smile is calculated to make impact and the sensitive person so interprets it.

The face is so mobile and so responsive to our moods and perceptions that over a lifetime it forms the lines, furrows, planes, and coloration that tells about our stance with life. Note the sketch from Da Vinci's notebook (Figure 5).

8. The Eyes

No feature of the face speaks so much for us as the eyes, poetically known as the windows of the soul.

The more a nonverbal behavior is beyond control the more we depend upon it. Perhaps the least controlled of all our behaviors is the dilation of the pupils of the eyes when we look at a person we like. Studies at the University of Chicago with a sophisticated eye camera demonstrate this. Conversely, the steely-eyed look which we have all received from the person who dislikes us is in part the constriction of the pupil of the eye.

There are a number of other eye behaviors which for most people are beyond their monitoring. In the main, when we are sensitive to and like the other person we hold eye contact with him. Any teacher or public speaker knows the value of the listener who meets and holds his eyes as he speaks. It confirms and thus establishes the condition for maximum effectiveness in thought and speech. Research, for the most part done in England, indicates that women, God bless them, do this more than men.[14] There is, also, more eye meeting between members of the same

[13]*Ibid.*, p. 521.
[14]Argyle, *op. cit.*, Chapter 6.

FIGURE 5 Leonardo da Vinci, *Five Grotesque Heads.* Reproduced by gracious permission of Her Majesty Queen Elizabeth II. Royal Library, Windsor Castle.

sex than between members of the opposite sex, which fits a much older observation, that members of the same sex understand each other better than male and female understand each other. As we all know, much or prolonged eye contact between members of the opposite sex involves sexual attraction, and neither law nor mores have found a way to control the lovemaking of eyes that meet.

Women, more than men, search out the eyes of the other person as they speak. Indeed, women, it has been found, tend to talk less when

they cannot see their conversant. Not so with men who look more when listening, less when talking. Men can talk with ease to the back of their conversant.[15] This probably means, as Argyle suggests, that women depend upon the behavior of their listener to guide their speech. Men, more independent and of higher self-esteem, as the famous studies by Hovland show, depend less upon the response of their listener, and as listeners themselves check out the veracity of their conversant more carefully than women do.

But prolonged looking is not only the act of those searching for affiliation, but also of those intent upon control. The sergeant looks hard into the eye of his subordinate when he gives an order—and he may step up close when he does it. (Usually people hold longer eye contact at a distance than when close.) If the one so challenged wishes to meet the challenge he holds to the eye contact as long as he is looked into the eyes. If he weakens his eyes will drop. If he withdraws, that is, ignores the challenge, he looks away. The eyes have their unconscious language which has caused people down through the ages to believe that a dishonest person cannot look you in the eye, but the sharp rascal knows this. So that the most unscrupulous exploiters will feign honesty by intense prolonged looking into the other's eyes. Only the studied intensity gives them away—and it takes an extraordinary observer to sense this.

Here is an observation particularly relevant to the concept of this chapter. Prolonged looking at others on the part of a person, speaker or listener, indicates concern for the relationship. Short glances are involved when people are more content oriented. These scanning glances where content is the focus of attention last from .25 to .35 of a second. This is what we do in monologue, just a quick glance to see if the other person is "with us." The fixations which attend those times when we are intensifying the relationship or are trying to determine what the other person really means will usually last from one to seven seconds—about as long as we can fix attention. Eye contact (looking when the eyes of both parties meet) ranges, depending upon the nature of the conversation, from ten to thirty percent of the time. And in most conversations fixations on the other person's face, eyes or other feature, range from thirty to sixty percent of the conversation time. When we look at another's face we look at his eyes more than at any other feature and thus more at the upper part of the face than at the lower. We learn this early in life; the studies by René Spitz show that the baby concentrates on the mother's eyes, and is terrified when the mother wears a mask.[16] The lower part of the face may be covered without upsetting the child. The mask obscures identity,

[15]We are told by men (as we recall) that women, more than men, will talk behind your back.

[16]René Spitz, *The First Year of Life* (New York: International Universities Press, 1965).

emboldens a person, and lowers his fears, as research at the University of Delaware indicates.[17] Those who wish to live *incognito* wear dark glasses.

A potpourri of other findings about eye behavior throw light on the peculiar and significant role of the eyes in establishing the relationships of our conversations. As we come to the close of a comment we look at our listener in order to assess our impact, which at once—if we seem satisfied—signals our listener that he is free to speak. Conversants who like each other look more at each other than do conversants who dislike each other. We all know the meaning of being avoided, especially if we look and the other person does not look back, for we know when his peripheral vision alerts him that he is being looked at. If we want to be believed this urgent plea is registered in our prolonged and open look into our listener's eyes.

If we are looking at a person to whom we are listening, and we want to speak, we look away to signal our wish to take our turn. When we are giving longer comments, thus wanting not to be interrupted, we look less at our conversant. And when the content of our speech grows more concrete, replete with metaphors and stories, we look less at our listener, unconsciously knowing that the vivid and dramatic impact of words should act alone. As we shift to our thoughts and abstractions we look more and longer at our listener, apparently to compensate for the lowered power of abstract language. Just as we look less when we know our words are striking home, so we look less when smiling, "knowing" apparently that the smile is caring for that everlasting task of establishing and maintaining relationship.

Perhaps the degree to which we depend upon our looking, in figuring out the meaning of a conversation, is best sensed by listening, with eyes closed, to a conversation. While some people, like the blind person, learn quickly how to interpret from sound cues alone, most people report feelings of irritation and confusion. Our students often report "I heard the shuffling of feet, people moving in their chairs, people's breathing and sighing. I couldn't focus on the conversation. I got lost in a sea of sound."

9. The Voice

Other than the acts of the eyes perhaps the other most important nonverbal cues used in our interpretations are disclosed in the voice.[18] If the voice seems soft and easy or excited we know our partner likes us. When it is stern and harsh we know the opposite. If the voice trails off we know

[17] Argyle, *op. cit.*, pp. 114–15.

[18] Albert Mehrobian has evolved a formula: total impact = .07 verbal plus .28 vocal plus .55 facial. See "Communication Without Words," *Psychology Today* (September 1968), 53.

our conversant couldn't care less. And then there is the voice we can't figure out, and that is the voice of the person who chooses not to open himself to us. Dr. Paul Moses, a psychiatrist in San Francisco, in his *The Voice of Neurosis*, has made a detailed statement about the meanings of various aspects of the voice, such as rate, quality, ranges of pitch, and volume.[19] And although his critics do not like the cataloging certainty of Moses's observations, any sensitive person knows he makes important decisions in his life precisely on these awarenesses. "I don't think I'll take the position. Why? I don't think I could get along with him." Or, "I liked her right away. I know we will be good friends." "I felt uncomfortable as soon as the salesman spoke to me, so I decided to look elsewhere." "What's bugging you today, Honey?" We choose and get along with our mates and our presidents, in considerable degree, by interpretations of vocal cues.

Some recent research indicates that in all the complexities of a voice that make impact on us, in the main, it is the character of the pitch features of the voice that we sense when we feel we are attractive to the one speaking to us.[20] If we decide our conversant does not like us we note particularly the loudness features of his voice. And it is in the monotonous rhythms of his speech that we know our speaker is bored with us and thus he signals cessation of relationship.

BREAKING THE CODE

The language scholar Edward Sapir once said that nonverbal communication is "an elaborate code that is written nowhere, known by none, and understood by all." It is its very elusive complexity that, at least in part, causes us to depend so much upon it. One can monitor his words a good deal more easily than he can the way he says them. The elusiveness and the fascination are also a consequence of the fleeting character of the nonverbal statement. A word is said and held in memory, but a glance, a tilt of the head, and the intonation of a word is like the flickering flame in the fireplace. It comes from nowhere, flashes into its unique form, and goes to nowhere. In its moment of being it leaves its impression. And competence in reading the impression may, we suspect, be, in large measure, the consequence of being fascinated by it.

With the tape recorder, the moving picture and the television camera we now have ways to record nonverbal communication. It would be strange, if having found ways to capture the nonverbal statement we would not learn how to analyze it and perhaps even to break the code.

[19]Paul Moses, *The Voice of Neurosis* (New York: Grune and Stratton, 1954).
[20]Frances S. Costanzo, Norman N. Marke, Phillip R. Costanzo, "Voice Quality Profile and Perceived Emotion," *Journal of Counseling Psychology*, 16 (1969), 267–70.

IDENTITY IN NONVERBAL COMMUNICATION

If others decipher our meanings they do so, in the main, by noting the way that we say what we say. But we can read our own nonverbal cues too. The ultimate in self-awareness is probably attained by sensing the tensions of our own body, hearing the quality of our own laughter, and noting the nuances of our own voice. Again the camera and the tape recorder, now almost as common as typewriters, are available for our self-study, though much of our self-knowledge can be carried on by observing ourselves as we speak and listen.

In closing this discussion of the nonverbal statement, we are reminded of a haunting story we once read about the way the artist Rembrandt described himself to himself by visual cues. Of 700 paintings and uncounted sketches, etchings, and drawings, Rembrandt made 84 self-portraits, 58 of which were paintings. No other man in the visual arts has made such a close study of his own changing physical self as Rembrandt did. He began this work at twenty-one years of age and carried it on until his death at sixty-three, and he seemed to do the greatest number in years of great excitement or turmoil in his life. In one year during his early romance and marriage with Saskia, he painted himself twelve times. Emil Ludwig speaks of the great composure that dominates these self-portraits. During the next few years Rembrandt became the most successful portrait painter in Amsterdam, but into his self-portraits creeps a certain melancholy.

Saskia dies and the self-portraits stop for five years. When they reappear we see mixed sorrow and bitterness. Then Rembrandt marries again, but his fortunes dropped. He becomes less popular and he runs into deep economic trouble. As if bracing himself with self-commands, his self-portraits take on a resolute aura, suggesting the military commander. And he holds a grip on himself throughout the remaining years of his life, though he ages fast. The self-portraits take on many wrinkles, and then the flesh becomes flaccid. In this period, for the first time, however, appears a self portrait of the painter, painting. He knows who he is, despite the falling fortunes.

Then his second wife and his beloved son Titus, born of his first wife, die. Two more self-portraits appear, of the face alone, the aging body omitted. In the one he laughs. In the last a great pallor is more noticeable than the wrinkles. The eyes and mouth are deep. But the lips remain firmly closed, as in the portraits of his earlier youth.

In pictorial symbol, Rembrandt made a detailed commentary on his own life. Here was a man alive to the meaning of the messages from his

own body. On this note we close the discussion of nonverbal communication.

But in a sense we are just beginning that discussion. Each of the following chapters takes up a source of nonverbal information we use when we interact. In each chapter one's ability to apply the information to a specific movement of his own communication depends upon his capacity to read the noverbal cues involved.

OBJECTIVES

The purpose of this chapter is to improve your ability:

I. To understand the significance of the nonverbal code.

II. To be aware of the ambiguity of the nonverbal code.

III. To interpret the nonverbal code.

IV. To recognize the role of the body image to the ongoing formation of the self.

EVALUATION

Do one of the assignments at the beginning of your work on the nonverbal code, then another at the close to sense your growth in understanding nonverbal cues.

DISCUSSION QUESTIONS

1. *Objective I* Discuss the role and significance of the nonverbal code.

2. *Objective I* The following question anticipates the next chapter, but is particularly relevant here. What relationships do you see between defensiveness and the nonverbal code?

3. *Objective I* Discuss all the ways that we communicate with each other nonverbally. Which are the more important in your daily observation?

4. *Objective II* The term "nonverbal" is an odd one. It is an instance of defining something by stating what it is not. If it is not verbal, what is it? Is it music? Mathematics? What is it?

EXPLORATIONS

1. *Objective 1* Have the class discuss the material of the chapter with blindfolds on. What do you observe in the heightened awareness of sound?

2. *Objective I* Have three of your classmates put in ear plugs, or go into an observation room with one-way glass, if available, to observe a class discussion that they can see but cannot hear. Have them report their awareness of what went on at the end of the discussion. Most particularly pay attention to their interpretation of the interest of various persons in the discussion. What do you make of this? If the assignment is repeated with several other observers note the similarity of the reports. What do you conclude from this?

3. *Objective I* Blindfold half the class and carry on a discussion of material in the text or any subject. Compare the contributions of the blindfolded people with the others for (a) sharpness of contributions and (b) degree of self-orientation.

4. *Objective I* Read for an hour with ear plugs in. Remove the ear plugs and study for another hour. Report the differences in the two reading experiences.

5. *Objectives II & III* Record three interpretations of a statement such as "Don't wait for me," one instance intended to say "Please wait for me," another "I don't care if you go or not," another saying in effect "Go." Pass out to the class slips of paper with the three interpretations on them. Play the three interpretations. Have each class member number the interpretations on his paper in the order he heard them. Compare the results.

6. *Objectives II & III* The telephone distorts the sense of distance between the two conversants. Although your discussant cannot see you or touch you, he is in your ear, closer than any other person in any other situation. Call one of your classmates, both recording the conversation. Get together, play the recordings, and discuss them. What did you learn?

7. *Objectives II & III* Make a recording of yourself talking to a friend, and a second one saying the same thing to your class. Study the differences in the voice in the two situations. Play the two recordings to the class for observations.

8. *Objective III* In order to know how the vocal code adds to the verbal code read a statement silently. Then explain it to the class. Now read a statement of equal difficulty aloud. Then explain this to the class. Have the class compare your two explanations.

9. *Objective III* In order to sharpen your awareness of hearing your own reading to that of another, read an explanation aloud and then explain it to the class. Have another person in class read you a statement of equal diffi-

culty. Explain that to the class. Note how watching another read the statement adds to the ease of understanding.

10. *Objective III* The next time you are visiting go sit in your host's favorite chair. Observe his behavior. What cues do you depend upon to interpret the meaning of this to him?

11. *Objective III* Give a short speech to the class in which part of what you say you believe and part you do not. In short, part of the speech is a lie. Have the class try to detect which part you believe and which part you do not believe. What cues did the persons use who read you correctly?

12. *Objective III* Select a short section of a person speaking on videotape.

a. Play only the visual. Then have each class member write whether the feelings expressed by the speaker were generally affectionate, indifferent, or aggressive. Use a scale for the above as follows:

affectionate

1	2	3	4	5	6	7
slightly						highly

indifferent

1	2	3	4	5	6	7
slightly						highly

aggressive

1	2	3	4	5	6	7
slightly						highly

b. Let the class read a typed script of what was said. Again let them write down whether the speaker is expressing: affection, indifference, or aggression, and to what degree.

c. Play the sound alone and have the class judge again as above.

13. *Objective III* The blindfold trust walk. Blindfold half of the class. Let each of the other persons lead a blindfolded person out into and down the hall. The blindfolded person should note the quality of the voice and the touch of the person who is leading. What did you learn both as a leader and as a blindfolded person? Discuss.

14. *Objective III* To sense the impact of physical conditions, carry on parts of a discussion of a chapter, movie, or any common experience in three different conditions. Try ten minutes in chairs arranged in rows, ten minutes in chairs close together in a circle, ten minutes in chairs far apart in a circle.

15. *Objective III* Our usual concentration on the words of an exchange causes us to overlook the nonverbal cues available. To heighten awareness

of the nonverbal cue, divide into dyads. Look into the eyes of your partner for three minutes. Exchange the messages that each of you think you read.

16. *Objective III* Working at the same purpose, hold a discussion with one other person, occasionally changing the distance and position to each other. The positions are opposite, cornered, or side by side. Note how these variations alter your feelings, interaction and productivity.

17. *Objective III* If physical conditions permit give the same speech in a room where the audience sits in rising tiers and then from a platform in a room where the audience sits below you. Report the difference in your feelings and the responses of the audience.

18. *Objective IV* Make a videorecording of yourself in a discussion with one other person. Study your behavior with and without sound. How do you feel when you look at yourself? What does the experience make you say about yourself? How do you feel about yourself when you are listening to the other person? How do you feel about yourself when you are talking to the other person?

19. *Objective IV* Do the above assignment using a tape recorder. What does your voice make you say about your body image?

Only a student who can tolerate considerable self-confrontation should do the following assignments.

20. *Objective IV* Make a videorecording of yourself discussing something with another person or talking to an audience. Play the recording without sound in such a position that both you and the audience can watch. As the picture plays make commentary of the thoughts and feelings aroused in you.

21. *Objective IV* Bring pictures of yourself in various stages of life to class and talk about the perceptions, feelings, and memories aroused by the pictures.

22. *Objective IV* Draw a picture of yourself and discuss the features that dominate your attention, telling your pleasant and unpleasant responses to your self-observations.

23. *Objective IV* Look at a mirror and talk about what you see and feel.

5

Emotion and
Communication

Interaction has its basis in the underlying
irritability of all living substance.
*EDWARD T. HALL**

Men are disturbed not by things, but
by the views they take of them.
EPICTETUS

Even when . . . communication is felt in
silence . . . this silence is itself charged with
the words that had been exchanged
before it began.
PAUL TOURNIER†

Emotion is inextricably intertwined with communication that changes a person in any way.

For too long, emotion of any sort, or in any amount, has been thought of as troublesome to good communication. Anyone who wants to speak or hear a message right, we have been told, needs to keep his emotions out of it. He needs to act objectively, coolly, detachedly—unemotionally. The mature man, we have been led to believe, is a "rational" animal.

But emotion is a basic ingredient of life, and the belief that we can eliminate it from our communication leads to ludicrous behavior. You

*Edward T. Hall, *The Silent Language* (New York: Doubleday & Company, Inc., 1959), p. 62. By permission of Doubleday & Company, Inc.

†Paul Tournier, *The Meaning of Persons* (New York: Harper & Row Publishers, Inc., 1957), p. 130. By permission of Harper & Row, Publishers, Inc.

have doubtless heard a person say in a rising voice, "Now the only thing I'm interested in are the facts. I don't care how anyone else wants to go about it, but I'm not going to let emotion have anything to do with my part in it. Damn it, there's just too much sloppy thinking tangled up in this proposal." Pounding the table, he shouts, "Now here are the facts . . ."

People have not only been tempted to separate emotion and reason, but having separated them, to argue that reason can "replace" emotion. The blind plight of the fellow in the story above is the booby trap of every man at times.

The proposition this chapter seeks to develop is this: language that is rich in emotion accounts in large measure for the impact of communication. By definition emotion is arousal, and the absence of arousal is indifference. Communication without emotional involvement is meager and indifferent. Emotion, it turns out, is the fuel with which communication is powered. Hence, vital communication invigorates both speaker and listener.

THE PRICE OF LANGUAGE WITHOUT EMOTION

Conversely, tepid communication exhausts the persons involved. John Stuart Mill faced, at age twenty, a nervous breakdown. As he tried to think his way through the things that brought him to that pass, he concluded (1) that he was "suffering from an excess of analysis and a deficiency of feeling," and (2) that his father had been ineffective as a father because of his lack of tenderness. His father was, according to Mill, ashamed to show his emotions. Mill adds, ". . . absence of demonstrativeness in matters of affection and feeling is apt to starve the feelings themselves. If, for whatever reason, we habitually refuse to show our feelings, desuetude will eventually compel us to raise the question as to how real are feelings that are unable to address themselves to the person arousing them."[1] Emotion, Mill is saying, is one of the ingredients of life; it must be verbalized to find function, and it, along with the relationships to ourselves and others, withers when it goes unverbalized.

EMOTION AND WORDS

Where there are emotions there are words. On occasion the authors have asked students to recall a moment when something of lasting consequence happened to them. In a remarkable number of cases, the thing students say they remember are the words spoken in a situation saturated with feeling.

[1]R. V. Sampson, *The Psychology of Power*, pp. 70 and 87, from John Stuart Mill, *Autobiography*.

Here, for example, is what one student said:

> Our family has always thought of itself as closely-knit. I miss them when I'm at school, and I'm always glad to get home on vacations. Last year I was going with a girl who invited me home with her for the weekend. When we got there, she ran to her parents, and hugged them, and said, 'I love you.' It really hit me. It was so spontaneous and everything that I suddenly realized what a difference saying something like that out loud could make between people. It will sound corny, but I've found myself talking with my own parents ever since.

Or again, a father remembers a poignant experience which would have faded as most of our experiences do, except for the emotionally laden words in the encounter. One of his daughters, at age seven, had yet to master the art of riding a bicycle. It was a source of real embarrassment to her because virtually everyone her age in the neighborhood could not only ride but had already reached the "Look-Mom-no-hands!" stage. The father gave her the "feel" of balance, but to no avail. He finally decided time would have to solve the problem, and that he might as well relax and watch. Several days later his daughter marched solemnly into the house and said, "Come out here a minute." It was clearly a command. As the father stood on the sidewalk, his daughter mounted the bicycle, rode the length of the block, made a smooth turn, rode back, dismounted, and threw the kickstand into position, saying "I did it because you thought I could." That simple statement, says the father, has echoed through his head ever since as a reminder of how little we are usually aware of the impact of the words on our feelings and attitudes. The chief hallmark of the communication that hangs on, while so much of the flood of daily talk falls into some bottomless pit, is the emotional content.

LISTENING AND EMOTION

Emotion and Distorted Listening

Perhaps emotional aspects of communication have been discredited as they have because of the distortions we note in the listening of the emotionally disturbed. A unique study done with paretic patients showed that when the patients were confronted with factual information, they (a) replaced concrete concepts with generalities, (b) replaced concepts actually presented with more familiar concepts of their own, (c) diminished the significance of situations unacceptable to them, (d) found a motif and repeated it, (e) showed an "insufficient" grasp of both the whole of the message and of its detail.[2] Governed by excessive feeling,

2P. Schilder, "Studien zur Psychologie and Sumptomatologie der Progressiver Paralyse," *Abhandle Neurolog, Psychat. Grenzgeb*, 58 (1930), 1–76.

they did not respond discriminatively to speech most of us would call rational.

Two other researchers, trying to find out the factors most mischievous in the thinking of college students, concluded that one of them was ". . . permitting personal prejudices or deep-seated convictions to impair one's listening comprehension."[3] Aroused states in those experimental subjects, it was concluded, create a significant disturbance in the listening process.

Emotion and Memory

But we should not conclude from the above that some fixed amount of feeling is needed for good listening. Intense emotion, which may cause bad perception at the moment of occurrence, is also the character of memory which lasts for a lifetime. Walker and Tarte did an experiment in which it was shown that individual words associated with high arousal were rather poorly remembered when the subject was tested immediately, much better remembered on a test of long-term recall.[4] For words associated with the low arousal the pattern was reversed. It appears that the "stirred up" state may distort or block listening in the short run, but aid it in the long run.[5]

An explanation of this has been evolving. Gerald Blum and his associates talk about an amplification system.[6] When experience comes to us from the outside, it puts, they think, nervous impulses to work. These combine with impulses already inside the person, and in the process a closed loop of reverberating reaction is set up. It is like the sound that is made in a cave, seeming to increase as it echoes. The fact that the pattern is a closed loop, a phenomenon of "reverberation," helps explain why the message is kept from being immediately available to the consciousness of the person. So reverberation, though divorcing it from immediate consciousness, puts a heavy charge on the brain molecules, giving the message long duration.[7] You may draw a blank on what was actually

[3]Clyde W. Dow, and Charles E. Irvin, "How We Teach Listening," *Bulletin of the National Association of Secondary School Principals*, 38 (1954), 137–39.

[4]E. L. Walker and R. D. Tarte, "Memory Storage as a Function of Arousal and Time with Homogeneous and Heterogeneous Lists," *Journal of Verbal Learning and Verbal Behavior*, 2 (1963), 113–19.

[5]L. J. Kleinsmith and S. Kaplan, "Paired-Associate Learning as a Function of Arousal and Interpolated Interval," *Journal of Experimental Psychology*, 65 (1963), 190–93.

[6]Gerald S. Blum, P. James Getivitz, and Charles G. Stewart, "Cognitive Arousal: The Evolution of a Model," *Journal of Personality and Social Psychology*, 5 (1967), 138–51.

[7]Donald P. Spence, "Subliminal Perception and Perceptual Defense: Two Sides of a Single Problem," *Behavioral Science*, 12 (1967), 183–93.

said in that angry message your friend shouted at you earlier today, but be able to recreate it in colorful detail as you reflect on it several days later.

How Emotion Works—A Theory

There are numerous theories about the way emotion works, and all of them in one way or another relate chemistry and words. What we present here is a theory, borrowing from many and accommodating itself to the nature of listening described in Chapter 2. We start with the common observation that the filtering of a message is determined, in part, by our state of arousal. This point of view dates back at least to the time of the Greeks, but the beginning of its refinement came in the latter works of Pavlov and has been developed into a comprehensive theory by William Sargent in his book, *Battle For the Mind*.[8] Sargent points out that we listen to a message with an arousal at some point on a continuum, which at one extreme may be classified as hyper-responsive and at the other end, phlegmatic. We all know what it is to be too sensitive to a series of messages, good or bad. Our common expression at such times is, "It was more than I could take." People who exist at the hyper-responsive end of the arousal continuum most of the time grow chronically irritated by that sensitivity and hence build barriers to messages.

Conversely, if we live at the other end of the arousal continuum, we are relatively impervious to messages. We are lethargic or phlegmatic. External stimulation must be intense in order to get through. A person who lives at this state most of the time may be described variously as thick-skinned, dull, or a Rock of Gibraltar, depending upon the view of the observer.

Let us diagram the concept of the continuum between the two ex-extremes, just explained.

Intermittently Open and closed	Hyper-responsive
	Lively
	Calm
Usually closed to messages	Lethargic

What we note here, then, are two kinds of closedness, one at either end of the scale. People who are constantly open live for the most part at

[8]William Sargent, *Battle For the Mind* (Garden City, N.Y.: Doubleday Co., 1957).

mid-points between the extremes. They change relatively easily, which is to say they do not need to experience deep and intense emotions in order to listen.

Body Chemistry and Listening

A number of researchers have discovered some of the chemical and physiological behavior related to the receptive state. When we are opening ourselves to external experience, adrenalin increases, noradrenalin decreases, heart rate and blood pressure decrease.[9] Reaction time increases with increases of adrenalin, up to a point; then counteracting effects set in and a great imbalance (as adrenalin increases) leads to passiveness, anxiety, and depression. So the very process that opens one to messages, unchecked, leads to depression, and when pathological, to the depressive stage of manic-depression. Unchecked openness is apparently self-defeating.

Conversely, as we close ourselves to sensory input, noradrenalin increases, adrenalin decreases, heart rate and blood pressure increase. This is our self-assertive (and aggressive) state when we shift attention away from external stimuli in order to do our arranging and patterning, our talking back, our interpretation of the information received. It is also, understandably, the state we adopt when we face unpleasant stimuli, when we fight, or when we reject the "pressures" from our world. Interestingly, this condition, characterized by the dominance of noradrenalin, slows down our reaction time; apparently this is necessary for thinking. Yet the increase in heart rate and blood pressure may slow reaction time to the point where it blocks the flow of thought.

A number of the researchers have observed the dynamics of the process explained above and what they find is a network of feedback systems from heart to cortex (and other parts of the brain), from cortex to glands, glands to cortex, glands to heart, and heart to glands so that all centers initiating processes send to other centers messages that set in motion the opposite processes.[10] At least two important implications can be drawn from the above which bear upon an understanding of listening. First, the emotional state in which listening is likely to be most productive is a state between extremes, for such listening depends upon being open to our external world and yet at the same time not so overloaded by it that we cannot pattern its input. Because the cortex is involved in

9John E. Lacey, "Somatic Response Patterning and Stress: Some Revisions of Activation Theory," *Psychological Stress*, ed. Mortimer Appley and Richard Trumbull (New York: Appleton-Century-Crofts, 1967), pp. 14–38.

10Sanford I. Cohen, "Central Nervous System Functioning in Altered Sensory Environments," *Ibid.* pp. 77–112. Also see Arnold H. Buss, *The Psychology of Aggression* (New York: John Wiley and Sons, Inc., 1961).

this network, the second implication is that language plays an essential role in determining human emotions. The two points together mean that while body chemistry influences talking, talking also influences chemistry.

The Role of Self-Talk
in Our Emotions

As the therapist Albert Ellis points out so vividly in his works, there seem to be three stages in our response to a message.[11] Rather naively, we usually act as if the stimulus A is the cause and the response C the result.

A	B	C
Stimulus	What we say to ourselves about ourselves and the situation	Response

A report of an altercation between two people may go like this: "Then he snapped, 'O.K., take the day off,' and I said, 'No, if that is the way you feel about it, I won't.' I'll be damned if I am going to beg for any favors from him." The speaker will explain his responses (C) in terms of the language of the other (A).

Let us see this at work in a fairly typical student setting. Student X is about to leave her dormitory room, when her roommate asks, "Where are you going?" And suddenly X turns on her roommate and rasps, "What business is it of yours? Why do you always have to be prying into my affairs?" And she stalks out. Trying, later, to figure out what triggered her emotional outburst, X says of her roommate, "I just can't stand her. She makes me so mad." Her analysis is based on the notion that her roommate does something to her (at point A) which inescapably makes her react with anger (point C). But the question, "Where are you going?" does not necessarily have any kind of emotion *in it*. It has to have that assigned to it (point B); and student X does the assigning by saying things like the following to herself; "She wants to control me. She thinks I'm her little sister. Well, I'm not. She doesn't want me to have friends she can't have." On and on. It is the self-talk at point B, not the statement of the other person, that governs emotion.

No person, other than yourself, Albert Ellis believes, can make you angry. Nor do the events of the day make you sad or happy, or afraid. Events and other people stimulate you. But the stimulation has no deter-

[11]Albert Ellis, *Reason and Emotion in Psychotherapy* (New York: Lyle Stuart, 1962).

mining power as to effect. What counts is *what you say to yourself* about that source of stimulation.

A comparison of man, the language-maker, with other animals, is of some aid in correcting our false view of our emotions. So far as we can tell, animals do not hate or love because they do not have the labels necessary to do so. Arnold Buss puts it like this:

> Since hostility develops on the basis of the verbal labels that identify and categorize stimuli, and since language responses exist only in humans, hostility occurs only in humans.[12]

The usual explanation is that animals react to *signs*, while humans are able to react also to *symbols*. The chief difference between the two is that *signs* are words (or objects or events) *present to the senses* at the moment of reaction, while *symbols* are words (or things) which can stand for something not present. A snarling dog may associate the boy who wants to pet him with the salesman who beat him yesterday, but his snarl response occurs only in the presence of a person, and is limited to the moments of that presence. He does not anticipate, with an increasing distaste, the coming of the boy. And when the boy is gone he does not continue to relish his "worked up" state. But a human can grow madder by the minute because of what he tells himself. Indeed, he can sustain his hostility throughout a lifetime. So there is a richness and extravagance in human emotion that does not exist for animals. *Emotion, as humans experience it, occurs and is sustained in the symbols used in self-talk.*

The Kind of Emotion Aroused Is Determined by the Character of the Self-Talk. It naturally follows, then, that our listening determines whether the emotions aroused are positive or negative.

> It would appear that positive human emotions, such as feelings of love or elation, are often associated with or result from internalized sentences stated in some form or variation of the phrase, "This is good for me!" and that negative human emotions, such as feelings of anger or depression, are associated with or result from sentences stated in some form or variation of the phrase, "This is bad for me."[13]

Positive Emotions (love, courage, compassion) Increase One's Openness to Messages. The evidence summarized by Kenneth Gergen suggests not only that emotions can be induced by words but that the

[12]Arnold H. Buss, *The Psychology of Aggression* (New York: John Wiley & Sons, Inc., 1961).
[13]Ellis, *op cit.*, p. 51.

"positive" emotions so induced are a significant aid to one's listening.[14] Having mastered sophisticated hypnotic techniques, Blum and his associates—going one step further—carried out a study in which subjects were exposed to different degrees of "positive" (pleasure) arousal,[15] the state prescribed for the subject while he was hypnotized. The results showed that as subjects were exposed to higher degrees of pleasure they were able to react more alertly and that they committed fewer errors than they did when they were in neutral or negative states.

Goethe observed that we understand only that which we really love. To love involves the empathic ability to perceive through the eyes of the loved one. Could it be that any reservations or defensiveness we may have about the source of the messages leads us to make statements to ourselves that build barriers against understanding the message as it is intended by the other person? Could it be, in short, that he whom we cannot accept unconditionally we cannot understand? If this is true, the emotion of love (defined as "unconditional" acceptance) may play a central role in our understanding of one another. Both theory and the data suggest this.

We are dealing, here, with a challenge to a common belief that "love is blind." And there is no doubting that the sexual and social whirlwinds that catch up countless couples each spring excite "blind" response. But the love, romantic or otherwise, that endures into the summer and through the winter has to be built on the unconditional acceptance of another in full awareness of his faults.

Havelock Ellis, a British physician, catches the point in a comment about romantic love:

> The women whom I have loved, and almost worshipped, are women of whose defects I have been precisely and poignantly aware. The lover who is not thus aware seems to me a crude sort of lover, scarcely even a lover at all, merely a victim of delusion . . . I feel contempt for the "love" that is blind; to me there is no love without clear vision, and perhaps, also, no vision in the absence of love.[16]

There seems some justice in paraphrasing his last sentence to read, ". . . there is no love without listening, and perhaps, also, no listening in the absence of love."

[14]Kenneth J. Gergen, "To Be or Not To Be . . . A Single Self," from *To Be or Not To Be . . . Existential-Psychological Perspectives on the Self* (Gainesville: University of Florida Press, 1967), pp. 22–23.

[15]Blum, *op cit.*

[16]Havelock Ellis, in *Confessionals and Self-Portraits*, ed. Saul K. Padover (New York: The John Day Co., 1957).

But listening that asks such openness has to be built upon another "positive" emotion—courage, the willingness to take a chance. Ross Snyder, of the University of Chicago Theological Seminary, sees communication as made up of the ingredients shown in Figure 6 and in the approximate proportions shown there. You will note that he assigns a significant role to the capacity to take risk.

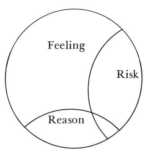

FIGURE 6 Ingredients in a unit of communication

The risk involved for a speaker is obvious. He may be misunderstood or rejected. He may even be ignored. The risk for the listener is equally obvious. He may be conned, exploited, and made to look ridiculous. Where is the person who has not been deeply hurt because he trusted another person without reservation? Hurt badly enough, a person may never again have the courage to accept another sufficiently to understand him.

This happens in Edward Albee's play, *The Zoo Story*. Peter, a stereotype of the comfortable, middle-class, respectable family man, is sitting on a park bench, when Jerry, a dissipated, carelessly-dressed, ne'er-do-well, walks up. Jerry tries to start a conversation with some questions of the type, "Which-way-is-it-to-the-zoo-from-here?" Peter answers in a perfunctory way. He has been brought up to be polite. But pretty soon Jerry is talking about more important things, raising questions about who Peter is, and launching into a detailed description of the kind of grim, communicationless life he himself leads day in and day out. At this point Peter senses the threat if he continues to listen, and he cries out, "Stop it! I don't want to hear any more!" As it turns out, Albee is not willing to let him escape, and the play roars on to its tragic climax. Peter has not found the courage to listen, and as the play closes we suspect he never will. Listening to understand another person requires courage.

Compassion is the third "positive" emotional state to be found in those who can maintain an openness in conversation. Courage, in its final test, reflects a capacity to listen to criticism without vindictive reaction, but compassion is a mirror of one's capacity to "keep caring" for the person who is criticizing us. In an exchange of letters between the author Sloan

Wilson and his daughter, who had just dropped out of college, we get the "feel" of compassion and the way it shapes communication between people. The father writes to his daughter, "I didn't want to spoil the visit, but frankly I cannot yet learn to be happy about the fact that you dropped out of college after only two and a half years. . . ." He goes on to point out the practical values he sees in having a college education, and he writes about the scorn he imagines his view might generate in his daughter. But he closes his letter with the hope that he and his daughter "can trust each other as individuals, not as representatives from the enemy camp of another generation . . . Love, Dad."

His daughter writes with equal assertion and compassion. "I think we ought to be open about it," she says. "You think I've made a rash—if not stupid—move; one that I'll regret. But I think I *have* made the right decision. . . ." She points out that if she had asked before she dropped out, her father would have told her bluntly not to do it. So, she argues, she had to go ahead on her own. She gives her reasons for her decision and closes her letter by writing:

> Never think that I left the home you worked so hard to create because I've lost respect for your opinions. It's just that I'm now gaining respect for my own opinions, too. My life may seem pointless and squalid to you, but it really is working for me. And no matter what you and I end up doing with ourselves, I don't think we could ask for more of each other than to believe in our own ideas and to try to live by them. I know this is what you've always wished for me, and though you may be shocked by the way I've chosen to go about it, I love you for letting me go ahead. Much love, Lisa.[17]

Here are a father and daughter who listen to each other, even in unalterable disagreement. Acceptance of another, "even knowing his faults," includes the courage to affirm that person when those "faults" lead to confrontation. Compassion is love when you can't have your way. Compassion is a state of feeling which causes us to say to ourselves, "If I were he I would act like he does."

Negative Emotions (fear, hostility, anger) Cause a Listener to Close Himself to Messages. The "negative" emotions, as most of us have discovered from experience, do drastic things to the organism.[18] We tend to quake and are inclined to action, either flight or attack, depending upon the way we talk to ourselves about the experience we are involved in. If the emotional state is primarily one of anger, both adrenalin and noradrenalin are secreted; if the state is primarily fear, the changes

[17]Sloan Wilson and Lisa Wilson, "Father vs. Daughter: Two Letters That Crossed in the Mail," *Woman's Day*, March, 1968, p. 50.
[18]Buss, *op. cit.*, p. 93ff.

produced by adrenalin alone seem more characteristic. But our concern is not so much with the physiological changes that take place as it is with their effect on behavior. Fear, in moderate quantities, often produces improvement in comprehension scores.[19] But the weight of the evidence shows that anger, hostility, and fear are disorganizing and disabling states. "An angry person," Buss points out, "finds it difficult to concentrate, to show skill in a task requiring attention and control.[20] And several studies conclude that subjects tend to recall material with which they are in agreement and to forget that with which they disagree. Listeners fearful of their own hostility will tend not to hear a hostile message, even when it is presented vividly.[21] Blum found that hypnotized subjects under the influence of increasing anxiety grow sluggish in response, become inaccurate, and report that their experience became "fuzzier and fainter."[22] Negative emotions, in the main, dampen our intellectual powers, and thus our capacity to listen.

While it is rather difficult to build a thesis for aggressive behavior, in a world unstabilized by struggle, anger and attack are to be desired over withdrawal and submission. This is seen when we examine the spectrum of emotions. On one end of the continuum is withdrawal and on the other is healthful acceptance, with aggression somewhere between.

Withdrawal	Attack	Acceptance
Depression	Anger	Love

Translated, for a discussion of listening, it means that, in the withdrawal stage, we do not listen. We close ourselves off because we do not have the strength to cope. At the anger stage we listen selectively. We listen for that by which to defend ourselves. As we move beyond anger, we come to the healthy state of love and acceptance. Anger is closer to health than is withdrawal.

Some people resent the labeling of "positive" and "negative" emotions. They feel that it is the imposition of the author's value scheme. One student said, "There are some people I just don't like and I do not intend to like them. You say I cannot understand them because I don't like them. The truth is I don't like them because I do understand them." Probably nobody likes everybody he knows and the authors do not feel disposed to preach the gospel of universal love. We do emphasize this, however: whether we like it or not, fear and anger blunt our powers to per-

[19]Charles R. Petrie, Jr., "The Listener," in Sam Duker, ed., *Listening Readings* (New York: Scarecrow Press, 1966), p. 340.
[20]Buss, *op. cit.*, p. 10.
[21]*Ibid.*, p. 110ff.
[22]Blum, *op. cit.*

ceive as sharply as our brains are capable of doing. Made indiscriminate by negative emotions, we perceive the world as a struggle between the "good guys" and the "bad guys." We know this view is inadequate, yet we nurture the emotions that sustain the view.

Emotions, Identity, and Empathy

The identity of a person comes essentially from seeing vividly the difference between his own view and that of the person with whom he talks. But if our emotions are negative not only is our power to hear shades of difference dulled, but our very pitting of ourselves against the other makes it impossible to adopt the posture of the other, so necessary to understanding him. And when we do not really understand him as he means to be heard we are unable to separate out from what he says that which tells about him and that which tells us about ourselves.

One can argue as does the student who confirmed his hatred, "The truth is I don't like them because I do understand them." But such a position is taken without clear understanding that our emotions make us into what we become. The nurturing of our hostile feelings internalizes conflict, creates *an attack upon the self.* The injunction to "love thine enemy" is not moral because it prescribes the appropriate attitude toward others. It is moral because it states the conditions necessary to attain maturity. Anxiety, fear, and particularly hostility, put cotton in our ears. Not hearing correctly, we design messages that impoverish and destroy the self. In all times, in all cultures, the most important and the hardest lesson to learn is that the emotions of divisiveness cut us off from listening to the information needed to give us coherent identity. This concept will be developed in full in the chapter on judgment.

Toward the Control of Emotion in Listening

If listening is, as it appears to be, so strongly influenced by emotion, the ultimate question is, "How far can we go in understanding and controlling our emotions?" Even supposing we are able to recognize our temperament and our habitual response from the foregoing discussions, are we trapped forever to be as we are, to have no power to choose our emotions? Indirectly, all the research already cited, which links glandular response and words, gives a qualified "no" to the question. Steven Mattis[23] concludes that sensitivity to emotional expressions, both in the self and others, can be increased by training. And the implication is that such increased sensitivity is the first step toward control. Davitz[24] points

[23] Joel R. Davitz, Editor, *The Communication of Emotional Meaning* (New York: McGraw-Hill Book Company, 1964), p. 152.
[24] *Ibid.*

out that, unless severe obstacles appear *en route*, emotional sensitivity is a function of maturity and thus that sensitivity develops as the person grows up.

SPEECH AND EMOTION

We can assert direction over our emotions. And to this end overt speech has a distinct advantage over silent speech. Not too surprisingly, the research shows that the person who expresses emotion more freely, who can be emotionally involved, has a better chance for interpreting the emotional expression of others. Thus he gets the critical data for change. Levy, for example, found significant intercorrelations between (1) the ability to express feelings vocally to others, (2) the ability to identify feelings expressed vocally by others, and (3) the ability to identify one's own vocal expressions of feeling.[25] Other research leads to the same conclusions.[26]

Verbalizing as a Key to Emotional Control

But awareness of the research alone is not enough to gain control. Nor is venting our emotions, as helpful as that often is. One achieves the control he wants by talking about his feelings and his aspired feelings, in addition to expressing them and understanding the theory. We are here noting that the power of control comes from learning to operate at a variety of language levels. Conversely, one can "blow his stack" repeatedly and get into deeper and deeper trouble, for while he gets temporary relief he sets the stage for the next blow-up. Staying at language level one he achieves no perspective. First steps in learning to *control* emotion come as he develops the power to talk *about* his feelings.

As one talks about his feelings two important things are achieved. First, he is not only sorting out his feelings (language level two) but analyzing them (three), and perhaps tying them to or throwing them out of his beliefs, principles, and values. Thus he decides what feelings to build into his universe. Then he can elicit some responses and inhibit others.

If I conclude, as I talk out an experience, "Nobody is going to take advantage of me!" I have not only talked *about* an emotional experience but am generalizing this experience into the language of my beliefs and values. I have, if only half consciously, shaped or reshaped and validated my perception of the universe: "It's every man for himself and an unsafe

25Joel R. Davitz, *The Language of Emotion* (New York: Academic Press, 1969), Chapter 4.

26In G. Lindzey, ed., *Assessment of Human Motives* (New York: Grove Press, 1960), pp. 87–118; Davitz, *op. cit.*, Chapter 10.

place for those who are not alert." I am setting myself up to respond with hostility to the next person who moves into my domain. So talk about emotion establishes for me the expectation which will determine future response. In short, freedom of choice is not a function of the moment of decision, but a function of the talk carried on previously about past experience. Action comes close to being automatic. The moment of decision that cues action is designed in talk between moments of action. The psychiatrist Carl Binger, a man of eighty, in telling about what he has learned in a lifetime, says:

> It is important to understand about luck or, better, chance and to realize that more often than not it is determined by the inner set of our personalities. There are some people who seem 'to get all the breaks,' just as there are some others who are constantly running head on into catastrophes of greater or lesser degree. The element of chance cannot be denied, but it plays less of a role in our fate than our private wishes do. In an uncanny way the outer world seems to conform to our inner needs, as though by some predetermined, almost inexorable mechanism. Many wise men know that luck or fate is much of our own making.[27]

Thus, the great function of talk in regard to our emotions is that the talking about an emotional experience sets us up to respond at the moment of action. The next two chapters on expectation and environment trace this theme in detail.

Talk about an emotional experience internalizes conversation—builds into ourselves our own mirror—so that when we are unexpectedly faced with an emotionally arousing experience we are able to carry on self-talk that sorts out consequences while we are still living out the experience. This is particularly useful in interaction involving more than two people, where the sharing of the group talk is great enough to allow each considerable time for his self-talk. One who has learned to talk about his emotions to others now (having internalized the mirror) can note the activity and words being aroused in himself. Imaginatively he can allow himself to respond in action and words as he is tempted, to consider the impact on others, to consider the consequent impact on himself. Who has not had the impulse to walk out of a meeting in disgust, but has decided that the consequence would be more troublesome than bearing the talk of the group? In silent speech we check out an emotional response against our value scheme, a lesson we learn by internalizing overt talk about our feelings.

All this may sound so obvious that its significance is not seen. Let us then do a "double take." As we gather data on the results of "Head

[27]Carl Binger, "Living High on Wit, Wisdom, and Love," *Saturday Review*, July 25, 1970, p. 13.

Start" and "Follow Up," the efforts to save the dropouts in our educational scheme, it begins to become clear that the critical difference between middle class children, who more often make it, and the impoverished lower classes is the ability to use language.[28] Not only are the middle class children more articulate (and logical articulateness is what we mean by verbal intelligence) but they talk more *about* their feelings than lower middle class children do. Let it be clear, they do not necessarily express their emotions more than lower class children do, perhaps less. But they talk more about them; they introspect their feelings more fully and more often. Thus they are guided into their cognitive growth.

He who does not see that intelligence is a ship afloat on the currents of emotion is not aware of his dependence upon his feelings. A man sticks with his job or leaves it as a consequence of the feelings aroused in him day by day. A person chooses his mate out of the feelings aroused in the day to day interaction. A person evolves himself and his spirit out of the feelings aroused by his hour to hour occupations over the years. If he but grunts his pleasures and displeasures he makes decisions on feelings that have not been consciously examined and therefore channeled, directed, and controlled. If one experiences in grunts he lives a happy or an unhappy life, which (as we shall see in the chapter ahead) is simply an automatic response to the love or lack of love experienced in his earliest years. To the degree that we are aware and masters of our fate we have learned to talk *about* our feelings in ways that lead to positive feelings and self-acceptance.

We must, of course, be careful in the choice of our conversant. The other person must not only be one we can trust, but one who sufficiently accepts himself not to be impelled to criticize and pass judgment upon us. Sometimes responses from others are self-affirming; too often they are not. The negative responses of many parents—"You ought to . . ."; "Why don't you act like your brother?"; "Aren't you ever going to grow up?"— are, of course, particularly powerful, for we do not choose our parents, and their shaping of our self-concepts begins before we know what is happening. Our only choice is to search out our listeners as we begin to identify with peer groups. If we are born to parents who help us achieve self-acceptance, we are fortunate. If we are not, we usually stumble upon a person who listens with interest, not judgment. The person sufficiently self-aware of the impact of others on himself and not too caught in self-condemnation seeks out accepting company. Thus, ultimately he learns to know and tolerate his feelings, then to follow those feelings that clarify

28Basil Bernstein, "Social Structure, Language, and Learning," in A. Harry Passow, Miriam Goldberg, and Abraham J. Tannenbaum, eds., *Education of the Disadvantaged* (New York: Holt, Rinehart and Winston, Inc., 1967), p. 231.

his thought. As Ellis says, our reason and our feelings "usually accompany each other, act in a circular cause-and-effect relationship, and in certain (though hardly all) respects are essentially the *same thing.*"[29]

Research on Expressed Emotions and Human Relationships

The most extensive research on the relation of overt language to emotion has been developed by Davitz.[30] By factor analysis he distinguished twelve clusters of emotional statements, his purpose being to examine the structure of human feelings. To the twelve clusters he gave the following names, assigned because they each describe the kind of statements that correlated into each cluster:

Cluster Names	*Description*[31]
Activation	High degree of activity
Hyperactivation	Very high degree of activity
Hypoactivation	Very low degree of activity
Moving toward	Attraction to source of stimulation
Moving against	Hostility toward source of stimulation
Moving away	Indifference to source of stimulation
Comfort	Feeling of well being
Discomfort	Irritation
Tension	Decided irritation
Enhancement	Confidence in self
Incompetence	Distress with the functioning of the self
Inadequacy	A sense of being unable to cope

As one might guess by comparing the cluster labels it turns out there are a series of correlations among the clusters. Thus by further factor analysis Davitz found that high activity, comfort, confidence, and moving toward people clustered separate from the other eight clusters, but also that the other eight divided, though less powerfully, into two clusters. The three clusters can be seen readily in Table 1.

The data show not only the affinity of our relationships with people and the words that echo in our heads, but how we should learn to talk about experience if we want a given relationship. For instance, one cannot talk indifferently or negatively most of the time without ending up

[29] Albert Ellis, *op. cit.*
[30] Davitz, *op. cit.*
[31] These are our descriptions. A better description is of course a list of all the statements that clustered. For this see Chapter 4 of *The Language of Emotion.*

TABLE 1 A structural analysis of emotional statements and the social consequences[32]

	Relatedness to People		
	Toward	*Away*	*Against*
Emotional Dimension	Positive	Indifferent	Negative
Activation	High	Hypo	Hyper
Hedonic Tone (Self Acceptance)	Comfort	Discomfort	Tension
(Confidence) Enhancement (Self Evaluation)	Competent	Incompetent	Inadequate

isolating himself and seeing himself as inadequate. Conversely, if one wants to feel competent he must talk about his perceptions and experience in positive ways.

Davitz's data and these interpretations are further confirmed by similar results evolved in a study by Berlo, Lemert, and Mertz with entirely different objectives and with an entirely different set of statements.[33] In their factor analysis they were searching for the essential characteristics of credibility—the believability of a speaker for a listener. This research suggested that the listener who believes a speaker attributes dynamism, trustworthiness, and competence to him. Note the similarity, if not identity, of meaning between the two words in each of the three cells of the following chart:

Activation	Self Acceptance	Self Evaluation
Dynamism	Trustworthiness	Competence

Davitz was studying the dimensions of feelings about the self. Berlo, Lemert, and Mertz were studying the dimensions of feelings about others. The analyses and conclusions are, for all practical purposes, the same.

[32]This is not precisely the structure Davitz evolved, though it adheres to the statistical clusters he discovered. As he says "the horizontal organization does not derive directly from correlational treatment" (p. 119). Our design of the data focuses attention upon relationships.

[33]David K. Berlo, James B. Lemert, and Robert J. Mertz, "Dimensions for Evaluating the Acceptability of Message Sources," *Public Opinion Quarterly*, 33 (Winter, 1969), 563–76.

Conclusions

In Spearman's studies many years ago about the character of intelligence he found a "g" (a general) factor that seemed to pervade. The intellectually sensitive person seems to discriminate among all sorts of data—verbal, spatial, mathematical. In like fashion it appears that the emotionally sensitive person discriminates among the emotional tones of human speech, music, and visual art. As one may suspect, those sensitive intellectually are most often those who are also sensitive to emotional meaning. Thomas Wolfe, canvassing his experience in the person of the fictional George Webber, in *You Can't Go Home Again*, comes to the conclusion that vital interaction between our emotions and intelligence (fused in our self-talk) is the key to healthy growth.

> He had traveled through England, France, and Germany, had seen countless new "sights" and people, and—cursing, whoring, drinking, brawling his way across the continent—had had his head bashed in, some teeth knocked out, and his nose broken in a beer-hall fight. And then, in the solitude of convalescence in a Munich hospital, lying in bed upon his back with his ruined face turned upward toward the ceiling, he had had nothing else to do but think. There, at last, he had learned a little sense. He had learned that he could not devour the earth, that he must know and accept his limitations. He realized that much of his torment of the years past had been self-inflicted, and an inevitable part of growing up. And, most important of all for one who had taken so long to grow up, he thought he had learned not to be the slave of his emotions.
>
> Most of the trouble he had brought upon himself, he saw, had come from leaping down the throat of things. Very well, he would look before he leaped hereafter. The trick was to get his reason and his emotions pulling together in double harness, instead of between them. He would try to give his head command and see what happened: then if head said, "Leap!"—he'd leap with all his heart.[34]

OBJECTIVES

The purpose of this chapter is to help you:

I. To understand that the language you use to describe your experience is deeply involved in your emotions.

[34]Thomas Wolfe, *You Can't Go Home Again.* By permission of Harper & Row Publishers, Inc.

II. To understand that your emotions shape your relationships with your-self and others.

III. To talk with others about differences of view without arousing nega-tive emotions in yourself or others.

IV. To learn how to express your emotions in the interest of personal growth and interpersonal relations.

EVALUATION

As you have probably noted we believe that our emotions and our inter-personal relationships are two sides of the same coin. Thus much of the change in interpersonal skill depends upon understanding our emotions and handling them well. We suggest you write a paper describing what you have learned from the chapter that seems pertinent to your relationship with your-self and others. At the end state a goal about your relationships with yourself or others that you are going to try to achieve in the remainder of the semes-ter. At the end of the semester write an additional paragraph evaluating your progress.

DISCUSSION QUESTIONS

1. *Objective I* Explain Albert Ellis' explanation of the way what we say about the stimulus determines the emotion experienced.

2. *Objective I* "You are responsible for your emotions." What does that statement mean?

3. *Objective II* Discuss the relationship of emotion to change in percep-tion.

4. *Objectives I & II* Discuss the relationship between anxiety and defen-siveness.

5. *Objectives I & II* Some people feel it is not appropriate to label certain emotions positive and others negative. Make a case for no distinction, argu-ing that the appropriateness of emotions must be evaluated relative to the situation that arouses them.

6. *Objective II* What are the relationships between emotion and identity, between emotion and empathy?

EXPLORATIONS

1. *Objective I* Thinking of the Ellis view, report what you said to yourself just prior to an emotional outburst in a conflict with another person. Analyze the statement as to whether it was rational or irrational.

2. *Objectives I & III* Note the way you have, on a given occasion, said

something you thought you ought to say even though you predicted accurately that it would arouse hostility in the other person. You have decided to avoid emotional involvement in the conflict. Note the role of the self-prediction and how it controlled your emotions in the incident. Discuss this with another person or write it out.

3. *Objective II* Discuss a typical verbal exchange with your father, stating the incident and the words exchanged. What were the emotions of the interaction? Describe the relationship of the two of you in the interaction.

4. *Objective II* Tell about an emotional experience of your life. Then explain the relationship that existed with the other person in the experience. Note that the two explanations are different ways of talking about the same thing.

5. *Objectives II & IV* Select two people and sit them face to face. Place a stick, ashtray, pen, ruler, or something else between them. Have neither of the two persons say anything to each other. Note what they do with the object. Have each participant talk about the feelings he experienced during the situation.

6. *Objective III* Tell about an argument you were in, in which you felt the other person was defensive. Tell how he distorted what you said in order to protect himself. Have the class determine whether you sound defensive in your explanation.

7. *Objective III* Recount an incident in which you discovered your own defensive behavior. Tell what condition it was that allowed you to see the defensive behavior.

8. *Objective III* Talk about a value very important to you. Then choose from the class a person who sincerely disapproves of or is indifferent to your value and ask him to explain why. Respond to him. Ask monitors who have been assigned to the task to evaluate the degree to which you were defensive in your response or in any way showed hostility.

9. *Objective III* Do the above assignment recording your response on tape. Listen to the recorded response and evaluate your defensiveness or the absence of it.

10. *Objective III* One of the most desirable objectives of leadership in our times is to be cool under fire. Plan a scene with one of your classmates in which you are to present a point of view which in turn he is to vigorously attack. Your objective is to respond to him without feeling or expressing hostility. If you are successful, how do you account for it? Did you divorce your ego from the attack? Or are you teaching yourself to accept yourself as an imperfect person?

11. *Objective III* Invite a member of the class who feels he does not understand you to confront you and tell why you are difficult for him to understand. Respond to him trying not to feel hostility or shame. Describe to the class the degree of your success.

12. *Objective III* Repeat the above assignment, if you sense a reserve of confidence. The purpose of these assignments is to desensitize you to at-

tack. But to endure more than your poise permits is to sensitize, not desensitize, to throw you back into the tendency to respond defensively.

13. *Objective III* The next time you get into an argument at home try to respond without hostility or shame. Tell about the experience in class. What was the impact on yourself? Your family?

14. *Objective III* If you are secure enough to do it, give a speech in class about the discrepancy between your ideal self and your actual self. In this assignment there are these assumptions: (1) not accepting our weaknesses is the cause of our defensiveness, and (2) defensiveness obstructs our growth. Behind all the conflicts between people are the conflicts in people.

15. *Objective III* Divide into groups of five or six. Listen to each of the group members tell about his feelings of the moment. Discuss those statements which sounded the most bona fide. Whose (if any) statements seemed out of touch with his feelings? Discuss the nonverbal cues, if you can identify them, that will help you form your observations.

This assignment is only for those who feel secure enough.

16. *Objectives II & III* Break up into groups of four. Each person in turn tells each of the others what he likes and dislikes about him. Note the level of relationship expressed in both the positive and negative statements that each makes. How well are you able to express both? What does your ability to express the one as compared to the other tell you about yourself? Write a paper or make an entry in your journal about the experience, the knowledge you gained about yourself and the others.

17. *Objective IV* Write a statement about something you heard sometime in your life that had a great impact on you for good or ill. Label it "Something I heard that made a difference in my life." Read the statement to the class either over a public address system or from behind a screen. Have the class make comments. You will note they will be emotionally involved, deeply so. You have removed the emotional constraints of the visual code. Discuss this fact.

18. *Objective IV* Do the above assignment for forty minutes with a series of your classmates. Write a paper or journal entry about the impact of the day's class.

19. *Objective IV* Break up into dyads, matching strangers. Each will be alert to the other person's nonverbal behavior. Get acquainted by exchanging the usual information about name, hometown, siblings, etc. Intersperse in the conversation statements about your feelings of the moment. Discuss with each other the degree of authenticity about the statement of feelings.

20. *Objective IV* Form dyads of strangers in which each person is to try to learn from the other how he seems to manage the problem of social acceptance (how easily he establishes friendships, the embarrassment felt in establishing new relationships, the need for social approval). Comment (see Chapter 3) on your feelings as you express your feelings. Comment also on your feelings as you make inquiry about the other's feelings. Comment on your feelings as you respond to the inquiries of the other person. Comment on your feelings about the authenticity of your exchanges with each other.

6
The Role of Expectation

Prince Stepan never chose a line of action or
an opinion, but thought and action were
alike suggested to him, just as he never chose
the shape of a hat or coat, but took those
that were fashionable.

*TOLSTOY**

This chapter concerns a person's expectations or needs which determine what messages he will listen to and how he will respond to them. Let us begin with a true, if desperately tragic, story.

Lee Harvey Oswald made a name for himself as the assassin of President John F. Kennedy. Why did he listen to the President as he did, and thus find need to destroy him?

A fascinating observation for the student of communication is the consistency with which several themes ran through his strange behavior.[1] (1) His early life was filled with anxiety; (2) as an adult he seemed set not to "like" anything; (3) he consistently withdrew from people; and (4) at the same time he had fantasies about the way he would dominate and control them. What were the communications that led him down his tragic course?

*Count Leo Tolstoy, *Anna Karenina* (New York: Thomas Y. Crowell Company, 1886); translated by Nathan Haskell Dole; copyright 1914 by Nathan Haskell Dole.

[1]Lee Harvey Oswald, *Life* (February 21, 1964), 68a–80.

Oswald's father died two months before the boy was born. His mother, unhappy and apparently immersed in self-pity and bitterness, was at home with him for the first two years of his life; then her sister, or whoever could be obtained, served as a baby-sitter. At age three he was placed in an orphanage. Later, when his mother remarried, he was moved back to the home in Ft. Worth, where he lived in the midst of a constant quarrel between a stepfather he came to appreciate and a violent mother. When the marriage culminated in divorce, there was a lonesome year-and-a-half in New York City. The estranged boy, thirteen at the time, was absent from school forty-seven days in a three-month period. This brought him to Youth House on a charge of truancy. Dr. Renatus Hartogs, the psychiatrist who filed a report on him, had some interesting things to say: "(Outwardly) he is calm, but inside him is much anger. . . . (He is) extremely resentful of people who derive benefits from a father. . . . This will cause him to be extremely vengeful to authority or to father figures. . . ." The psychiatrist described him as a boy with "personality pattern disturbance . . . and passive-aggressive tendencies." Social workers who interviewed him there reported that "He could not become verbally productive and talk freely about himself and his feelings." They concluded that, "In an environment where affection was withheld, he was unable to relate with anyone because he had not learned the techniques and skills which would have permitted it."

He dropped out of high school, went into the Marines, hated it, got out on a ruse, defected to the Soviet Union for three years, decided that Russia was not for him, came back to the United States, drifted from job to job, made an abortive attempt to go to Cuba, tried to shoot General Edward Walker, failed, was arrested for the assassination of President Kennedy and the shooting of Patrolman Tippitt.

As the report of the President's Commission on the assassination put it, "Perhaps the outstanding conclusion . . . is that Oswald was profoundly alienated from the world in which he lived." Persons from almost every stage of his life reported that he was "never satisfied with anything." On the ship bringing him back from Russia to the United States he wrote notes in which he damned both United States capitalism and Russian communism. His wife said of him he wouldn't be happy anywhere, "Only on the moon, perhaps."

In reading his life one is impressed with the repetition in it. Change the geography, the people, the politics, the time, change any factor you can think of, and the Oswald reaction is consistent—he didn't like what he found, and he responded by withdrawing (often snarling) to fantasy where he could even the score. It is as though somewhere, back there early in his life, something had been planted in him from which he could never escape; as though his behavior were guided by an unchanging expectation.

And that is the point of this chapter, that life does something to each of us. It does it early and it does it deeply.[2] And when it has been done we come out equipped with a readiness to notice some things and to ignore others. For each person that is an exceedingly important fact, because it means that he is prone to hear what he expects to hear—and to miss the rest. But equally important—on the hopeful side—only as each of us comes to listen to his own expectations and to test them in his speech with others does he come to some freedom to choose what to listen to.

RECEPTION VS. PERCEPTION

Two interrelated processes, reception and perception, work together to determine what we listen to. The reception process is an ancient one, intimately related to the survival system. Basically, it is designed to tell us about any changes in the messages coming to the ear, thus alerting us to possible danger. To illustrate, if one is told to listen to a given message and a second message is sent simultaneously, the only kind of data the person will usually report about the second source of information is where it came from—above, below, to the left or right—and whether the message got louder or softer, whether it changed from some mechanical noise to the growl of an animal or to a human voice or from one voice to another—this only if the voices are radically different.[3] The listener will not report *what* the second message is about, unless it is some simple and repeated thing like a cry for help. What we note here in such research is that *reception by ear is tuned to change.* In the long history of man's evolution those who have survived, apparently, were those who shifted attention appropriately and scanned for danger at any change in the sounds within the space monitored by the ears, just as ships at war scan the air above and the water below with radar and sonar, searching for any new object, alerting the ship to careful examination. In like fashion, the reception process of man's ears is set for change. We cock our heads and tighten the timpani when alerted. This is the basic nature of oral reception—hearing.

As reception is tuned to changing signals outside the organism, so perception—the pattern of meaning ascribed to what is heard—is tuned to needs within. Or to sharpen the difference between reception behavior and perception behavior, put it this way: we hear changes in the sounds in our environment, but we listen for what we *expect* to hear. Again the

2John Bowlby, *Attachment and Loss* (New York: Basic Books, Inc., 1969).

3Harold Bate, "The Relative Roles of Reception and Perception in Listening to Speech" (Unpublished, Kalamazoo, Michigan: Department of Speech Pathology and Audiology, Western Michigan University).

research illustrates. If we are sent two messages at once and then told to respond to one of them, usually we are confused, not knowing what to listen for; we hear both and listen to neither. If, however, we are told beforehand which message to respond to—and we want to obey—we will listen to the one message and ignore the other.[4] The expectations of the listener are central to what he perceives.

In research done at Purdue University, Charles Kelly found that in two out of three cases where subjects were warned in advance that they would be tested over orally presented material, listening comprehension was significantly better than for those who were not so warned.[5] He also found that offering cash awards would help produce higher levels of listening comprehension. The old adage is true: "Money talks." Kelly concluded that there was little doubt that the kind of "sets" within which people listened could make a significant difference in how well they listened.

One of the authors found the same conclusion in a different kind of research.[6] He read short statements of information to college students and then tested them for recall. With half the subjects he made a short introductory remark indicating the character of the information to come —for instance, "The next material explains the carbon 14 method for dating prehistoric objects." The group of students getting these short introductions made significantly higher scores in the listening tests that followed than did those who listened without any introductory comments. To know what to listen for is to listen better. Listening is tuned to the expectations of the listener.

HOW RECEPTION AND PERCEPTION WORK TOGETHER

Of course, a question arises: which process, reception or perception, dominates in forming our expectancies? And the answer to the question throws still further light on the beautiful order that governs the way we listen. Again the research using simultaneous messages is of aid. If the person is directed to listen to one of two messages and his name is used in the second one, he is alerted, and he will now listen to the part of the message that follows. Perhaps we may say then that while a prevailing

[4]D. E. Broadbent, *Perception and Communication* (New York: Pergamon Press, 1958).

[5]Charles M. Kelly, "Listening Test Results and Actual Day-to-Day Listening Performance," in Sam Duker, *Listening Readings* (New York: Scarecrow Press, 1966), pp. 136–44.

[6]Charles T. Brown, "Studies in Listening Comprehension," *Speech Monographs*, 26 (November, 1959), 288–94.

apprehension about one's external world dominates reception, hearing—what one perceives—is always, in some way, deeply related to the self-concern. Thus reception and perception operate in common purpose. Both are tuned to the basic needs of the listener.

We listen to what is basically important to the self, and the ears, like sentinels on duty, are tuned to changes in noises of the environment searching for the messages significant to the self. Recent research concerning arousal and listening illustrates the point in a graphic way.[7] If one is listening to a series of words spaced ten seconds apart, the derhmometer which registers arousal reflects the degree to which the words have meaning or impact on the listener. The closer the words get to the basic needs of the listener, the more the sweep of the needle. The words *sex, war,* and *death* cause more response than the words *sand, books,* and *golf.* In almost all cases the name of the listener arouses him more than any other word, for the name is apparently the heart of the image of the self. The needs of the self predict what we shall hear and listen to.

LISTENING AND
THE HISTORY OF A SELF

But the self has a history. Everything that we listen to accumulates and shapes us. And so our listening at any given moment is controlled by the peculiar feelings about the self, the sender of the message, and the message itself as a consequence of the mixture of all the things we have heard from the beginning of our listening in early childhood. As we each know from our experience, we are forever caught in a ping-pong game, in which at one moment we are searching for our own identity in a mass of observations, feelings, and sensations, and at the next we are trying to establish some world view of meaning in order to give our lives direction. Out of our searching we mark out beliefs and attitudes with which to guide ourselves, much as a pioneer in a wilderness notes his compass and blazes the trees to mark a trail. Our beliefs, values, and attitudes are formed out of our experience, and they, in turn, determine how we shall listen, how we shall be formed.

This perspective, too, is borne out by the available research. Lazarus, Eriksen, and Fonda explored the way certain personality dynamics affect the perception of incoming messages.[8] Among other things they asked

[7]Loren D. Crane, Richard J. Dieker, and Charles T. Brown, "The Physiological Response to the Communication Modes: Reading, Listening, Writing, Speaking, and Evaluating," *The Journal of Communication,* 20 (September, 1970), 231–40.

[8]R. S. Lazarus, C. W. Eriksen, and C. P. Fonda, "Personality Dynamics and Auditory Perception," in David Beardslee and Michael Wertheimer, *Readings in Perception* (New York: D. Van Nostrand Co., Inc., 1958), Part 5.

experimental subjects to complete statements like, "He hated . . ." Some people, they discovered, were "set" to express whatever hostilities they felt. Such people might finish the sentence, "He hated successful people." On the other hand, people who were "set" to cover up their hostilities, or had few, might finish the sentence, "He hated to be caught in the rain without his umbrella." Give these people a cluster of sentences beginning in such a way as to allow them, even invite them, to express hostility, and they would consistently interpret the messages in nonhostile ways.

Everyone brings an expectation, a readiness to respond in a certain way, to every message he hears. "Every message," as another writer has put it, "is received in a frame other than its own." Note the way past political beliefs control the listening to political speeches, as illustrated in the following experiment:[9]

During the campaign for the presidential election in 1960, students at Ohio State University were asked to indicate their party preference. Those who had listened to the now-famous televised debates between Kennedy and Nixon were then confronted with lists of statements taken verbatim from the debates. They were asked to indicate those statements with which they agreed and those with which they disagreed. The final request was to match the candidates and the statements. Part of the findings of the experiment showed that out of 299 statements they *disagreed* with, and which were made by the candidate of their choice, subjects ascribed 206 of them (72 percent) to the opposing candidate. "If I don't like that statement my candidate didn't say it," is the implicit reasoning. The distortion was not so great when subjects were dealing with statements with which they agreed, although even here they attributed 35 percent of the statements made by the opposing candidate to their own candidate. We listen in accordance with the beliefs and attitudes that we have forged in the past.

And of course our beliefs and attitudes reach far back, before we had any political beliefs, to our childhood; our tendency to listen as we do is inextricably related to communication with our parents. The following illustrates. A group of students took the Allport, Vernon, Lindzey *Test of Values* and then gave talks about what they had learned about themselves as a consequence of examining their scores. One young man said this:

> My test showed me high in economic values. I guess I would say the test is no good if it didn't, for I am a Business Major. I've been thinking about what I really want. First of all, I've got to say this. I want to start

[9]Hans Sebald, "Limitations of Communication: Mechanisms of Image Maintenance in Form of Selective Perception, Selective Memory and Selective Distortion," *Journal of Communication*, 12 (September, 1962), 142–49.

my work career at from $7,000 to $9,000 next year and I want to exceed $20,000 in a few years. I haven't put a ceiling on myself. And I don't really care where I work, but the work's got to be managerial. I want to be a man who understands people and can manage them skillfully.

Now note the peculiar listening sets as reflected in each of the six statements that follow. One man remarked incredulously,

(1)

Seven thousand to nine thousand to start? You aren't going to make it. I've been reading a report of beginning salaries for college graduates—$6,500 would be more realistic. Besides, why say $20,000? Whether you know it or not, you are putting a ceiling on yourself when you say that. I'd say you are not very realistic at either end. You want to start too high and you are willing to settle for too little in the end.

A girl said,

(2)

I wonder why you think of yourself as an occupational self and why even the first thing stressed is the price tag. I try to get enough money to do what I want to do, but I can change plans easily if money is a problem. Money is just a convenience to me.

The original speaker, who had set off the exchange, responded,

(3)

But people judge you on how much money you make. It's hard to be satisfied with yourself if others don't look up to you—and they don't if you don't make good money. Money is a measure of your influence and your worth. You can't escape what others think.

Then a second girl chimed in,

(4)

I was born and lived my early years in Cicero, Illinois. But over the years my father has worked hard, climbed into management positions, and now, after a series of moves and promotions, is taking us to Shaker Heights in Cleveland. I am not ashamed of our economic past but I am proud to say I live in Shaker Heights.

There was silence for a moment before one man made this remark:

(5)

Can't we talk about something else. I don't like to talk about money. Money is a private matter and it ought not be discussed.

Asked a girl,

(6)

Why shouldn't it be discussed? I can tell you I have to discuss money because it gives me lots of trouble. You know I overdrew my checking account thirteen times last year. The bank called my dad and said, 'Please close that girl's account and just send her money by the week.' He did and then I was always broke before the week was over. So my dad doubled the weekly amount and I still went broke. This year I started to work and I told my father I wanted nothing from him but room, board, and tuition.

Here we have a series of comments stimulated by a statement by a young man about his economic aspirations. Each of the remarks stands alone, in no logical fashion tied to the comments that set it off, but intimately and logically related to the life of the speaker. The great diversity among the remarks thus tells us about the unique overall expectations of each of these persons. One cannot really understand the listening and the resulting comments of the six persons unless he knows each of them, what each has brought as a total life to the hearing of the message which in turn makes him perceive and talk as he does.

As a consequence, we held interviews with each of the respondents, including the original speaker, and their accounts are given in assignment four at the end of the chapter, designed by way of analogy to help you reflect upon the experiences that have created your present stance toward life.

It will be noted in examining those stories, that each of them in one way or another ran back to the family and to the emerging attitudes of the student: (1) about money, (2) about himself, and (3) about his parents—from whom he evolved. That tuning of the ears that causes us to listen in our unique way is learned in our earliest communications with the significant others of our environment.

THE OPEN AND CLOSED EXPECTATIONS

Beyond this, another observation can be made: It seems that some people are "set" to listen to messages, while others are "set" to close against them. Those who are open can accommodate a message—whether it is pleasant or not—without the distressing emotions of frustration, anxiety, guilt, or hostility. They affirm the life in themselves and their environment.

The expectation works the opposite way for those who have learned to be closed to messages: Messages get on their nerves; they complain and criticize. Or they grow angry—with themselves or somebody else. At worst, they give up to depression and despair.

There is danger, of course, in over-simplifying "reality" when all re-

action is described as "open" or "closed." But the available research suggests that people do develop more or less consistent postures toward the world around them. Milton Rokeach, in his pioneering study published under the title, *The Open and Closed Mind*, finds support for belief and disbelief systems that are significantly more "open" in some people, and more "closed" in others.[10] His research suggests that the "open" person can "receive, evaluate, and act on relevant information received from the outside on its own intrinsic merits, unencumbered by irrelevant factors in the situation arising from within the person or from the outside." Everyone has to deal somehow with his power needs, the need for self-aggrandizement, the need to allay anxiety, and so on. But the point is that the "open" person is not forced by such things as fear, or a compulsive need for praise, to ignore or distort messages from the outside.

The "closed" person, on the other hand, is plagued by many irrational factors. He is likely to reject information not so much because of its merits or defects, but, rather, on the basis of whether external sources would punish him if he were to accept it. He operates on the notion that: "What the external source says is true about the world should become all mixed up with what the external source wants us to believe is true, and wants us to do about it."

As Rokeach sees it, there is a constant war waged in each of us between the "need to know" on the one hand, and the "need to ward off threat" on the other. We want to receive messages, he thinks, but we also will do anything we have to do to protect ourselves. "A person will be open to information," says Rokeach, "*insofar as possible*, and will reject it, screen it out, or alter it *insofar as necessary*." Thus we are all more open at one time than another, and some listeners are generally "ready" to receive messages, while others are generally "ready" to reject or distort or ignore them.

Over the years that we have gathered material for this book we have searched for the lives of modern leaders who have maintained the open stance to life, who have been able to listen and speak defenselessly. We did not want examples here from student life, but rather models of older persons to guide young people as they move into positions of leadership. No search has been more frustrating and yet so revealing of the problems we face as a people. Leaders are the most powerful teachers in a social order. The posture they take becomes the example of the wise way. Only two names in recent years have suggested themselves to us as persons set essentially in the open posture, Eleanor Roosevelt and Adlai Stevenson, who always pleasantly shocked us by their candor in public statements.

[10]Milton Rokeach, *The Open and Closed Mind* (New York: Basic Books, Inc., 1960).

But they are now dated. Had Stevenson made the presidency he still might be considered current. We thought of Norman Cousins, former editor of the *Saturday Review*, but your generation does not really know Mr. Cousins. We thought of Robert Kennedy and Martin Luther King, but, though we greatly admire both, the facts of their lives do not demonstrate basic openness. Their example makes us wonder if there is such a thing as an open reformer. Reforming involves competition, competition involves strategy, and strategy by its very nature means concealment of intention. Maybe the worst feature of democracy is the personality stress placed on those who struggle to the top.

In any event, that you may see the kind of open trust in a man of great position and leadership, we have settled for a remarkable man out of the pages of ancient history. Marcus Aurelius was emperor of the Roman Empire for nineteen years during a disruptive time of earthquakes, plagues, attacks by the Parthians, Germans, and Britons. He ruled with firmness and yet with great charity for his enemies, lowered the tax for the poor, and devoted himself to easing the path of all people in the far-flung kingdom. How can one explain this humanitarian attitude in the most powerful man on earth, especially in disruptive times? Only by knowing his past. He was the favorite nephew and constant companion of Emperor Pius who preceded him. In peaceful times, from the age of seventeen until he became emperor at forty, he identified closely with a mature man of peace. Thus for nineteen years of turmoil he could remain the same. Indeed he seemed to become more open to his fellow men as troubles developed. This spirit is reflected in a little book he wrote entitled *Meditations*. He thanks the gods for providing him with a "mild tempered father," loving mother, sisters and brothers. He made these resolutions early in life, he said: ". . . to endure the freedom of speech"—this in the second century after Christ—"not to meddle in other people's affairs," "not to be ready to listen to slander," "to be a hearer of wise men." Aurelius is talking about the expectation of the open ears.[11] He admired greatly, he said, his friend Sextus who never showed anger and passion, but was always affectionate. He said:

> I have learned that generally those among us who are called patricians are rather deficient in paternal affection. I received the idea of a polity in which there is a same law for all, a polity administered with regard to equal rights and equal freedom of speech, and the idea of a kingly government which respects most of all the freedom of the governed.

And then note this:

[11]Saul K. Padover, *Confessions and Self-Portraits* (New York: The John Day Co., 1957), pp. 151–53.

> I observed that everybody believed what he thought as he spoke, and that in all that he did he never had any bad intention.

In trying to understand Aurelius we observe the following, and consider it of no small importance. Aurelius had shown scholarly interest from youth, maintaining a kind of psychological detachment from action. Moreover, he was a faithful Stoic. A stoic personality holds to his faith despite travail and indeed accepts the trial as necessary to strengthen his character.

From the life of this remarkable man we are inclined to conclude that three unique conditions are probably necessary to the development of open leadership: an affectionate, secure childhood, a capacity to meditate, to pull oneself away occasionally from the scene of action, and a belief that trial is the test of what you really believe.

But democratic leadership, as suggested, emerges from the competitive drive to attain a position of power. If the strategy of outdoing another is central to both the system and the needs of the personality, then obviously leadership is exercised mainly by relatively closed men.

They must have the organizational talents of leadership and a certain attractiveness or charisma. They need not, however, be open; indeed, strategy is the name of the game. Thus, even on television, a two-dimensional representation not fully revealing all the nonverbal cues, we sense a certain incongruence between the voice and the words of a Lyndon Johnson. President Nixon's physical behavior and even his words suggest too much concern for the performance. We are inclined to wonder about the feelings and attitudes of the man behind the mask. We sense mostly the will to power. In Senator McGovern one is led to believe he sees a man of high purpose, but again one hears a voice suggesting that that is the *intended* image. Senator McCarthy, the ideal of youth in 1968, has been known as the enigmatic candidate. He seems to be caught between image-making and telling it "like it is," a certain sadness reflecting the knowledge that truth would sound like naiveté to the large masses of closed and suspicious persons. Young people, who in the main honor openness and honesty, know and admire him because he wants to be honest. Robert Kennedy, in his campaign for the presidency, at times revealed a man of deep humanitarian concern, and even the skeptical blacks found him "for real." His brother, President Kennedy, though usually calculating, openly confessed his miscalculation in the "Bay of Pigs" incident, openly confessing the duplicity of the government's role in the incident. We will wager that this will stand as one of his finest moments, along with that moment when on television he openly laid the prestige of the presidency on the line against the steel companies who were set on raising prices. Yet the nation is quite willing to consider for

the presidency Senator Edward Kennedy, whom few feel has told the whole story about a certain tragic night. And although Governor Wallace is openly defiant, his voice, facial expressions, and carefully selected words tell us we do not know what he would do if he were president. Note the eyes of the Democratic candidates at the hour of this writing (Figure 7) for a fascinating study of the question of openness and closedness.

One should not read into the above a veiled polemic against politicians or a basic skepticism about democracy, but only that openness, and the resulting trust so necessary to the development of growth-producing relationships is a challenge to the human race because of its mortal enemy, power. We cannot erase power from the human scene, but it generates all the traits that close us off from one another.

Most, if not all, profound literature in one way or another concerns the dramatic working out of a life closed by a set of circumstances in early years. Consider the tragic tale of Alan Paton's *Too Late the Phalarope*. The title derives from an ironic incident in which the father and his adult son, about whom the novel concerns itself, are walking together, after a picnic at the beach. They see a bird and discuss whether it is, in

FIGURE 7 Cover courtesy of TIME, The Weekly Newsmagazine; © Time Inc.

fact, a phalarope. For once the two discuss and argue as equals, both understanding for the moment how the other sees and feels. But too late!

Throughout Pieter's boyhood his father had been the fearsome, unpredictable final authority—as cold as a court of law and as threatening as the next clap of thunder. As a consequence, Pieter, not learning to identify with his father, never learned to identify closely with anyone. Even in his marriage, he settled for a union with a woman to whom he remained a stranger. But it is hard, if not impossible, to go through life never revealing oneself to anyone. Thus Pieter, unable to relate with anyone of equal social station, stumbles into an affair with a black servant girl, Stephanie.

In South Africa, where the story takes place, such a relationship breaks the most stringent of the social taboos. But the affair would likely never have been "discovered" had it not been for Sergeant Steyn, an incompetent man who had developed an almost psychopathic hatred for Pieter. The sergeant saw the Lieutenant and the girl pass each other on the street, in midday, pause and say a few words to each other casually, and move on. He had no reason at all to suspect them, but the intensity of his desire for revenge alerted him to any opportunity to get even. Desire transformed into expectation, it suddenly occurred to him that there just *might* be something between the two. Playing his hunch, he bribed the girl to put a shell in her lover's left-hand jacket pocket the next time he came to her in the dark edge of the city. She did. And the shell became the piece of evidence that led to the trial and the undoing of Pieter and his family.

But enough of tragedy. Is there no hope for those whose early experience closes them up?

Perhaps Shakespeare's *King Lear* is the great story of a life, long-closed, that opens; and the power of the drama rests in Shakespeare's profound understanding of the trauma that one must experience when such conversion takes place.

Vain, unpredictable, demanding, King Lear lives into his eighties, having been told what he wants to hear by the self-seekers who surround a man of power. Thus he has never learned to listen to people and relate to them. Old and weary, he decides to divide his kingdom among his three daughters. But, of course, he must extract words of extravagant love and devotion from each before he bequeaths his kingdom. Two of the daughters, rapacious creatures as the play shows, attest their undying love. "I love you more than word can wield the matter," one says. The second lies, "I profess myself an enemy to all other joys that compete for my love of you." But Cordelia, the third daughter, will have no part of

such extravagance. She says, "I cannot heave myself into my mouth. I love your majesty according to my bond," which is to say, as any dutiful daughter loves her father. Lear's vanity is pricked, and he sternly shouts the famous line that rings across the centuries, "Mend your speech a little, lest you may mar your fortunes." But Cordelia, unshaken, argues that when she marries, half her love goes to her husband. "I love you as the daughter of a loving father. I shall always be respectful and concerned with your self-being," she says, "but I will not be owned."

Angrily the king divides his kingdom between the other two daughters. In an ensuing power struggle between these two the king sadly learns that neither has any love for him once they get their lands. They do not even have a place for him to stay when he visits. The bewildered old man discovers he is without power or love. At first he rages, and unceremoniously departs from the castle of one of the daughters. He is caught in a violent storm and the son of a faithful friend leads him to shelter in a hovel. Physically exhausted, shocked by disloyalty, he goes mad. While his two scheming daughters plot against each other, Cordelia sends a doctor to care for her father, and she herself goes to tend him. The doctor drugs the raving old king, who falls asleep. As he awakens, he returns to sanity, aided by the comfort of the daughter he had disinherited. Place, position, pomp, and circumstance now mean nothing to the dying old man. As in his madness he had torn off his clothes, so now he tears off the trappings of his former pompous life. "I am a very foolish old man," he says to Cordelia. "If you have poison for me, I will drink it. I know you do not love, for your sisters have, as I do remember, done me wrong: you have some cause, they do not."

"No cause, no cause," answers Cordelia quietly.

The old man's last few hours exist in appreciation of the meaning of love. And for one who searches the meaning of listening in our lives and the experience that opens closed ears, the final scenes and symbols of the drama are deeply significant.

As a consequence of the plotting of the other sisters, Cordelia is killed, despite the old king's efforts to save her. And his last cries are:

"No . . . No, no, no life! Why should a dog, a horse, a rat have life, and thou no breath at all! Thou'lt come no more, never, never, never, never, never!" When we love, the worst of all anguish is the recognition that the voice of the loved one will speak no more.

"Look on her! Look! Her lips! Look there, look there!" Lear crumbles and dies. But he dies a man who knows the heart of life. Shakespeare is saying for us that humanity and civilization rest with those who can listen to each other, and that meaning is nestled in our relationships with each other.

However, the essential insight to be taken from Shakespeare's phenomenal imagination is that not only is there an inextricable relationship between love and the open expectation, but also that those who do not come to listening naturally by early training must sink into the pit and live out destructive emotions—from which the weak do not return—before a revolution within the molecules of the brain will allow us to listen with open response.

OPENNESS, CLOSEDNESS, SPEAKING, AND LISTENING

In introducing the illustration of Marcus Aurelius we noted that speaking ought not be identified with closedness and listening with openness, though in class discussions we have found that students often make this connection. Both speaking and listening can be closed or open. Yet there are important causal connections among the variables that should be examined.

In Figure 8, the continuum open-closed can slide up and down. In the example cited the person is about 75 percent open to himself, 50 percent open nonverbally and 25 percent open in his words with others. (It should be clear that the 75, 50, and 25 have no meaning aside from the relationships we are making among listening, nonverbal speech, and overt speech.) There are three significant points suggested by the diagram. One, a person is most open to himself, less open in his nonverbal response, still less so in the words he says to others. We cannot say to others what we cannot say to ourselves. Two, the nonverbal, standing as it does between our listening and our speaking, is the monitor of the discrepancy between what we believe and what we say. And any good observer is always watching for the congruity between *what* the other person says and *how* he says it. If the two codes match closely he assumes the person is saying aloud what he says to himself. If they are not congruent, he questions what he hears, and he says to himself, "What is he saying to himself he chooses not to say to me? Can I trust him?" Third, although one cannot say to others what he cannot say to himself, yet he can "force" himself to say to others what he is reticent to say, thus increasing his capacity to speak to the self in greater depth. Perhaps the dynamics of the confessional best illustrate the point. Saying to the priest what before we could only say to the self, and receiving acceptance from the other, lowers the internal barriers, and the confessor can now involve himself in more honest talk with himself.

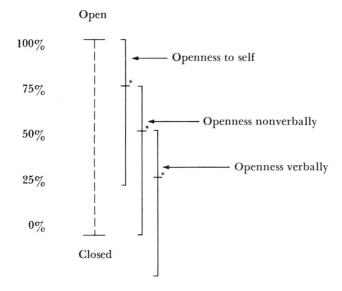

*—— = Position of a person on each sliding scale

FIGURE 8

Once again we note the fascinating union of speech and listening in the functions of communication in human life.

SUMMARY

And so what have we tried to say in this chapter? That research, our own life experience, the revelations of men who have lived full, if sometimes warped, lives, and the insights of great literary artists, tell us that our determining tendencies begin in our earliest impressions from our parents. The best of all lives are probably lived by those who hear positive messages from early in life and thus hold to an optimistic view. If a person, in the main, turns negative in his expectations, someone is going to get hurt—himself, others or both. And the desire to turn from an accent on the negative to an essentially positive view will probably be spawned, if it comes at all, in a period of deep emotional upheaval.

OBJECTIVES

The material and the assignments of this chapter are designed to help you in three ways:

 I. To become more aware of your stance toward life.

 II. To understand the experiences in your life that have created your present stance.

 III. To become more open.

EVALUATION

In order to check the impact of this chapter and the remainder of the course write in your journal, or elsewhere, a discussion about your religion, politics, financial status, sexual attitudes, body image, intelligence, other people in your life including your parents, brothers, and sisters, before you read the chapter. Then at the end of the course do the same thing, comparing the two statements on openness.

As a second way of evaluating your openness, if you have the Personality Orientation Inventory by Everett Shostrom available to you, note in particular your time competence ratio and your support ratio. Indeed all the scores are pertinent. The higher the scores the more open, the lower the scores the more closed you are to your own experience.

DISCUSSION QUESTIONS

1. *Objectives I & II* Discuss with your classmates the relative values of being open and closed. What are the best arguments for and against either posture?

2. *Background to all 3 Objectives* Discuss the difference between reception and perception.

3. *Background to all 3 Objectives* Discuss the meaning and significance of the following illustrations in the chapter: Marcus Aurelius, modern political leaders, *Too Late the Phalarope*, and *King Lear*.

EXPLORATIONS

1. *Objective I* Agree with your classmates to see a given movie at your neighborhood theatre on a given date. Let each of you after seeing the movie prepare a statement about its impact on you. Give a speech in class about that impact. Listen to the other speeches. Write a paper, or make a journal entry, comparing your stance in life with that of another student in the class.

2. *Objective I* Do the assignment above, using a novel instead of a movie, a novel such as *Native Son* by Richard Wright, *Too Late the Phalarope* by Alan Paton, *Siddhartha* by Hermann Hesse, *A Death in the Family* by James Agee, *Notes From the Underground* by Feodor Dostoyevsky.

3. *Objectives I & III* Rank order the following values: honesty, fairness, love, hope, beauty, nonviolence, pleasure, responsibility, commitment, freedom. Give a prepared speech to the class explaining why you put the top one and bottom one in their respective places. Listen to the reasoning and the experiences cited by other students when they do the assignment. Make your comments about the striking differences in a paper, or your journal.

4. *Objective II* In order to increase your ability and to test your ability to see the relationship between historical events in a life and the way they prepare the person to listen as he does in a later situation read the following stories told the authors in interviews. The six students interviewed are those who made the comments about money on pages 100 to 102. Match the comments on those pages with the six stories cited here. (You may check your ability to sense these relationships by noting the correct matching on page 106.) Following are the stories:

(A)

I hate my father. I know he means well and he wants me to be a good person. He would do anything for me and yet he doesn't trust me. He was raised by an older sister who was the madame in a brothel, and boy! Is he strict! Ever since I was a small girl he has lectured me by the hour about being a good girl. I have to account for all my time and every penny I make or spend. I am not supposed to use cosmetics and he'd die if he knew I smoke. I really am not only under suspicion all the time but in order to keep from being lectured to the point where we get in a fight, I just have to lie to him much of the time. I am not supposed to date so I have to tell him, when I'm home, that I have to study at the library, in order to go out with a boy. I hate it, but what am I going to do? I like boys, and I don't want to end up an old maid.

But this disturbs me very much. I know he pulled himself up out of the gutter and I know I am terribly important to him, and I know he's afraid. Besides, I learned from my aunt, and a neighbor, too, that he

tells how proud he is of me and how well I am doing in the university. He never had a chance to go to school. I feel like a heel.

Here is the story of one of the men:

(B)

Sure you have to have money to buy things but I don't want to be a slave to it. When I came back from Vietnam, my dad wanted me to buy a new car. We looked at six different makes and finally I said, 'Let's not do this, Dad; I don't want a new car.' My car is only a three-year old and it runs good. I don't want to get in the rat race. In fact I want to forget about money as much as I can. I'm afraid of being trapped. I guess I always wanted freedom and now especially after having spent two years in the army. I guess I'm trying to get discharged from the economy now. The best way I know to do it is just not to think about money.

Maybe I'm an escapist. That's what the therapist who works on my stuttering says.

In her interview one of the girls made a number of comments that indicate this same flight need. But the twist of feeling is different and thus her listening set is different. Here's what she said:

(C)

I have a great need for independence, mostly independence from the culture, I guess, and what bugs me is that much of my need comes from my fear of being trapped.

Maybe you won't understand this, but I resent my parents for giving me everything I want. It puts me in a hell of a spot. I take what they give me. I'm glad to get it and I thank them. Then I hate them. I don't want my parents to buy my love. My love is not for sale. Besides, they are unconsciously trying to make me an addict of things. I want to belong to myself and other people. As a child, I was a loner, a spectator. My mother would ask Mary over to play with me because she thought I spent too much of my time alone. Mary would usually end up playing with my brother because I really wasn't interested in her or anybody else. But I am now. I've got to be alone a lot, but I really want to be related to others, too. I swing back and forth. . . .

I have made the most remarkable discovery. I've been booby-trapping my parents. Instead of making decisions, like joining the Peace Corps and then announcing it to my parents, I ask their advice, knowing they will insist upon my following their decision. That way I don't have to take the responsibility for my own decisions. I am powerless to resist them, because I don't want to make decisions. To be responsible scares the hell out of me. . . .

After that story of distress let us move along to a more peaceful sketch. Which of the six respondents do you think the following might be?

(D)

My father is an Irish immigrant who had a ninth-grade education before he went to work. He went to night school until he was a junior in college. Now he's the purchasing agent for a paper mill. My mother died when I was seven and my father was left with four of us to raise. In two years he married a woman who was a mistake for she didn't love us kids and tried to get my father to give us away. Five years later she died of cancer, but during those years my father was very gentle with us. We were poor as church mice but I always felt comfortable in our house because my father never punished us and always bragged to everybody about anything we did. Actually he has always spoiled us. Last semester I made the Dean's list and he told half the world. When I was sick part of a semester two years ago, I brought home a 1.8. He looked at the grades and said, 'I hope this doesn't trouble you; it was the best you could do when you were sick.' My father's a great guy.

All of us kids are business-minded. I guess because my father is that way. We all know the paper business. In recent years he has taken each of us on business trips and he spends hours discussing his work. I think I could run a paper mill.

I'm a marketing major and I expect to be a buyer, maybe of women's clothes. But most of all I want to get married and while I love nice things, I don't really care how well I live so long as the marriage is good. The important thing will be that my husband does the work he loves. After all, one-third of a person's life is spent in his work.

Consider this one:

(E)

I am a second generation American-born citizen whose grandparents came from Poland. And I am one of the first among my relatives to go to college. I've got to make good. I've worked ever since I can remember. Had a paper route when I was small and worked every summer. I like to work and I work hard. Last summer I was in a construction gang and made $4.50 an hour, the most I ever made. The boss told me I did twice as much work as some men and I could have a job any time I wanted it.

But it takes lots of money to keep me going. Dates and my automobile keep me pressed. My folks don't say too much because they pay only for a small part of my education. My dad doesn't make very much, but it's not his fault. One of his legs was hurt many years ago in a fall and he has had a series of operations. He's in constant pain.

Maybe it's because he could not be the sole provider of the family—my mother has always worked in a factory—that makes me want to

make good money. My mother's working has always disturbed my dad and he can't do anything about it. Come to think about it, most of the conversations in our house have something to do about money. My room's just above the kitchen and, almost every night of my life, when I have gone to bed I have heard my folks in the kitchen talking over a cup of coffee before they go to bed. It's always about how much somebody's making, or how a neighbor is wasting his money, or how my uncle is shrewd in the way he saves.

Here is the last of the group of stories:

(F)

I am 22, a junior, a management major who has been a pre-law major, an engineer, and a pre-dental major, in four colleges. I have enough hours to graduate now but I got to go another year to get enough credits for my major. I'm supposed to be a scatterbrain, but I'm going to make good—damn good, just like my dad. He's an administrative engineer, about third or fourth level in management. I've got my goal set for plant manager. Then as I get near that I'll decide what to shoot for beyond that.

I've got to be a success. That's my goal in life. Ever since I was a kid my dad has always criticized me. I never did anything right. He's a perfectionist. Now I know he's right but all my life he's bugged me. One time I tore a '59 Chevy down to the block and rebuilt it and when I finished, it ran like a top. He heard a hum in it and by God that's all he could hear. Always in school I was the troublesome DeChaine kid. You know—the teacher in the room ahead heard about me before I got there.

Until I was in the eleventh grade everybody had me spotted as a drop-out. Then I said to myself one day, 'No, by God, I'll show them. I'm going to be a success.'

You said to yourself, 'I'm going to be a success?' we observed.

Yeh, no. Really it was mostly my girl. We were very close. She said, 'Why do you let them all bug you? Why do you believe them? It's your life you know, not theirs. Why let them tell you what to believe about yourself?' I should have married her. She made me believe in myself. A neighbor man had something to do with it, too. If our family went away, he always invited me in for dinner—always was good to me. He had been in a whole series of accidents and was really handicapped —one arm gone—but I never heard him complain. I say to myself, 'OK, Jim, get your college education, but if you become half the man old John is, you'll be doing all right.' Some way old John had something to do with my decision to make good.

This is how the statements on pages 100–102 match up with the interviews on pages 112–115.

1	F
2	C
3	E
4	A
5	B
6	D

5. *Objective II* Give an autobiographical speech showing how the events of your life have led you to your present attitude toward the future. What do you expect to achieve in your life? What price do you think you are willing to pay for specific objectives? Have the class evaluate the congruence between your expectations in life and the events you say have shaped you. In this assignment you will need to evaluate the impact of your father, mother, brothers, sisters, friends, teachers, church. Note in the speeches of others what seem to be the greatest forces in life.

6. *Objective III* Rank everybody in class, including yourself, on a scale measuring the tension between openness and closedness, 1 being the most open person. Obtain the average rank for yourself and compare it with your own ranking. Are you as open, in your own judgment, as your classmates see you? What are the values and emotional states of the persons ranked most open by the class?

7
Environmental Impact

And I have known the eyes already, known them
 all—
The eyes that fix you in a formulated phrase,
And when I am formulated, sprawling on a pin,
When I am pinned and wriggling on the wall,
Then how should I begin
To spit out all the butt-ends of my days
 and ways?
And how should I presume?

*T. S. ELIOT**

Man is tuned to every message he hears, by forces in his environment so strong that very often he does not, whether he knows it or not, independently choose what he will listen to or what he will remember—especially if he does not understand those environmental forces. Each of us emerges as a creature either relatively open to the signals around him or relatively closed to them, as a result of forces that, as we have seen in the previous chapter, reach back into the early years of his life. In this chapter we want to explore some of the environmental factors that shape our communicating and to examine the way they work.

F. C. Bartlett's classic study of cultural factors in remembering provides a starting point.[1] He had heard stories about the prodigious listening memory feats performed by Swazi herdsmen in Africa and wanted to

[1]Reported in Eugene L. Hartley and Ruth E. Hartley, *Fundamentals of Social Psychology* (New York: Alfred A. Knopf, 1969), pp. 42–43.

find out what might be at the bottom of such extraordinary powers. In a series of memory tests, using subject matter of a sort contained in conventional memory experiments, he 'found no significant difference between the performance of the natives and a sampling of Europeans. But he did find impressive capacities in the natives when it came to particular kinds of information. For example, he reports one herdsman who was able to reproduce a list of about twenty cattle bought by his employer during the year, along with the price and distinguishing mark of each animal as well as the name of the individual from whom each animal had been purchased. Fellow herdsmen could recall, in surprising detail, individual characteristics of their livestock over long periods of time. In short, the prevailing talk of the environment makes us listen for particular details. What is important in a culture is attended to and remembered with great clarity. Who does not have a nephew, in this sports-minded American culture, who can repeat almost play-by-play the account of a football game which he watched on TV?

But the environment does not affect communication through memory alone. It apparently does important things to the very way we organize incoming signals. E. L. Horowitz[2] showed school children, grades 1 to 10, pictures of over a dozen different national flags. He asked the children to choose the "best looking" flag. And he discovered that among first-grade pupils the Siamese flag was the most popular. It was a colorful flag, with a white elephant on a red background. But by the time he got to the tenth graders he discovered that they were all choosing the United States flag. It would be interesting to ask, "What made the attractiveness of white elephants on a red background fade for those youngsters?" Whatever the answer to that question might be, it seems clear that something important led them to perceive things differently as the years went by— and that "something" is suspected to be their growing up in a nation state.

So strong is the cultural grip on a person that he may insist on distorting what he thinks he hears even in the presence of efforts to give him a clearer picture of the "realities." According to anthropologist Edward T. Hall[3], it was long thought, in parts of Latin America, that a man could not possibly suppress the love urges when he was alone with a woman. And it was considered, likewise, that a woman in such circumstances would find herself unable to resist the man. Hall says,

> Americans who were going to Latin America had to be cautioned that if
> they let themselves get into a situation with a member of the opposite sex
> where something could have happened, it would be no use to tell people

[2]E. L. Horowitz, "Some Aspects of the Development of Patriotism in Children," *Sociometry*, 3 (1940), 329–41.

[3]Edward T. Hall, *The Silent Language* (New York: Doubleday & Co., 1959), pp. 66–67.

that it had not. The Latin response would be, "After all, you're a man, aren't you? She's a woman, isn't she?" The point the Americans couldn't get through their heads was that these people really considered that men and women were constituted differently from the way an American views them. In Latin America both sexes expect their will power to be provided by other people rather than by personal inhibition.

It is no secret that Americans have been getting into all sorts of trouble in Latin America for a long time. But what is eloquent in Hall's observations is the apparent power that a culture exerts over what a person in that culture will expect and, therefore, hear—or see, or know.

In our culture three forces seem to stand out as especially potent influences on our communication: (1) the peculiar reference groups of our social life, (2) the electronic technology peculiar to this age, and (3) the impact of nuclear capability.

After discussing the character of these three forces with particular reference to college students we should like to examine the tension in the institutions of our culture between the inclination to open a person to more comprehensive listening and the opposite inclination, to close him to other views. Let us turn our attention first to the power of reference groups, the significant others in shaping a person's communication.

REFERENCE GROUPS AND COMMUNICATION

We all recognize in our everyday experience how, when we speak, we select our language and color it in different ways for different people. The listener profoundly influences what the speaker says. The sense of this observation can be caught in one's response to the question, "What would you think if you didn't know what anyone else thought about what you thought?"

On the other hand, and at least equally important, as a listener, our response to the speaker is shaped in part by the way we imagine others whom we respect would listen to his message. It may be that the single most important influence on our whole being is, as some sociologists have suggested, the audience—imagined or real—before whom we speak and with whom we listen. "The mind," said sociologist C. H. Cooley a number of years ago, "is not a hermit's cell, but a place of hospitality and intercourse. We have no higher life that is really apart from other people. It is by imagining them our personality is built up."[4] A paraphrase of Cooley applied to communication would run like this: "It is by imagining how significant other people in our lives would react that we shape our communication."

[4] C. H. Cooley, *Human Nature and the Social Order* (New York: Charles Scribner's Sons, 1902), pp. 58–62.

Such a statement takes on vital meaning for one of the authors when he reflects upon a conversation he had recently with a candidate for a teaching position in economics. Said the applicant, at one point in the interview, "I want to indoctrinate students in the benefits of the private profit system. Too many of these kids don't have any idea how important it is for us to protect the system that has given us everything we have." The listener found himself imagining how that speech would sound to his liberal colleagues on the faculty, to the activist students in his classes, to friends in his professional association. And those musings, in turn, determined how he was dealing with the message he was receiving. He listened as he thought the significant people in his environment would listen.

The phrase used to focus attention on this phenomenon, as we have noted, is the "reference group." One writer defines a reference group as "that group, real or imaginary, whose standpoint is being used as the frame of reference by the actor."[5] And it should likely be added that the group becomes especially significant when one is evaluating himself or when he is developing attitudes. The way we seem to develop a self-concept is something like this: We try out a behavior, or an idea, or an attitude. We scan the way important groups in our life would react. We retain or reject the behavior or attitude on the basis of the fit between our choice and that of the reference group. The teenaged girl who is overheard telling her friend on the phone, "I couldn't possibly go to the party. All of my blue jeans are in the wash," is responding to a reference group. The man who insists on displaying only "original art" in his home (no reproductions allowed) may be responding to a reference group —the respected artists among his friends and acquaintances.

You will notice that reference groups and membership groups need not be synonymous. There is many a church member for whom the church is not a reference group; that is, for whom the church is not the screen through which he filters his experience. And it is a source of embarrassment and frustration for labor union officials to note that members of their unions sometimes do not use the "standpoint" of the unions as their "frame of reference" when deciding which political candidate to support. On the other hand, people often listen at the command of reference groups to which they do not belong. People wanting to move up the social and economic ladder may, for example, be strongly influenced by upper middle class attitudes and values, even though they do not belong to the upper middle class. The point is that groups which one considers important have a profound effect on his perceptions, and choice of group rests on aspiration as well as membership.

[5] Tamotsu Shibutoni, *Society and Personality* (Englewood Cliffs, N.J.: Prentice-Hall, Inc., 1961), p. 257.

Such reference groups, then, have a fascinating effect on all the dimensions of communication. They dictate the way we talk, and the way we talk influences the way we are listened to, and the way we are listened to in turn determines the way we listen to others. President John F. Kennedy and his brother Robert were listened to in a way that made them idols and inspired their listeners because the president and his brother often spoke as if the great men of our past—Washington, Jefferson, Lincoln—as well as the unborn of the future, sat in the wings of the audience. Their reference group included all mankind. And in so speaking their listeners were inspired to sit beside and rub shoulders with the great people of history. Thus inspired, the living audience reinforced the Kennedys' inclination to be guided by the ears of all men. One senses this particularly in the public speech and the changing personality of Robert Kennedy following the death of his brother. And although one's imagination may be at work in an analysis such as this, one can not help but wonder if part of President Johnson's loss of leadership was not due to his inability to be guided in his public speech by the great reference groups of all time. In any event, the point of consequence here is the realization that for each of us our unseen audience (even in a parked car on lover's lane) guides the way we listen to another person speak, and our unseen audience, guiding our own speech, determines in large measure the way we shall be listened to, thus teaching us the way to listen.

The Family as Reference Group

Obviously, the family is a particularly powerful reference group in the molding of communication. Its role emerges in stark outline when a a study is made of the way some of the "extremes" in our society respond to their families. One such group is made up of the most alienated young people—youth who have dropped out of college and turned away from any conventional occupation, rejecting the widely-accepted values of their society. Kenneth Keniston has studied a number of such persons in depth and has reported the syndrome he found. About the family he says, "No other social institution plays a comparable part in shaping the motivations, the adaptations, the inhibitions, and the values of the young."[6] regardless of the way they turn. To support that conclusion, Keniston cites the effects that seem to flow from the dramatic changes in the modern family. It has shrunk, not just in terms of the number of children, but in terms of the number of members directly related to an individual's life. In primitive tribes, and in the early life of this country, and even now in many Asian countries, the family includes grandparents, great-grandparents, many uncles and aunts, and cousins of various magnitudes.

[6]Kenneth Keniston, *The Uncommitted* (New York: Dell Publishing Co., Inc., 1965), p. 309.

The modern American family, in contrast, is rarely large enough to include more than the parents and the siblings. It was typical of the alienated youth Keniston studied to report that their images of their grandparents were vague, albeit usually very pleasant. They simply didn't have much contact. They became communicators used to living in the presence of fewer and fewer depth relationships, vulnerable in a new way to creeping alienation.

In the Keniston study two other facets of family life emerged as special sources of alienation: the dependence-independence problem every child is asked to resolve, and the masculine-feminine balance he must somehow learn to establish.

The alienated American middle-class child, so this theory goes, usually grows up in a comfortable environment. His parents provide him all he needs. They protect him, admire him, have fun with him. At the same time, they (especially the mother) try to teach him to be independent, try to get him ready to carry his own responsibilities. As he moves through adolescence he is faced with choosing between the warm, comfortable, nourishing dependency of childhood and the cold, impersonal, demanding independence of adulthood. Keniston points out that the contrast between the two choices, for those so protected, is one that makes adulthood very unattractive.

> Among the alienated, of course, this contrast between childhood and adulthood is fundamental and extreme; the most basic theme of their lives is the loss of their maternal paradise; their enduring desire to regain it, and their rejection of conventional adulthood because it offers so little of the warmth, caring, intimacy, and fusion they desire.[7]

It is not difficult to imagine how "closed" the listening must be if one is losing this internal battle, or how "open" it may be, too, if mature independence is attained.

The other force that looms large for Keniston in explaining the uncommitted is the conflict between masculine and feminine inclinations in life. It is significant that in the early history of the alienated youth studied there appears a dominating environment of women—very few men. These alienated young males, rarely bitter about their fathers, simply have not had enough contact with them to develop the identification with them that is "normal" in our culture.

This statement from one of them, is typical:

> My father has always been more or less disinterested, except when an important decision or some breach of discipline came up. Recently, he has

[7]*Ibid.*, pp. 304–305.

tried to become more of a friend or "Dad," but I am too independent and unemotional, and the result is always a miserable failure.[8]

Overall, the alienated have very little to say about their fathers, much more to say about their mothers. They are tuned to listen to the "feminine" messages of life (the dependency messages). Tuned to love (mostly erotic), the alienated young man hears only corrupt discord in straight society and yearns for the rhythms of the womb. Sexually, he either moves toward homosexuality or toward a violent assertion of his masculinity (as though to prove he has not been victimized by the feminine force). In either case, his capacity for "opening" to the messages that might contribute to his growth as a more complete person is diminished.[9]

On the other hand, the activists, the involved youth reported in Keniston's companion study, *Young Radicals*,[10] were much more directly identified with their parents, and the males were impressively more likely to emulate the image of the father than was true for the alienated.

Moreover, the parents of the activist were usually highly "principled" people who had used moral injunctions, that is, strong statements about what is right and what is wrong, as their chief means of directing their child's behavior. And thus the young radical had come to live by these admonitions. His motivation was, however, also excited by a kind of ambivalent feeling about the father who, while admired and loved, was also conceived as less powerful and more ineffective than youth's ideals demand. Sometimes this ambivalence about the father proved to be a consequence of a parental relationship in which the mother dominated. The ambivalence was also, apparently, excited by the father who harbored self-doubts. Whatever the source of ambivalence, in the activist group the young male carried out the ideals of his father because from early in life he had been accepted as competent, and he trusted his own feelings, thoughts, and convictions sufficiently to put them to the test of action. The Jewish family, with its emphasis on freedom, and with its lively acceptance of conflict as "natural," seems to have fostered this kind of healthy openness in many of its offspring.

The family is, obviously, not the only significant reference group, but its influence must not be understated. Margaret Mead did some work for the United States government, during World War II, on the tensions that arose continually between English and American officials who, it was hoped, could find ways of working together. She came to the conclusion that much of the abrasiveness could be traced to the differences in child-

[8]*Ibid.*, p. 116.

[9]For an excellent elaboration of this theme see *The Uncommitted*, Chap. 10.

[10]Kenneth Keniston, *Young Radicals* (New York: Harcourt, Brace, Jovanovich, 1968).

rearing in the two cultures. In the English family, it was the father who talked and the son who listened. The British lad grew up identifying with a confident, articulate, reflective father. At the American dinner table, on the other hand, junior chatted along willy-nilly, father tolerating anything but the most blatant disturbance. And the American boy developed with a great sense of freedom to express himself, but with an insecurity born of the fact that he had no model on which to rely. The result was that he was often blustery, given to overstatement—impatient and impulsive. The account of Dr. Mead's efforts asserts that once the diplomats involved had come to an understanding of their cultural differences they found cooperation easier. Our point is that as these men attempted to communicate they were doing so in the presence of their identity in the family in which they grew up—and that made an immense difference.[11]

Race as a Reference Group

In recent years we have begun to learn the meaning of race as a reference group. That early white Americans could allow themselves to enslave blacks (not other exploitable whites) as they did, is a phenomenon of American white personality that not only scars our history but tells us much about the environment out of which we, who are white, were born. Even now the mass of white people cannot understand the responses of the black man to that history. The black man's behavior is in the main perceived as unpredictable, irrational, and irresponsible, humorously perceived in the following black man's story:

A brother died and went to Heaven. He was appropriately outfitted with white robe, halo, and wings. The wings fascinated him; he fluttered them, stretched them, and began tentatively to fly. As he gained experience he tried long swooping glides, he flew high, he flew low, he flew backwards, he flew upside down, and finally, he made dive-bombing attacks on the peaceful citizenry below. Swoosh—within inches of the golden streets. Down over their heads he came scaring the hell out of cherubim and seraphim. Finally his antics were too much for the management to bear and he was grounded, his wings removed and locked up. As he sat forlornly on the curb a black brother came up.

"Now ain't you a bitch—the way you were performing and carrying on. I told you you were going to lose your wings. If you'd listen to me you'd still have them. No, you had to perform—and now here you sit grounded with no wings!"

The miscreant looked up, "But I was a flying son of a bitch while I had 'em, wasn't I!"[12]

[11]Hartley and Hartley, *op. cit.*, p. 52.
[12]Excerpted from BLACK RAGE by William H. Grier and Price M. Cobbs (Basic Books, Inc., Publishers, New York, 1968), p. 95.

Two black psychiatrists, William Grier and Price Cobbs, point out in *Black Rage*, from which the above story came, that often and naturally, in the presence of extreme frustration and despair, the organism is tuned essentially to messages that offer relief—to any promise of pleasure, any lead to an exhilarating moment, any open road to momentary power. The black brother picked up the opportunities the moment offered him. The torment of the black man as listener in a world dominated by white voices must be excruciating. Repeatedly Grier and Cobbs see patients whose worlds are coming apart because they must listen to too many conflicting voices at once. And always as they listen there are opposing reference groups peering over their shoulders, demanding that they be on the side of the angels—that is, on all sides.

A common pattern, for example, is the case of the black man who needs to express himself aggressively, vigorously if he is to make his way in a competitive, white-dominated society, but who has been taught by his mother, until it is in the very marrow of his bones, that he must be a "good nigger," that he must adapt to the white man's world if he is to achieve or even survive. The struggle between reference groups becomes his private battleground. As he listens he imagines how his black brothers would size up his response; he feels his mother's presence; he can't shake off the material pressures of the white culture (all of those things he has wanted and never had), but along with them go the expectations and norms of the white reference groups too. It is small wonder that he ends up sometimes in deep despair and says to himself, "You're black, and you're no damn good. Don't try."

A black girl in one of the author's classes broke down one day in the midst of an explanation she was making to a predominantly white group of students, and left the room crying. In a conference later she said the sudden weeping was inexplicable to her at the time. But the more she thought about it the clearer it seemed to her that she was caught by forces deep inside her. She had been telling the class about the takeover of a building on the campus in which she had participated, along with other black students. She said she was proud to be part of that action, that she couldn't have stayed away. She found herself feeling very much alive among those who represented a primary reference group in her life. Yet in telling this experience to a white group, she was conscious of a deep-seated gentleness that sprang, she thought, from her early years at home. Her mother, with whom she identified closely, had displayed a consistent compassion for all humans even in the face of great pain and struggle. The girl therefore found herself disturbed by the overtones of violence in the demonstration and the white reaction to it. "I guess if it ever came down to the decision: 'Either don't hurt someone, or do something for your race,' I wouldn't be able to choose to hurt." There seemed

to be struggling, inside her, the race as reference group *vs.* her mother and early home life as reference group. What would one hear under those circumstances?

We also recall the black girl in class who told of the struggle within her, and at home, in her decision to wear her hair natural. "My mother and aunt argued it was bad for me to let my hair grow natural. And when I resisted, washed my hair, and took the bus to the hairdresser's I remember with terrible vividness how I felt everybody was staring at me scornfully. After my hair was cut and shaped I felt worse. All the way home I fought back the tears. Only after I got home did the change begin to come. My mother stood back, took one look, and said 'I like it. It's beautiful. You're beautiful, my child.' "

The white person, of course, is also trapped by the conflicting reference groups in his life as he tries to listen to the black. He may "lean over backward" to hear what he thinks the "progressive," "liberal" elements of the culture would like him to hear. He may start listening at a high level of emotional involvement if his reference group is made up of campus activists. He may exaggerate or distort messages to fit his stereotypes if his reference group is made of staunch defenders of the status quo. But as the black cannot escape his blackness, neither can the white escape the history of his whiteness. He cannot listen except in the presence of the white race as reference group.

It comes as no surprise, therefore, to discover that one study of white college women[13] showed that the process of acquiring more favorable attitudes toward black people involved both dis-attachment from previous reference groups unfavorable to blacks and attachment to new reference groups favorable to blacks. In short, one is not likely to receive a new set of messages so long as the filters provided by his present reference groups are resistant.

The Peer Group

To feel we belong is to set the basic condition for the exchange of information with understanding. Perhaps outside the family the most powerful group shaping our communicating is that made up of those of our own age in the socioeconomic class with which we identify. This includes our friends, but it extends to all those close to us in age, social ideals, and economic status. In college, alienated, radical, or somewhere-between-students dress much alike and groom much alike as a badge of peer identity. Thus they get to feel the same way about their bodies, at least. Perhaps equally important, the peculiar language of each younger

[13]Leonard Pearlin, "Shifting Group Attachments and Attitudes toward Negroes," *Social Forces*, 33 (1954), 47–50.

generation separates it from the language of the family. Older conversants are supposed to be able to translate this language, but they are frowned upon if they use it.

Lest we perceive this response as an idiosyncracy of the young adult, it should be noted that the college professor is likely to become upset, too, by the student who adopts the language of the professor *with ease*. The professor will tend to be pleased by his protege who *reaches* for professional language, providing he shows a certain discomfort, if not awkwardness. But if the student talks in professional language with assurance, the professor is confronted with the alternative of accepting the student as something close to a peer or putting him back in his "rightful" place. Even the graduate student who uses the language of the professor with authority is likely to be perceived as distressing. When it comes to communication between teacher and student, it is almost as if there were an unwritten code demanding translation of each other—each (of necessity) listening in the language of the other, speaking back—at the command of the other—in his own tongue.

But the transgressions of speaking in the language of the other group are held in check, not only by the other groups but even more tenaciously by the peer group to which the speaker belongs. Professors punish professors who adopt the language of youth, and students punish students who talk like professors. We are thus not only enforced to listen and speak as our peer group does, but in doing so to perceive the world and its future as our peer group does.

What difference might that make in the communicating of today's college student, as compared with that of any previous generation? The student's peers, who came, early in our history, only from the homes of the wealthy and privileged, now include many from the most impoverished homes and depressed neighborhoods. Exposure to a broader spectrum of social conditions was almost certain to arouse the students' social concern. Seventy-five percent of our college students, according to one study, say they feel morally obliged to do something about social injustice.[14] Although only one-third commit themselves to involvement, by way of discussion groups, protesting, or teaching some youngster who needs special help, 85 percent say that involvement is the best teacher. And the thrust of the most active students on today's campus has great power, in large measure, because almost all students emotionally support the activist.

Moreover, the very increase in the size of the college population, with the average age in our society dropping to 24, makes the voice of the

[14]Jeffrey K. Hadden, "The Private Generation," *Psychology Today* (October, 1969), 32.

young people a new power in the social scene, and they know it. More-over, their power has been increased immensely by the results of the ag-gressive demands of black students. In the past, tactics of intimidation and strike power plays would have met with expulsion from colleges and universities. But the liberal white men who direct many of these institu-tions are deeply conscious that the black man must take his place as equal in the social order, not only for his sake but for the sake of the awaken-ening of the white man. He knows that he must tolerate the hate of the black man until the black man has worn out his anger and moves to more self-confidence and to more faith in the white man. Thus the thoughtful white man knows he cannot escape the penalty of his forefather's arro-gance and exploitation. So he listens to the black student and concedes what he can. The white student, riding the coattails of the black student, makes similar demands. The opening of the university to a wider spec-trum of youth in America, and the peculiar role of the black student in college, is changing the listening and the speaking of all college youth.

The Erosion of Empathic Authority

Not only is the college student peer group changing the communicat-ing of its members as a consequence of its changing size and character, but it is also changing because it is tuned less and less to the values of its elders, and this largely because the elders have been gradually, if inad-vertently, eliminating themselves as models of personal authority. Con-sider some of the ways this has come about. Over the past century the industrial system has taken more and more fathers out of the home and field to factory or office. Working long hours separated from his children the father has become a stranger to them. Strangers are not models. Moreover, in our experience, one-third of the students in college are from divorced homes, or homes in deep distress. Such parents are not mod-els, either. And the very breakdown of such a large minority of family units is inevitably related to the college students' doubts about the basic character of older people. All the changes in the environment that we have discussed, and will discuss, in this chapter, have created great self-doubt among the generations still in authority.[15] What have we wrought? The very self-doubt and stammering of authority has eroded the model of authority. Moreover, since 1945 the university has eroded the power of the professor—and the older generation—as it substituted for him a graduate student teacher. This act alone has changed the basic feelings about a college education. Working together, all these forces tend to pro-duce a student population relatively alienated from the feelings and

[15]T. George Harris, "The Young are Captives of Each Other: A Conversation with David Riesman," *Psychology Today*, October, 1969, 28.

aspirations of older America, and as it turns out, deeply concerned about humanistic values. The demand for relevance is a demand for education that deals with existential anxiety. "Get your stuff together" is the present phrase expressing the central determination of a college student out of empathic touch with older models of personal authority, captive of peers without experience, and driven by confusion, to confront authority. A generation that does not provide a close relationship with its children develops relative strangers with a new set of values for the society.

ELECTRONIC TECHNOLOGY
AS AN ENVIRONMENTAL FORCE

Also, drastic things are happening to the communication habits of today, particularly among the young, as a consequence of the overwhelming and unpredictable impact of radio and television. It is easy to underestimate the psychological climate created by intimate contact with the mechanical person. Most Americans are listening to, or are at least in the presence of, blaring radio and flickering television several hours a day. The folklore about these electronic monsters is that they have injured the communicative capacities of our young people. This is not so if the listening test for immediate recall is the criterion for judging. One of the authors studied a group of grade school children in the little rural town of Topeka, Indiana. Half of his sample was made up of Amish children who, by virtue of their membership in a sect that rejects the accoutrements of a materialistic society, had neither radios to listen to nor television to watch. The other part of the sample was composed of non-Amish children in the locality who had both radio and TV accessible and who listened to them for five to six hours a day. He discovered, as he had hypothesized, that the children exposed to TV were, indeed, significantly better listeners.[16] Exposure to a constant flow of messages apparently improves the capacity to respond to a variety of messages.

But the implications go deeper than that. The medium, as Marshall McLuhan[17] never tires of pointing out, is the message. That is, it is the very presence of television (regardless of the program it might be carrying at a moment) that makes the difference. It makes a difference because it exposes us to instantaneous experience. It provides that experience not only to us, but to many of mankind all over the globe. It creates for us, to use McLuhan's term, "A global village." Men everywhere watched

[16]Charles T. Brown, "Three Studies of the Listening of Children," *Speech Monographs* 33 (June 1965), 129–38.

[17]Marshall McLuhan, see especially *The Gutenberg Galaxy* and *Understanding Media*.

man's first walk on the moon—knowing instantly what could have been known only by those directly present before TV.

There is a sense in which the arrival of television has forced us to attend to messages we might easily have ignored or put at a distance before. It confronts us steadily, inescapably, with riots in the streets, struggles for political power, intimate and candid exchanges between fathers and sons, grief in process.

> The shock of recognition! In an electric information environment, minority groups can no longer be contained—ignored. Too many people know too much about each other. Our new environment compels commitment and participation. We have become irrevocably involved with, and responsible for, each other.[18]

No one can know whether this emerging phenomenon of involvement will prove our undoing or our salvation. But from the rising tide of human turmoil all over the world it is plain that voices are being heard now that were never heard before. A recent traveler to Thailand tells of emerging from the edge of a deep jungle to look out over a rice paddy, and catching, suddenly, the strains of music. It startled him. Then he noticed in the paddy a native boy, riding on a water buffalo hooked to a primitive plow—the boy outfitted with a transistor radio! The electronic part of our environment is no longer the luxury of the wealthy; it is a part of the atmosphere on the planet Earth, exciting change and constantly at its work.

There are other profound effects of electronic communication; most particularly a significant revolt against its dehumanizing impact. The media have a tendency to bleach human life as they present it; people on radio and TV are not quite real, only sounds and images. Moreover, media experience insulates the viewer-listener from the vitality of personal experience. If there is suffering or death on a street in Bangkok, the viewer sees it only for a few seconds. He is spared all but the minimal contacts with it. He sits passively and watches. But there comes a time for many when the urge to make contact with reality can no longer be put off. Said a Congressman, whose daughter had left a very comfortable existence to live in near-poverty in San Francisco, "I wonder what she is trying to tell me?" And as he pondered the question, he found himself answering it: "Maybe she has decided she wants to actually feel life—to touch it, try it, test it, make her own way through it." That kind of profound search for "reality" may be one of the *leitmotifs* in our kind of world. If the older generation cannot understand their young, it may be

[18]Marshall McLuhan and Quentin Fiore, *The Medium is the Massage* (New York: Bantam Books, Inc., 1967), p. 24.

that the impact of feeling the miseries and disorders of the earth, once one has settled into life, is something quite different from feeling these things, if only through television, from the beginning. So the media have also spread the gap between the generations.

Still another dimension of the technologized environment that has portents for communication is the feeling of helplessness it seems to inspire in the individual, whether he acts or just shakes his head—the feeling that the complexity and unpredictability are too much for him to deal with. Toward the beginning of his *Love and Will*, Rollo May captures the essence of the matter: "No human," he says, "can long endure the perpetually numbing experience of his own powerlessness." Such a feeling can result in: (1) a feeling of apathy, a world in which the muffs are pulled over the ears and the shades are drawn; or (2) a revolt against apathy, based on a vigorous search for communication that will culminate in action.

Initial action, like the beginning of any problem solving, involves scanning behavior guided by restless feelings. Young people know, or rather they feel, that any set of workable solutions for the problems that beset the earth will operate upon humanistic values outside those the Establishment presently invokes. In short, they as a generation question the social and political perspectives of present authority. Thus, at least unconsciously, young people are searching for patterns that transcend the usual frames of reference. They like poetry that is vague, shapeless, indeed meaningless, to many older people. They are attracted to music that sounds primitive and/or noisy to older people. They improvise in their dancing; no waltz or fox trot for them. They like the painting they cannot "understand." If they cannot verbalize what they are up to, they are obviously developing a tolerance for ambiguity. While a shapeless finished product is a failed effort, the first stages of any effort to encompass principles and values that transcend those patterns perceived as no longer workable, must reach for new perceptions, new patterns. The person who can hear "noise" as "music" has discovered some new dimensions of order. Unconsciously, this is what the young people are doing, and these motivations are, in part, the consequence of the spilling of the wild disorder of the earth, through the television set, into the living room of every home.

Added to the above influences is the impact of the commercial aspect of electronic media. No medium has sold products from detergent to automobiles with more blatant hucksterism. In contrast, the distinctive atmosphere created in a magazine picture presenting a smart suit of clothes is a subtle persuader for the most sophisticated person. The forced enthusiasm, exaggeration, and spoof of the television commercial does not escape even the dull intellect. Apparently the TV advertisers

have settled for repetition and do not conceive of believability as pertinent. It is our judgment—though it is difficult to establish cause and effect in the social milieu—that the heavy exposure to television since the beginning of their lives is a factor of significance in the college students' attitude toward the commercial world. According to Hadden's survey, previously cited, 61 percent of the college seniors say they are caught between the urge to do work that leads to economic success and their desire to do interesting work. While almost all affirm the free enterprise system, almost half believe industry demands more conformity than they can tolerate. Forty percent expect to work in education or research organizations. "In short, students tend to look upon business men the way the middle-class English look down on tradesmen . . . and this is true even among students who plan to go into business!" These attitudes are most pronounced in college students who represent affluent homes. Apparently the impact of success-driven America joins with mass media to produce a college student relatively uninterested in the prestigious values of the older generation. Students want comforts but they are not dedicated to the value schemes of the industrial world—at least in part because their exposure to the commercial mind via television causes them to see it as limited and shallow.

THE IMPACT OF ATOMIC CAPABILITY

The Atomic Age crashed in on us with two explosions and the obliteration of two cities in Japan. Ever since then, there have been increasing doubts about whether established rules for governing the earth are still applicable. All the wars since 1945 have been restrained and inhibited. "Unconditional surrender" belongs to history. Insults and exploitation by small nations, like the capture of a spy ship, are tolerated annoyances. Although the authority of naked power is still the ultimate faith of the social order, the use of power is restrained. The finality of all-out war is a monster threatening the traditional tenets of law, justice, authority, and survival.

Children born since 1945 have developed, therefore, an awareness about the threat of the end of human time different from any ever held by people who lived before. Man's symbolic power to escape the present moment and conceive judgment, when man's time is up, has been a basic theme that pervades Hebrew and Christian thought. The myth of judgment divides the good from the bad, and the good live on. Judgment day leaves room for hope. But the atomic bomb is the leveler, killing hope, making no discriminations, and it is not in the hands of an All Knowing God, but in those of power-oriented, fallible, often unwise and possibly

insane men. Born to this awareness, unconsciously, the generation in college is more "now" oriented because it has less faith in the future. It has, at once, more urgency to live fully, more drive to touch life deeply, and more revolutionary zeal than its parents expressed in their youth.

According to Hadden, 60 percent of the seniors in college do not believe their elders have "the intelligence and moral sensitivity to deal with the urban crisis," and an equal percent have little hope even for survival unless the institutions become more sensitive to human needs.[19] Living in the shadow of such despair, college students openly express their high value of love and affection, yet feel the need to be aggressive, especially with the "Establishment." And they feel confused for they sense the incongruity of love and attack. Even more than many of their elders, they feel the incongruity of the national search for safety by escalation of the instruments of destruction.

The attack of youth upon the Pentagon and the government foreign policy is more than an attack on the immediate issues. The more articulate young people do not believe in the elder generation's perceptions of law and order—and their peers at large side with them more than with their parents. They do not doubt the dedication of the Establishment, but they conceive of it as a victim of dedicated delusion. They do not claim to know the solution. The path of their parents feels wrong to them—and that is where it stands.

TRANSITION

To this point we have discussed three of the environmental forces that shape the listening of a person today. The first centers on the reference groups, those groups of people significant in the life of a person. The influence of reference groups has shaped the communication of people since the beginning of man. The other two forces are products of recent invention. Radio and television are making the world itself a reference group, and the very impersonality of so much mass communication is causing a revolt in the young, creating need for more personal relation, more humanness, more appreciation of the intimate. The commercializing of television is heightening the revolt. The third environmental force, and one peculiar to our time, is the shock of nuclear capability, and this too has caused college youth to turn away from the past in search of a way out.

Yet it would be wrong to conclude that the total impact of the environmental forces has been to increase the openness of youth or older

[19] Jeffrey K. Hadden, "The Private Generation," *Psychology Today, op. cit.*

people. As we see it, the present environment acts both to open and to close us to new messages. And this tension is not new, but a condition of all time reflecting the fact that each person is unique and experiences life in his own way. Thus the impact of the environment we live in makes some people more permissive, more willing to search for accommodations for the odd view, to tolerate errors, to find some broader value that allows listening to almost anything. The threat of our times also produces some people who become less permissive, who feel we can tolerate no more nonsense, which is to say they close their ears to new messages and demand discipline of those who say or do the "wrong" things. Let us trace, at this point, the environmental forces from early in life that bear upon us to produce openness or closedness.

THE ORIGINS OF OPENNESS

According to René Spitz, relaxed openness to experience begins in the feelings of the mother for the newborn baby.[20] If the mother loves her baby and has few fears about the baby, the infant relaxes in her arms and feels comfort and pleasure, as once he felt in her womb. The tension and the temperature of the mother's arms and body are determined by her feelings about herself and the baby. These muscular tensions are communicated from the body of the mother to the body of the baby. It is hard to prove or disprove the importance of this early tactile communication, or even to demonstrate that it really exists, but the studies by Harry Harlow and others with animals seem to bear out the reasoning.[21] For instance, baby monkeys fed by a bottle tied to a wire dummy-substitute-for-a-mother grow up frightened and neurotic. They mature slowly and remain relatively dwarfed in capability. Infant monkeys reared by a "wire mother" covered with soft terry cloth do better. But there is nothing so good as a real monkey mother.

Spitz's studies show that as the human child begins to see and hear, he learns to identify with the eyes of the mother and to distinguish the peculiar note of her voice. The qualities of the voice are shaped by feelings and muscle tone. Thus the baby gradually learns to associate the tensions he feels in the mother's arms with the tensions of the throat, mouth, and upper half of the mother's face. As he slips out of his mother's arms and spends more and more time moving about independently, he learns more and more to ascertain the safety of his situation in the

[20]René Spitz, *The First Year of Life* (New York: International Universities Press, 1965).

[21]Allan M. Schrier, Harry F. Harlow, and Fred Stollnitz, eds., *Behavior of Nonhuman Primates: Modern Research Trends* (New York: Academic Press, 1965).

looks of people and the sound of their voices. Thus, gradually he shifts from tactile communication to the distance communication of eyes and ears. To make a long story short, children born of a secure mother, and, indeed, parents, who love each other and their offspring, are open from the beginning to the multiplicity of complex messages that characterize the universe of man. So we stand with them at the threshold of the influence of the family as reference group.

Other Avenues to Openness

There are those who will want to argue the point, but it appears to the authors that education is a moving force toward more openness in young people. The trend seems to be away from the authority of information and toward the needs of the learner. For this we must give credit or damnation to John Dewey as the prime force in our century. The elementary school, especially, has been highly impressed by the importance of moving at the child's pace, discovering his interests, and adapting to his vision. The faith is now deeply entrenched in the lower grades that the teacher must identify with the child, as he is, and that out of this comes the magical reciprocation in which the child identifies with adult motives and aspires to them. Margaret Mead has pointed out, with her usual vividness, the way each culture sets the motive level by the quality, the age level, and the identification capacity of those who teach.[22]

To some the whole university system seems hopelessly split and basically threatened. But sociologists Christopher Jencks and David Riesman see the possibility that when things look most discouraging the forces for beneficial change may be most thoroughly at work.[23] The truth of the matter is that many universities are experimenting with courses without grades, with independent study, with wider use of elective systems. The student voice is listened to more within the classroom than once was the case, and the organized fifty-minute lecture, where enrollments permit, is giving way to more informal presentation of ideas by professors, more presentation by the students, and a more extensive interplay of ideas between student and instructor. Students are finding membership on committees in departments and at administrative levels, places once considered exclusively the domain of professors and administrators. There can be real hope that the shift toward the open, more relaxed, and anxiety-decreasing end of the scale at all levels of education, among students, teachers, and administrators, will induce the development of more

[22]Margaret Mead, *The School in American Culture* (Cambridge: Harvard University Press, 1951).

[23]Christopher Jencks and David Riesman, *The Academic Revolution* (New York: Doubleday, 1968).

open communication among all concerned. Democracy is so much a part of our political experience we often fail to see its role in developing leaders who listen to the people (and people who listen to themselves). Almost all persons over eighteen in America now may cast a vote for president, governor, mayor, and a long list of lawmakers at national, state, and city levels. Everybody, including children, feels free to say what he pleases—wise or unwise—about or to public officials. Incendiary and threatening statements, including proposals for the overthrow of the government, are increasingly less novel. At this hour, the environment of our political culture supports considerable willful, individual, and self-affirming activity. If Uncle Sam does not listen as the client-centered therapist does, at least he allows the client to talk.

THE DYNAMICS OF THE CLOSED ENVIRONMENT

We have just reviewed some of the environmental influences that create an open person in our culture. Let us do the reverse, and show the powerful present-day influences that tend to close us up and seal us off from communicating with each other. Again, citing Spitz, many babies are born to mothers who do not want them. Such a mother is irritated, burdened, or deeply distressed by the baby. Thus, for her, the very sight of the baby may cause bodily tensions and fever which are communicated to him when he is held. He grows tense. Rough handling and spankings stir fear. As this baby wiggles out of his mother's arms, however, he does not get free of her attitudes, for now he sees stern looks and hears the harsh voice. He learns, that is, he perceives, the injury and threat of injury in his environment. For reasons not entirely clear, infants go through a period of tension known as the eight-month anxiety. Those infants in a threatening or non-supportive environment, especially in this period, learn to approach their world apprehensively.

One out of every three marriages ends in divorce. Children in these homes go with one of the parents, usually the mother. Then the internalization of conflict is complete, and they tend to develop the defensive equipment to deal with it. Even in the most compatible marriage there is some conflict, so that some prejudice and closedness is engendered in the children of almost every home.

Forces Toward Closedness

In picturing the educational institution in the previous section we cited the forces that relax the student and open his ears. Yet one can show the opposite trends in education, too. The urge to be scientific and rigorous shifts data into the foreground while, relatively speaking, the

learner fades into the background. Except in the early elementary grades, acceleration of learning and testing have increased in recent years. The consequence has been that those who want to stay in school listen apprehensively to that which they consider pertinent to their survival, speaking cautiously if they speak at all.

Yet of all institutions the most defensive, and thus the most effective in closing the mind, is the State. Alexander Hamilton is reported to have said, "If men were angels there would be no need of government," which is to say that governments are instituted to protect us from each other. But one need not be so pessimistic about the nature of man to explain the need of government. A traffic light at a busy intersection is not necessarily installed to catch people who go through the intersection when it is red, but more likely, to inform all when it is safe to proceed. Law does have an educational purpose in a highly populated world, teaching us to know how we may act to mutual benefit. Yet, law must prohibit in order to insure its execution, and this necessity seems to feed an extensively negative and defensive kind of thinking among many, including some lawmakers and police officers.

The very budget of our federal government tells us about its long-standing primary function, for roughly eighty percent of federal monies go to paying for wars, past, present, and future. For us the whole philosophy of national governments is brought into sharp focus when we recognize that most of them ask or demand that the young endanger or give up their lives for the execution of policy instituted by older men. In this fundamental respect, governments have become more closed and coercive over the centuries. In primitive tribes the young join the older men in war games, and often those wars are essentially means of teaching the young courage and the confrontation of death. But modern nation states have quite other purposes. They are highly suspicious of each other, deeply involved in contesting differences in ideology, and compulsively driven to close their ears to the reasoning of other cultures. They are caught in what has been called "the dialogue of the deaf."

SUMMARY

What, then, have we been saying? Two things. First, and more extensively, that our speaking and listening are always controlled in part by the reference groups to which we belong. Second, that critical examination of our culture shows one can find evidence that our institutions have and are developing, at once, both open and closed characteristics in people. Finally, if one wants to sense the direction and impact of the shift from hour to hour he must learn to weigh the relative impacts in the opposing directions.

OBJECTIVES

The purposes of this chapter are:

I. To learn how the environment, whatever it may be, places constraint on one's drive to be free.

II. To teach you to respond empathically to a person whose environment, out of which he came, is radically different from your own.

EVALUATION

Write a short paper on the frustrations of your present life. At the end of the semester write a statement of your feelings of frustrations of that hour. Compare the two statements.

The question is this: Are you learning to deal with the problem of frustration? And are you learning to recognize what frustrates you? Our assumption is that as one's frustration lessens he is learning to deal with his freedom within the constraints of his environment.

This is not to say that the absence of frustration is the proof of appropriate adjustment. Indeed without frustration there is no growth. But excessive frustration is debilitating, a consequence of insisting upon living in an inhospitable environment or in perceiving your freedom unrealistically. In other words, one's ability to keep his frustration level appropriate to his growth needs depends upon his ability to find an environment appropriate to his unique needs.

DISCUSSION QUESTIONS

1. *Objective I* "The environment never gives freedom beyond the constraints that form it. Thus the freer the environment the freer the individual. The more constrained the environment the more constrained the individual." Discuss this statement in the light of the chapter.

2. *Objective I* "No person chooses his parents or his neighborhood. Thus you cannot escape who you are." Discuss this statement in the light of the chapter.

EXPLORATIONS

1. *Objective I* Write a paper or give a speech describing the areas of your freedom and the constraints your environment has placed on your freedom.

2. *Objective I* Read "The Bound Man" (in Ilse Aichinger, THE BOUND MAN AND OTHER STORIES, Farrar, Straus & Giroux, Inc.). Discuss the implications of the story.

3. *Objective I* Make the best case you can for absolute freedom on the campus. Present it to the class for discussion.

4. *Objective I* Make the best case you can for absolute authority in the hands of the president of your college or university. Present your argument to the class for discussion.

5. *Objectives I & II* If you have done assignment 3 or 4 above, after modifications for the effective objections you found in the class discussion submit an article to the campus paper.

6. *Objective II* Divide the class into its subcultures on the basis of race, sex, socioeconomic differences. Then form small groups with members from each culture. Let a member from each subculture in a group tell about the significant experiences which have shaped his attitudes. Compare the significant differences in the experiences of each subculture.

7. *Objective II* Form the above groups and place in the center of each group an object, such as a gun, key, wallet, watch, earring, scarf, and let a member of each subculture say what seeing the object arouses in him. Compare the comments.

8
Judgment, Criticism, and Discrimination

> But you'll be asking me why I'm writing you
> like this. Well . . . you're a sort of confessor
> to me, boss, and I'm not ashamed to admit all
> my sins to you. Do you know why? So far
> as I can see, whether I do right or wrong, you
> don't care a rap. You hold a damp sponge,
> like God, and flap! slap! you just wipe it
> all out. That's what prompts me to tell you
> everything like this. So listen!
>
> *KAZANTZAKIS**

In a terrifying play called *The Shrike*, a wife, for her own purposes, commits her husband to a mental hospital.[1] The husband sees that he is being used but assumes that he can extricate himself from the situation. Everything he says, however, exacts a response from his fellow inmates at the hospital, from his "solicitous" wife who keeps visiting him, and from carefully coached friends she invites to see him, that adds up to the judgment: "You are insane." As it dawns on the man that anything he says is going to be interpreted as irrational, he becomes desperate, and therefore, excessive in what he says. That, of course, provides the very

*From Nikos Kazantzakis, *Zorba the Greek*; © 1952 by Simon and Schuster, Inc. Reprinted by permission of the publishers.

[1]Joseph Kramm, *The Shrike* (New York Dramatic Play Service, Inc., 1967). The shrike is sometimes called "butcherbird" because it impales its victims (grasshoppers, smaller birds, etc.) on thorns or barbs and then tears them to pieces. Significantly, their call is a shriek, but their song is a sweet warble.

evidence needed by his listeners to confirm their judgment. The final scene shows this once stable man reduced to blathering nonsense and helplessness. The shrike moves in for the kill.

The play is profoundly disturbing because we recognize it as an exaggerated model of what happens among people day in and day out. In our communication with each other, we habitually, often unconsciously, sit in judgment, as the play vividly illustrates. However, *The Shrike* does not tell the full story of judgment. What happens to the person who convinces another that he is mad? Judgment, as we shall see, wreaks its vengeance on the person who pronounces it.

We are involved, in this chapter, with the most serious problem in human communication—judgmental speaking and its response, judgmental listening. If the communicative exchange is relatively free of judgment, information transfer, problem solving, and human growth evolve. If the interaction is guided by judgments of self and the other persons involved, frustration, confusion, hostility and threat usually result. Although the destructive results of judgment are easy to see, as the chapter will demonstrate, the erasure of judgment from our communication is extremely difficult to attain. What we are discussing in this chapter is probably the ultimate achievement in human maturity—the ability to live beyond judgment in our communication.

DESCRIPTIONS AND ANALYSES OF JUDGMENT, CRITICISM, AND DISCRIMINATION

Some workable definitions are needed. The authors conceive of judgment as an attitude in communication, at one end of a continuum, opposed, at the other end, by the attitude of noncritical discrimination. Criticism, mixed of the qualities of both judgment and discrimination, stands halfway between.

Judgment	Criticism	Discrimination

What do we mean by the term judgment? Quite literally, and probably best understood in its literal form, judgment is the work of a judge. A judge executes an act involving the moral assumptions that good and evil exist and that they exist in mortal conflict. Some acts are good and some are bad, and each tries to destroy the other. These assumptions, of necessity, employ the concepts of guilt and punishment. The judge on the bench, holds the right and the power to exercise decisions about punishment, perhaps the imprisonment or freedom of another person. Judging a person, whether one holds the title of judge or not, then, is the act

of passing an opinion on the value or worth of another person's behavior, or perhaps his very being. The judging act, therefore, assumes superiority of position, power, and integrity on the part of the judge. It should be noted that the judge in a court of law carries out his work in prescribed decorum. He must not give way to the passion beneath judgment. He is permitted to exercise only two attitudes, firmness and gravity.

By contrast, most of our daily judgments of each other are saturated with emotions, and it is in understanding this that we arrive at a comprehension of the fundamental character of judgment. Quite simply, our judgments of another are very likely to be favorable *if we like the person.* If we dislike him, our judgments will probably be unfavorable. And, as we all know, we are likely to be more temperate and compassionate in our unfavorable judgments of people we like than we are in those unfavorable judgments of people we dislike.

If the above is a fair description of the nature of judgment, what, then, do we mean when we speak of criticism and discrimination? In our view, discrimination, as opposed to judgment, is simply the response to perceptual data. One may note that another person is tall or short, fat or thin, light or dark, male or female, standing or sitting, talking or not talking. It is hard to conceive of communicating effectively without these perceptual discriminations. "Nonevaluative listening" so often discussed in recent explorations into communication is not nondiscriminating. The counselor recognizes the *differences* that the counselee is so desperately trying to separate out for himself. Any good listener in any situation does this. If, however, we, as listeners, respect the inviolate integrity of the other person, we interfere with his observations and interpretations only insofar as he seeks our help. We allow him the first of all freedoms, the freedom to live without our claim upon his observations. He is allowed to see as he sees. When we respect the inviolate integrity of another person we help him—if he asks for our observations—to gain the data that would facilitate his arriving at his own perceptions and decisions. We may say to the novice golfer, "Turning the right wrist like this, to the left, usually gets rid of the slice." We have listened, we have observed, we have stated our observation. In this instance we have even gone so far as to offer advice. But we have not criticized. There is a different tone and a different impact when we say, "Come on, that's lousy golf," or "Why don't you get rid of your slice?" or even, "You sliced again." That is criticism.

Let it be clear that judgment, criticism, *and even a simple statement* of our observations about another assumes a superiority over the other, if in varying degrees. They differ considerably however, in emotional intensity and the feelings of relationship. "You're a liar!" is an explosive

judgment. The person who makes such judgment closes his ears to further credible examination of what the other says. The emotional entanglements are much more taut than they would be had he said, "That is not true; I wish you would re-examine that; look at it this way." This latter statement is critical, but not highly charged because the speaker has not passed sentence on the other person. Yet, to state one's own observation arouses still different feelings. "I saw what happened this way . . ." says I saw differently from you, but you may be right. As different as the three above statements are, however, they have a common intent and effect. They all tend to assume control of the other person and thus assume varying degrees of responsibility for that person.

Judgment	*Criticism*	*Discrimination*
Great Authority		Little Authority
Strong Feelings		Weak Feelings

FIGURE 9

We would not want to suggest, by citing these observations, that we oppose all control, the elimination of which is really impossible. One's very presence in another person's life is a controlling factor. To eradicate completely the control of one person over another asks, quite literally, for the elimination of communication between people. (Even the memory of a person long dead has its controlling impact.) Just an observation, *even unstated*, that differs from the other's has its impact. It is an awareness of the immense power-of-being, on all people in whose presence we live, that we need among our understandings in order to sense the power of our judgments and criticisms.

The Power of Discriminative Perception, Said and Unsaid

The chapter on expectation discussed, in the main, the way our expectations determine what we will say and hear. Now we are concerned with the same phenomenon, but turned around—the subtle power of our expectations (of the other person) over his self-image. Strangely, most people think that what they think and feel, but do not say, does not get communicated, illustrated by the comment, "I didn't say anything, but I thought plenty."

The most dramatic proof of the power of the unsaid is revealed in

recent research on the expectations of the researcher.[2] In a series of studies it has been demonstrated that unconsciously the person conducting an experiment tends to communicate to his subjects what he expects to find. If one experimenter is told, "Your subjects are the bright ones," and the other, "Your subjects have the lower IQ," the results will tend to show this difference, even though the subjects are all equally intelligent.[3] We assign no magic or mystery to these findings, though after five years of exploration the research does not reveal the significant visual and verbal cues that do the communicating. The research does show that both are involved and that the more creditable and more competent researcher communicates his expectations more effectively than does the less creditable and less competent researcher. The more unconscious the sender is of these expectations the more subtly he communicates them.

So the father *shapes* his son by his unconscious fantasy of the boy's future. And, if the father fears for his son's future, this is communicated too. How much of the anxiety of the earth is the product of parents' apprehension about the goodness of their children? How much of the aspiration of the human spirit is the consequence of the unfulfilled dreams of a parent watching his child? How much of the anger of the black man is the unstated image of the black man in the perceptions of the white man who talks with him—or, again, the perceptions of his, the black man's, parents? How many of the failures in life are "the self-fulfilling prophesies" of teachers and parents? How much is each of us sculpted from the expectations of other people?[4]

If we are indifferent to another person, especially if that person is related by blood or proximity in our life, we send a powerful message to him about him. If indifference is replaced by fascination, consider the difference on the recipient. There is an immense power that each of us exerts over all others with whom we talk, hidden in our perceptions of

[2]J. G. Adair and Joyce Epstein, "Verbal Cues in the Mediation of Experimenter Bias," paper read at Midwestern Psychological Assoc. (Chicago, May, 1967); K. L. Fode, "The Effect of Non-Visual and Non-Verbal Interaction on Experimenter Bias" (Master's thesis, University of North Dakota, 1960).

[3]Robert Rosenthal and Lenore Jacobson, *Pygmalion in the Classroom* (New York: Holt, Rinehart and Winston, Inc., 1968).

[4]B. F. Skinner in *Beyond Freedom and Dignity* (New York: Alfred A. Knopf, Inc., 1971), holds to the view that humans are entirely controlled by genes and environmental reinforcement. Your authors accept the significance and power of enviromental reinforcement. But we do not see how one can hold so exclusively to the view of environmental control and at once set out to change the environment. Or, if the environment makes one want to change it on what basis can one assume that his effort is wise? If one tries to persuade he assumes there are available alternatives that his arguments can influence. His argumentative act is an expression of the awareness of the existence of human choice . . .

the other person. When these are unstated they make unconscious impact. When they are stated they make conscious impact. It is hard to say which is the more powerful.

Inclusion vs. Exclusion As one tries to think through the meaning of these things, it seems to us that he must come to the conclusion that the most significant thing we are discussing is the inclusion or exclusion power of the message. In judgment, said or unsaid, the person judged is excluded. The judged person is "sent to jail," or "charged a fine," or "executed." At best he has to change before, if ever, he is again included. The criticized person is not excluded, but is threatened with that possibility. He could fail. The observed person is under scrutiny, and surveillance arouses fear of being judged and excluded. Said and unsaid observations, criticisms, and judgments probably differ only to the degree that the receiver can tell clearly what he is receiving. But the essential point in our analysis is the inclusion or exclusion of the receiver of the message.

We asked Dr. Joseph Agnello, a stutterer, who despite crippling early years has become a speech therapist and researcher, to tell us the great impacts that have shaped his life thus far. He cited three.

> I spent three years in the first grade. I still remember the last day of the first year. One by one the other children were called to the front of the room and given slips that passed them into the second grade. The last two were not called; we sat there silently, me and the little girl whom we all knew to be an imbecile. I said to myself, 'I am hopelessly stupid,' and I wet my pants. Over the years I gradually changed my feelings of stupidity into the hostile conviction that people make me stutter. They like to do this to me. I said to myself, 'People are all evil and enjoy my plight.' The second great impression of my life came with the patience of a therapist, Dr. Charles Van Riper, who taught me to talk better and by his help taught me that there is love, devotion, and goodness in people. The third great change in my life came when I went to graduate school, and the voice scientist, Dr. John Black, listened respectfully to my talk. I said, 'I have a brain, I can think.'

If one examines the three incidents he sees the issue at hand in bold relief. The first incident was judgmental and entirely destructive; it excluded the boy. The first positive change involved an inclusive act which said: "I can help and you can learn to talk." The listening of the graduate professor said covertly: "Speak, I want to hear." In neither of the two productive incidents of the stutterer's story is judgment or criticism in the foreground, if it exists at all. The main point we are making here is that, said or unsaid, our perceptions of the person we speak to have a

significant impact on him. When those perceptions involve criticism or judgment they can be devastating.

THE NEED TO JUDGE

Why do humans find it so necessary to pass judgment on each other? Are most of us perversely aggressive, wanting to hurt others, or do we suffer delusions that we are God, believing it our assignment in life to make judgments? Certainly the need to judge others is deep in all of us, which is to say the act of judging tells more about the giver than the receiver of the judgment. Out of the maze of World War II stories one emerges that reveals the workings of the terrible drive to judge. It involves an encounter between General George Patton and one of his soldiers in a field hospital. A reporter explains what happened on that day in August of 1943 when Patton walked into the medical tent of the 15th Evacuation Hospital.

Private Charles H. Kuhl was admitted to the 3rd Battalion, 26th Infantry aid station in Sicily on August 2, 1943, at 2:10 P.M. He had been in the Army eight months and with the 1st Division about thirty days. A diagnosis of "Exhaustion" was made at the station by Lieutenant H. L. Sanger, Medical Corps, and Kuhl was evacuated to C Company, 1st Medical Battalion, well to the rear of the fighting. There a note was made on his medical tag stating that he had been admitted to this place three times during the Sicilian campaign. He was evacuated to the clearing company by Captain J. D. Broom, M. C., put in "quarters" and given sodium amytal, one capsule night and morning, on the prescription of Captain N. S. Nedell, M. C. On August 3rd the following remark appeared on Kuhl's Emergency Tag: 'Psychoneuroses anxiety state—moderately severe. Soldier has been twice before in hospital within ten days. He can't take it at front evidently. He is repeatedly returned.' (signed) Capt. T. P. Covington, Medical Corps.

By this route and in this way Private Kuhl arrived in the receiving tent of the 15th Evacuation Hospital, where the blow was struck that was heard round the world.

'I came into the tent,' explains General Patton, 'with the commanding officer of the outfit and other medical officers.

'I spoke to the various patients, especially commending the wounded men. I just get sick inside myself when I see a fellow torn apart, and some of the wounded were in terrible, ghastly shape. Then I came to this man and asked him what was the matter.'

The soldier replied, 'I guess I can't take it.'

'Looking at the others in the tent, so many of them badly beaten up, I simply flew off the handle.'

Patton called the man a coward and slapped him across the face with his gloves.

The soldier fell back. Patton grabbed him by the scruff of the neck and kicked him out of the tent.

Kuhl was immediately picked up by corpsmen and taken to a ward.[5]

General Patton's responses provide the data for noting the following about the need to judge:

1. The need to judge assumes the inferiority of the person being judged.
2. The need to judge assumes the moral degeneration of the person being judged.
3. The need to judge is triggered by the presence of the person that arouses the judge's anxiety.

General Patton, we discover late in the account, "went all to pieces." He explained his crying and "flying off the handle" as a consequence of seeing behavior diagnosed as "psychoneuroses anxiety state." Seeing this behavior caused him to feel anxiety and stimulated the terrible fear that he might be reaching his own breaking point. We accept our weaknesses, or blame ourselves, or blame others. If we are essentially aggressive, we blame others. The need to judge, in the main, is an aggressive effort to throw off anxiety about the self.

The Genesis and Maintenance of Anxiety

In our efforts to understand the ubiquitous phenomenon of judgmental speech we have found, as highlighted by the story of General Patton, that the agent is anxiety. We have noted that people who are at peace with themselves have no need to pass judgment on others, and along with this, that people who have achieved self-acceptance can calmly tolerate the judgment of others. Or, to say it again, if it were not for anxiety we would neither give nor be victimized by judgment. What are the workings of anxiety? What is its origin? What is its relation to listening? How is it that things happen to a person as he grows up which seem to equip him to make judgments automatically? Harry Stack Sullivan refused to believe that this was simply a product of man's natural cussedness.[6] He did not find evidence, he said, in his clinical cases, that people were "by birth" malevolent. He thought, instead, that something like this happens: The human infant is born into a physical world with

[5]By members of the Overseas Press Club, *Deadline Delayed* (New York: E. P. Dutton and Company, Inc., 1947). Reprinted by permission of Overseas Press Club.

[6]Harry Stack Sullivan, *The Interpersonal Theory of Psychiatry* (New York: W. W. Norton and Co., Inc., 1953).

which he is virtually helpless to cope. A "mothering one" (either his real mother, or a mother-substitute) helps him meet his needs.

As the infant, then, becomes a child, a preadolescent, and an adolescent, he is *taught* anxiety by the "significant others" in his life—his parents, his friends, his teachers, and so on. That is, he *learns* from experience with these others whether to be anxious. At one point in his explanation Sullivan asserts that the capacity to love (the capacity for intimacy) is directly related to the degree to which the "significant others" in one's life have taught him not to be anxious. In other words, if the infant learns to expect tenderness, but as he grows he discovers that the "significant others" in his life are sitting in judgment on him, making arbitrary demands on him, blocking his efforts to develop his talents, he at once decreases his intimacy with them and becomes increasingly filled with anxiety. And as his anxiety level increases he grows more judgmental in his attitudes toward others. On the other hand, to the extent that the need for tenderness is met, the anxiety level lowers, as does the "need" to be judgmental in his attitudes toward others.

The observations of the authors would support this theory. For instance, the students we work with show some of the same patterns so often one could almost make predictions like these: If a student is reluctant to risk his ideas with others, seeking safety in silence, or, if a student presents himself as a bold, aggressive judge of other people's ideas (so that his fellow students finally accuse him of "playing God"), the chances are good that either or both of his parents listened to him primarily as critics.

THE RESULTS OF BEING JUDGED

The results of being judged have been suggested from the opening story of the chapter, but they need to be examined more fully. Let us come to focus with a typical case. A girl in one of our classes took an aggressive attitude among her peers. The more obvious cues suggested that she felt she was better than they. Sometimes she would laugh at another's ideas as ridiculous. One day, when a student was talking about uneducable children, she said with a sneer, "I hope we don't have any like that in here." By the time the semester was a third gone, she had antagonized almost all the class members to the extent that when she spoke we noted them trying to restrain themselves from saying what they were thinking. She was a bright girl, quite aware of how people were responding, and unhappy with the image they had of her. In a diary, which was part of the class work, she wrestled with the question, "How did I get the way I am?"

At the beginning of the semester she had written that communication

between herself and her mother was very good. As the semester went along, she began to see that maybe her love of an argument was the product of the model her mother had presented: "My mother always taught me to say what I had to say in the strongest possible way and to let someone else cut it down if they could." But always she would add that her mother had given her good training. Then one day she exploded, out of the blue, with this statement: "I never did anything right! She always criticized me. I even said to her one time, 'Why don't you praise me once in awhile when I do something right?' And do you know what she said to me? She said, 'Because I expect it.' "

No explanation of what this meant in the life of the girl seemed to be necessary. In a crystal clear moment all understood. The child who has been listened to by a "critic" all of his formative years may find himself, an adult, with a deep-seated need to "play God."

Fear wears a thousand faces—subtle, deceptive faces learned early in life. A strange form of psychic process begins in criticism received, transforms itself into anxiety, evolves into self-doubt, forms a mask, out of the mouth of which pours criticism, which transforms itself into anxiety in another person—and on it goes.

As Sidney Jourard emphasizes, each of us discovers his identity in conversation with others. It follows that no man completely escapes the judgment that any other man places upon him, spoken or unspoken.[7] Of course, the more we respect or fear the judge, the more we are impressed and imprisoned by his sentence. But we do not escape the judgment of another, even though we do not respect or like him. We often try to escape into expressions of anger and contempt ("I don't give a damn what he says . . .") but our emotional outbursts—silent or overt—are but proof that we did not escape.

And if the "repeated" criticism or judgment is more than we can bear, we repress it, pushing it down into our underworld, burying it below verbal recall. There, out of control, it does its mischief. All of us suffer uneasiness about ourselves we cannot explain. Most of us suffer feelings of inarticulateness and lack of command in the presence of authority figures whose very presence arouses the echoes of unpleasant judgments of the self we cannot shake. Some of us occasionally need the help of a skillful counselor or conversant who induces us to speak and to gain control of the judgment festering in the unconscious.

Listening to the Double Bind

Listening to judgment, we have noted, can be confusing for a variety of reasons. Different people give different judgments. Unspoken judg-

[7]Sidney M. Jourard, *The Transparent Self* (Princeton, N.J.: D. Van Nostrand Company, Inc., 1964).

ments are hard to interpret and often received without knowing where or how we got them. But the most confusing states arise as a result of mixed judgments and criticisms from more than one person.

The following is a classic story of a boy caught in the cross fire of the differing judgments of his parents:

> A boy of seven had been accused by his father of having stolen his pen. He vigorously protested his innocence, but was not believed. Possibly to save him from being doubly punished as a thief and as a liar, his mother told his father that he had confessed to her that he had stolen the pen. However, the boy still would not admit to the theft, and his father gave him a thrashing for stealing and for lying twice over. As both his parents treated him completely as though he both had done the deed and had confessed it, he began to think that he could remember having actually done it after all, and was not even sure whether or not he had in fact confessed. His mother later discovered that he had not in fact stolen the pen, and admitted this to the boy, without, however, telling his father. She said to the boy, 'Come and kiss your mummy and make it up.' He felt in some way that to go and kiss his mother and make it up to her in the circumstances was somehow to be completely twisted. Yet the longing to go to her, to embrace her, and be at one with her again was so strong as to be almost unendurable. Although at that time he could not, of course, articulate the situation clearly to himself, he stood without moving towards her. She then said, 'Well, if you don't love your mummy I'll just have to go away,' and walked out of the room. The room seemed to spin. The longing was unbearable, but suddenly, everything was different yet the same. He saw the room and himself for the first time. The longing to cling had gone. He had somehow broken into a new region of solitude. He was quite alone. Could this woman in front of him have any connexion with him? As a man, he always thought of this incident as the crucial event in his life. It was a deliverance from bondage, but not without a price to pay.[8]

One is tempted to believe that no child should have more than one parent. The conflicting judgments of one are hard enough to handle. A boy runs out of school and his mother comes to pick him up. She

> opens her arms to hug him and he stands a little way off. The mother says, 'Don't you love your mommy?' He says, 'No.' The mother says 'But mommy knows you do, Darling,' and gives him a big hug.[9]

As Laing says, the mother is impervious to what the boy says he feels, overruling the boy's testimony by telling him what he does feel and rewarding him for saying what he did not say. That is the double-bind.

[8]Ronald D. Laing, *The Self and Others* (Chicago: Quandrangle Books, 1962), pp. 160–161. By permission of Random House.

[9]*Ibid.*, p. 147.

Listening to Favorable Judgment

We have discussed the weight and power of the unfavorable judgments we hear. What about the favorable judgment, the rewards and praise—the positive reinforcement? Is this all good? In a very real sense positive judgment is restricting too. A judgment of any description asserts power. And he who learns to depend upon the praise of others evolves into the other-oriented person, the faceless conformer who pervades our culture.[10] The freedom to become ourselves may be impaired as much by praise as by blame. A friend told us about an occasion when he said to his wife, "You know, I've noticed when I call you endearing terms, you shrug them off as if they were nothing—or you act as if you didn't even hear them. How come?" The two were on an all-day automobile trip alone. He was driving. There was a long pause and finally he was aware his wife was crying. Hesitatingly she finally sobbed, "I know. And I know that you must be hurt by it. But when you say those things to me, I feel uneasy. I always think of what I really am, and how far that falls short of what you are saying about me, and I hate myself." The authors recall countless conversations with young people who were tearing at the chains their parents had placed upon them by the seemingly harmless praising of their values. "I know I can trust you," places a firm control over the one spoken to. In the eyes of the authors, favorable judgment is preferable to punishing judgment only in the fact that the relationship between speaker and listener is sustained by the former, destroyed by the latter. But judgment, pleasant or unpleasant, exacts a threatening control over the listener.

We all know the fright induced by listening to praise. "Can I live up to the praise?" is the question aroused. "If I win your praise, I can also lose your praise," is a knowledge gained. "As the giver of the judgment, even though you praise me, you assume the authority to change your approval." What is the meaning of reward if there is no power to withhold it, and even to punish?

Most people equate praise and confirmation. Praise from a person who feels only praise is not praise in the sense we are talking about here. It is acceptance. Unconditional praise is positive feeling for another—minus the control of praise. Sharing with another one's unalterable favorable feelings about him is acceptance, and quite a different thing from favorable judgment. Acceptance on the part of a listener leaves the speaker free. Favorable judgment exacts a measure of control.

[10]David Riesman in collaboration with Reuel Denny and Nathan Glazer, *The Lonely Crowd* (New Haven, Conn.: Yale University Press, 1950).

The Place for Praise Our position on the impact of listening to judgmental responses—favorable or unfavorable—is one that counsels restraint, but we need to look at what to us seems an exception to the rule. What about the person, especially the child, who as a consequence of negative judgments has learned to conceive of himself as stupid, ugly, or in some other way unacceptable? Those who use operant conditioning techniques can demonstrate radically favorable changes, for instance, in the slow learner whose bright behavior is reinforced. It is our observation that positive reinforcement of bright behavior—where negative images are fixed—is more effective than unconditional acceptance, for one can be accepted even though stupid, and that helps little. Our position is this, that those who have developed negative self-images, because they have been negatively reinforced, need the opposite reinforcement. But—considering our above description of the meaning of being judged—it should be recognized that we conceive of reward as an antidote for the negative convictions about self, not food for the nourishment of life. Rewards are wisely used when an antidote is needed.

A Summary of the Results of Being Judged

But the central point we want to make about the impact of being judged—good or bad—is this: judgment arouses those devastating doubts about the self which distort our ability to hear ourselves or others realistically. Jack Gibb, reporting the results of a detailed study of hours of taped discussions, concludes that the effect of judgment on the listener takes these forms: (a) It prevents the listener from concentrating on the message, (b) It causes the listener to distort what he receives, (c) It masks the listener's cues to the motives, values, and emotions of the sender. Gibb observes, moreover, that the loss of efficiency in listening is in direct ratio to the increase in defensive behavior. The more the defensiveness, the greater the distortion by the listener.[11] Yet defend we must when we are judged.

THE RESULTS OF MAKING THE JUDGMENT

Thus far we have discussed the nature of judgment and the impact of listening to the judgments about ourselves made by others. Let us study the boomerang effect. What are the effects on the speaker in adopting the role and speaking the lines of the judge? It is an age-old commonplace to remind people that every time they point a finger at another person they inescapably point three fingers at themselves. That is what

[11]Jack Gibb, "Defensive Communication," *ETC.*, 22 (June, 1965), 221–29.

seems to happen to the judgmental speaker. The more he "sits in judg-
ment on" other persons, the more he is forced to judge himself. This is
so because every conclusion one draws about another is a revelation of
the self. After all, we cannot know anything about another which is totally
foreign to the self. The person who consistently focuses on the errors of
others reinforces and thus develops a prevailing uneasiness about himself.
He becomes more and more fearful of his own weaknesses. Harry Stack
Sullivan has said it with a new twist of the biblical statement: "Judge
not," says Sullivan, "Lest ye be forced to judge yourself!"

A teacher, in a modern novel, is critical of some of his colleagues; he
feels constantly antagonistic toward his principal; and he dwells on
the hopeless stupidity of his students. Unavoidably, in that process, he
comes to think of himself as worthless.[12] His suicidal leap into the depths
of a stone quarry is a logical way to end the story. Fortunately, for most
of us teachers, the impact of our judgments is not so devastating.

There is some empirical evidence, too, that the critical view of others
turns back against the self and blocks growth. When a person is trying,
for example, to improve his speaking, the effect of his critical stance in
listening to his fellows is clearly negative. One of the authors ran a study
for several semesters, searching for an understanding of the relationships
between the way we speak and the way we listen. Here is how he did the
study and what he learned.

In a beginning speech class, listeners were asked to write in a note-
book whatever responses they wished to make at the close of each speech.
It was understood that the comments were *not* to be shown to the
speaker, that the responses were being made so that the listener, at a later
date, might study his notes to see what kind of responses characterized
his listening. At the close of the semester the notebooks were collected
and each statement was classified into one or more of the following
categories:

1. A statement of the main point the speaker made.
2. A citation of the part of the speech that seemed most interesting.
3. A restatement of what the speaker said.
4. Criticism of what the speaker said or the way he said it.
5. A creative response; a statement of the thoughts generated by the speaker.

The instructor, of course, had evaluated the speakers as speakers
throughout the semester, noting whatever they had gained in: (1) fluency,
(2) clarity of statement, (3) flexibility in handling situations, and (4) in-
sightfulness—maturity in relating to self and others. Such measurement

[12]John Updike, *The Centaur* (New York: Alfred A. Knopf, Inc., 1963).

was, of course, subjective on the part of the instructor. The following is what seemed to emerge.

The student who showed decided growth in all criteria made responses in all five categories of listening behavior. For instance, a girl who seemed to make the greatest strides in the class showed: 34 statements of the main point, 6 statements of high interest, 16 restatements of the speaker's thinking, 33 criticisms, and 6 creative remarks. On the other hand, the most rigid, unchanging behavior was noted in a girl whose listening responses were limited in variety and were essentially critical: 0 statements of the main point, 1 observation of a high point of interest, 3 restatements of the speaker's thinking, 31 criticisms, and 4 creative remarks. Strikingly, her criticisms were in the main positive. All the inflexible speakers demonstrated a predominance of criticism in their listening, and the degree of positiveness or negativeness in the criticism did not seem to be the significant factor. The point is that a clear dominance of critical response in listening correlated with rigidity. Yet while critical remarks characterized the listening of those who did not grow, many who were highly critical did grow, but in a distinctive way. They increased in fluency, clarity of statement, and sometimes flexibility in handling situations. They did not develop insight. Their growth, in other words, was in performance. Insight seemed to develop only in those relatively low in critical listening, or in those who listened critically as only one of several dominant behaviors.

We expected to find that the decisive factor separating those who grew in insight from those who did not would be the creative response. Not so. The vital factor related to insight seemed to be the presence of restatements of the thinking of the speaker. A speaker who failed to develop powers of insight seldom restated the thinking of those he listened to. All speakers who seemed to mature as persons as well as speakers showed a decided tendency to restate the thinking of the speaker they listened to.

These pilot studies suggest that the good speaker listens in many different ways and most particularly in the tendency to restate and translate the flow of the other person's thought. Speakers who changed the least tended to listen almost exclusively in a critical fashion.

The way our judging affects our daily work may be seen in the following, taken from studies in leadership and organization. It concerns a young employment interviewer, just learning her job.

> The third applicant wanted to be a foreman of the shipping gang. He was a burly 250-pounder who said that he used to work in the steel mills near Gary. He spoke loudly, with much self-assurance. 'Some sort of bully —a leering Casanova of the hot-rod set,' Jean thought. Jean always did

dislike guys like this, especially this sort of massive redhead. Just like her kid brother used to be—'a real pest!' The more he bragged about his qualifications, the more Jean became annoyed. It wouldn't do to let her feelings show; interviewers were supposed to be friendly and objective. She smiled sweetly, even if she did have a mild suspicion that her antagonism might be coming through. 'I am sorry, we cannot use you just now,' she said. 'You don't seem to have the kind of experience we are looking for. But we'll be sure to keep your application on the active file and call you as soon as something comes up. Thank you for thinking of applying with us.'[13]

There is no way of knowing how much the interviewer missed or distorted the potential of the applicant. But the point is clear: from the moment she judged the applicant "a massive redhead" like her brother her capacity to search out his qualifications was limited.

But the loss in efficiency and productivity in the economy is the small part of the price we pay for sitting in judgment on each other. The incalculable price is the dwarfing and sterilization of our lives, the alienation, estrangement, loneliness, deep feelings of meaninglessness. Our tendency to take a critical view of those around us builds our cell for our own imprisonment. There we starve.

Perhaps we come too close, here, to preaching, but we feel impelled to add this. Every person who has cured himself of despair has taken the medicine of service-to-others, not judgment. And it is not the service rendered that is the good, as good as that is—for only those who have been given can give. It is the feeling stirred in the giver when he acts in service to others—beyond the world of judgment—that is the essential we are examining here. Conversely, the price the judge must pay for his occupation is diminished meaning for his own life.

A CASE FOR CRITICAL LISTENING

Because of the forces that twist the lives of so many from the moment of birth, we do not live in the best of all possible worlds. We do have our exploiters. One of the writers learned this as a small boy when he bought a pair of rusty ice skates with rotted leather straps from an older boy. The younger boy said, "How much do you want for them?" "How much money do you have?" asked the older boy. "Fifty cents," answered the younger boy. "You can have them for fifty cents," said the older boy quickly. With the aid of old neckties to hold the skates on, the younger one learned his first lessons in skating, and in critical listening.

[13]Reprinted by permission from Robert Tennenbaum, Irvin R. Weschler, and Fred Massarik, "The Process of Understanding People," *Leadership and Organization: A Behavioral Science Approach* (New York: McGraw-Hill Book Company, 1961).

One student in a communication class selected as her project the study of gullibility, or, insensitivity to the exploitive cues in nonverbal behavior. She was troublesome to both herself and her poor graduate student husband as she continually stumbled into expensive "bargains" with appliance salesmen. She had lived all her life, before going to college, in a small town on the shores of Lake Superior. She was not accustomed to the language of the industrial world and was completely unsuspecting in the face of aggressive salesmanship. We may be amazed that there could exist anyone so credulous, but several bad purchases in rapid succession had forced her into a study of herself and critical listening.

Critical listening is a self-protective device. And educators have tried a number of analyses designed to teach us how not to be taken in. There is "slanting" that we are warned to watch for, where the language and evidence is carefully selected to cover up the true nature of that which we are asked to accept. A quarter of a century ago every high school student was taught the propaganda devices of card-stacking, plain-folks argument, bandwagon psychology and others. Every few years the educational system takes some new approach to the teaching of critical thinking, and it would require a lengthy discussion to mention the many categories of logical errors which have been taught to help protect us.

Although incidental to our main point here, the research on the learning of such analyses does not support the value of the training. Those trained to recognize "guilt by association" or any other category of persuasive trap learn to identify the category but show no less tendency to be impressed when it is used. The conclusions drawn are these. We are guided in our listening by our beliefs. That which fits our beliefs we accept; that which does not we reject. And we change our beliefs when acting on them frustrates us or gets us into trouble. It was the bad skating on those fifty-cent skates that taught a gullible boy to examine the speech of others skeptically. Critical listening is skeptical listening and skeptical listening is suspicious in character. It looks for every clue of falsity and deception. When the automobile salesman begins breathing hard we know his deep need of victory and should examine the potential arrangements with a skeptical eye and ear. But we have no ear, in the defensive set, for understanding the salesman's needs as a person.

The doubts that arouse and guide critical listening are obviously justified in a ruthless world. But what about judgmental listening? This is something else. Survival is not enhanced for either the exploiter or the exploited when final judgment comes, unless one concludes that a break in civil communication is desirable.

Those who sit in judgment on each other are either at a standoff or in a state of battle. Judgmental listening that is condemning is the listening of enemies. Judgmental listening that is praising is the listening of friends,

in danger of mutual disillusionment. It is rather difficult to build a case for judgmental listening, but we do have to learn to be sufficiently skeptical and therefore critical in our listening in order to survive.

NONJUDGMENTAL DISCRIMINATION EXAMINED

It should be clear to the least suspecting reader that this book holds to the position that most people know how to communicate critically considerably better than they know how to listen and speak discriminatively but noncritically. Indeed, it is difficult for many persons to understand the behavior of the noncritical response. To make doubly sure we know what we mean by a noncritical response, here are some final examples: "You make me think of the time I was trying to figure out where to go to college." "You are not looking forward to the end of school because you do not know what you are going to tell your parents when you get home." "Driving a Jaguar gives you the feel of the road and this you prefer to the comfortable ride that masks that out." Nonjudgmental listening and its response tries to capture and understand the basic intent of the speaker. And when the speaker is deeply moved, as in a case where a counseling friend is sought out, the listener responds something like this: "You have felt, for some time now, that the distance between you and your wife is growing, and you can't help wondering if it may be your fault. But when you think it through, you can't escape the conclusion that it is wrong to blame yourself. And this business of first thinking one thing and then the other is a constant frustration to you." The talent of capturing the nuances intended is just as difficult to develop as noting the error or weakness in another's argument—more difficult, because the culture does not train us to listen this way from early in life. But one has to have this kind of listening done for him only once to know the deep satisfaction of being understood. Anxiety fades and one feels whole. It turns out that for the other person, the listener in the exchange, the great value of trusting and listening accurately is that moment of insight provided for the self. As S. I. Hayakawa says, "It is only as we fully understand opinions and attitudes different from our own and the reasons for them that we better understand our own place in the scheme of things."[14]

How to Develop
Nonjudgmental Discrimination

How can we develop our discriminative powers? The answer is simple, but the workings of the procedure are subtle. We learn discriminative

[14]S. I. Hayakawa, *Symbol, Status, and Personality* (New York: Harcourt, Brace, Jovanovich, 1963), pp. 47–48.

communication by speaking openly and by being spoken to openly. Let us see how to do the latter first. W. J. Powell found, in one study, the best way to get another person to talk openly is to talk about oneself to him.[15] In short we teach what we do. The open and defenseless speech of the other person that follows will say both positive and negative things about the self. Telling the other person what you heard in his speech also causes him to reveal himself further. But the openness that follows, according to Powell's research, will tend to be more exclusively self-critical. Rewards, encouragement, and confirmation have no opening or closing effect.

But the reader may rightly ask "How does self-disclosure produce less judgment and criticism in observations?" This effect can be seen best when we turn to examining the internal communication process of a person as he—in his own speech—becomes more open. The following is a typical example of what people say when they are in the process of becoming less judgmental:

> As I bluntly told the other person my feelings and thought about him and what he was saying I always found he was surprised that I felt as I did about him. Then he would tell me how he had thought I had felt about him. This I found extremely valuable. His explanation showed me how I had concealed myself, but equally important, and at once, it showed some new feelings and attitudes of the other person, which I had not known. And so my prejudgments and my concealment began to break down together. Now I knew that both of us had judged each other wrongly. Strangely now I was out of judgment, trying to find out more about how the other person felt. *Instead* of listening *to* him now I was listening *with* him. I was experiencing what it was like to feel and to see as he does.[16]

If one examines the process suggested in the explanation one sees that judgment and concealment work hand in hand. Conversely, discriminative observation and openness go together. Thus by initiating self-disclosure we beget self-disclosure. With disclosure comes the information that lessens criticism and judgment.

One other thing. In the self-disclosure an appropriate emotion must be aroused in the listener, for, as we have learned, without emotions nothing changes. The "crisis teacher" just quoted, a black, when she speaks to a hostile white audience often begins, "OK, you don't like me or accept me, but I have a job to do. I have to help your kids and my

[15]W. J. Powell, "A Comparison of the Reinforcing Effects of Three Types of Experimenter Response on Two Classes of Verbal Behavior in an Experimental Interview" (Ph.D. dissertation, University of Florida, 1963).

[16]From an interview with Mrs. Judith Lyons, a "Crisis Teacher," South Junior High School, Kalamazoo, Michigan.

kids have a school situation that is peaceful enough to allow some learning. You don't need to like me, but help me know what I have to know in order to do my job. . . ." Expressing another person's pent-up feelings, with *appreciation* (as he would say them if he would say them) vents the judgmental feelings, and facilitates discriminative listening and speaking.

You will also note in the last example a demonstrated courage. Always there is risk in moving from judgment to discrimination, and courage must outweigh fear. We have to lower our defenses. Nonjudgment and courage are bedfellows, as are fear and defense.

Transition

The temptation to judge, as we have seen, is almost irresistible. And the inevitable consequence of judgment is the use of power to bring others to terms with that judgment. Our next chapter is devoted to an understanding of the workings of power.

OBJECTIVES

The chapter was designed to help you:

I. To sense the differences among judgmental, critical, and discriminative statements.

II. To understand the role of judgment in your life.

III. To develop nonjudgmental discriminative habits of communication behavior.

EVALUATION

1. Compare the papers or journal entries of the first of the semester with with recent papers or journal entries. Write a paper discussing the differences and similarities concerning your tendency to sit in judgment.

2. The following is a more objective way of doing the evaluation. But before the method is presented, two explanations are needed. As the chapter would suggest, relationships are always threatened by judgment. But, second, and beyond the data on the chapter, or any direct research we know, is this hunch: that the more the judgment the less the discrimination. (Related research shows that prejudiced people screen information for that needed to

support their prejudices.) The following evaluation system is designed to see what the relations may be between your judgments and your discriminations.

Select those papers or journal entries that have been most critical and least critical. Give those of both classifications a type-token analysis.

What is a type-token analysis? Any word that appears once in an explanation is a token. Any word that shows up twice or more in the explanation forms a type. Thus the more tokens in relation to the number of types the more unique and discriminative the explanation. Or to say it the other way around, the more often a person repeats himself the less discrimination there is in his statement. The purpose, then, of the evaluation is to see whether your judgmental or critical explanations are more or less discriminating than your nonjudgmental descriptive explanations.

In the paragraph above there are 30 tokens and 18 types in 93 words; that is, 30 words in 93 appeared once and 18 appeared more than once. Had there been 40 words appearing once and 18 appearing more than once, in the 93, we would say the explanation was more discriminating. Obviously, to compare two explanations of different length, it would be necessary to stop in the second explanation at the point where it exceeds the length of the shorter statement. Otherwise the shorter statement will always appear more discriminating since the more we talk the more likely we are to repeat a word.

DISCUSSION QUESTIONS

1. *Objective I* Define clearly the terms *judgment, criticism,* and *discrimination*.

2. *Objective I* Discuss the terms "inclusion" and "exclusion" as related to this chapter.

3. *Objective II* What relationships do you see between loneliness and judgment?

4. *Objective II* Discuss the differences in the results of judging another and in being judged by another.

5. *Objective II* "Judge not lest you be forced to judge yourself." What does that statement mean? Does it tally with your experience?

EXPLORATIONS

1. *Objective I* Select an interesting campus controversy to discuss in class. Record the discussion. Replay it and have each person count the number of judgments, criticisms, and descriptive discriminations he made. What observations can be made?

2. *Objectives I & III* Attend a campus event of interest to the class with two classmates. Agree ahead of time that one of you is going to report exclusively in judgmental terms. The second will report exclusively in critical terms. The third will report exclusively in descriptive statements. Have the class discuss whether each of the three of you stayed clearly within the classification of statements assigned to you. Discuss the different impact the reports made on both the speakers and the class.

3. *Objective II* Tell the class of an experience which had a powerful effect on you, in which you were judged good or bad. Have several class members explain the significance of the experience to you as he heard it. Note the person or persons who most clearly identify with your experience. Make comment.

4. *Objective II* Canvass your life for those persons who have aroused the most anxiety in you. Canvass your life for those persons who have helped you accept yourself. Note the differences in the level of criticism and judgment expressed in the communication of those who aroused your anxiety and those who made you feel comfortable with yourself. Write a paper or make a journal entry about your observations.

5. *Objective II* Have two classmates explain their attitudes toward race. Let the rest of the class rate the two on a scale between one and seven (one being the most racist) and evaluate the relative degree of racism. If there are black students in the class have them make commentary on both the speeches and the class evaluations.

6. *Objective III* Describe to the class, as if it were an audience from Mars, the meaning of the following words: prostitute, criminal, politician, college administrator, The Establishment, The Pentagon, dope pusher. Have the class members each rate your explanation of each word on a scale between one and seven (one being the most judgmental) to indicate the degree of criticism in your explanation of the word. Discuss with the class the cues they used for evaluating you.

7. *Objective III* List some abstract words such as democracy, beauty, justice, femininity, wisdom, freedom, hope, pleasure, worth. Read these or other words like them slowly to the class with the instruction that each person is to write the word he hears and then as many other words as come to mind as fast as they occur. Let each person count the words as a measure of discrimination. Let him also count the number of judgmental or critical words as a measure of his tendency to judge. Discuss.

8. *Objective III* Set the goal for a given day to go all day without making a single criticism or judgment about anybody or anything. Keep a record of those incidents in which you break the rule. Make comments on those incidents in a paper or in your journal.

9. *Objective III* Set the goal for a given day not to feel any criticism or judgment of your roommate. Note the way this forces you to see new potentials in him you had not before observed. Note your new feelings and awarenesses about yourself.

10. *Objective III* Select a person with whom you have found it difficult to relate. Attempt for a day when you are around him to resist any judgmental or critical feelings about him. Note the changes in his responses to you.

11. *Objective III* One of the deceptive features of our behavior when we think we have achieved an entirely descriptive view of a person or thing is a hidden or unconscious judgment that selects what we will describe. A way of becoming more aware of this self-deception is to practice slanting both positively and negatively in making comment. In order to sense this make a series of negative and positive statements about a person, place, event, group, or institution. What did you learn?

9

Power
in Communication

Those who question power do us a service,
for such questioning determines whether
we shall use power or whether power
shall use us.

JOHN F. KENNEDY

What is won by force is as transient
as the colors of a sunset.

DEAN ACHESON

In every communicative relationship there is a power problem. And whether that relationship will work depends, in large part, on whether the problem can be resolved for both parties. For it to go unresolved insures that the communication will gravitate into conflict.

There is an exercise called "The Press"[1] used occasionally in "human encounter" training groups. It is built on the assumption that deep inside each of us lies the inescapable question, "Who is going to control whom?" Two people are asked to stand facing each other in the center of the room, and are given the following directions: "One of you place your hands on the other's shoulders and press him to the ground. You may use any method you wish to get him down, but you must put him flat on his back on the ground. He may cooperate or resist depending on how he

[1]William C. Schutz, *Joy* (New York: Grove Press, 1967), pp. 157–67.

163

feels. When that is completed, reverse roles and do the same thing the other way."

Some people are afraid of the exercise, others are eager to try it. But reluctant or eager, those who participate in it or observe it report that it almost always stirs in them an awareness of an anxiety, stronger than they knew, about where they stand in the power game. "Can I tolerate someone exercising power over me?" "Will I insist on exercising power over the other?" "How do I feel about someone who exercises power over me?" "Do I have to exercise power to keep myself together?"

A person resolves such questions, theorizes Schutz,[2] in one of three ways. As one pattern, he may submit to the exercise of power by others, moving away from responsibilities that would require him to exercise it. Typically, he plays the role of loyal follower. Schutz calls such a person an *abdicrat*. The key, he says, to such reaction is the abdicrat's feeling that others do not regard him as a responsible adult, and would not help him if he got into a spot where he needed help. He feels hostility, but engages in hidden responses rather than in open, active rebellion. A second characteristic pattern is found in the person who is driven to exercise power in virtually all relationships. Everywhere such a person looks he sees hierarchies of power with himself at the top. He is a fighter, a competer. He can be labelled an *autocrat*. As with the *abdicrat*, he feels that others do not regard him as a capable, responsible adult. But his response is in the mood, "I'll show them!" The third, which Schutz calls the most appropriate response, presents a person neither threatened by, nor inclined to threaten others with, power. Where it is appropriate, he can use it (e.g., in a crisis) without doing so compulsively. He can be just as comfortable not using it, where that is appropriate. By the same token, he is comfortable having someone else either use, or not use, power with him where that is appropriate. In short, he is not driven as the other two types are. His type is labeled *democrat*.

What seems clear is that the compulsive need to exercise power, or the persistent effort to somehow escape it, is developed early in life, taught by the way significant others have used power in their relationship with us. We will return to this and the above later in the chapter.

But we have been using the key word without a definition. What do we mean when we speak of power? We mean, simply, "the capacity to induce another person to act or change in a given direction."[3] Human life is inconceivable without it, yet power is dangerous because it is deeply involved in the way humans communicate. This, in the end, is the

[2]William C. Schutz, *The Interpersonal Underworld* (Palo Alto, Calif.: Science and Behavior Books, Inc., 1958), pp. 28–30.

[3]C. G. Browne and Thomas S. Cohen, *The Study of Leadership* (Danville, Illinois: The Interstate Printers and Publishers, Inc., 1958), p. 375.

way our judgments and criticisms shape us and our communications. It may not be too much to hypothesize that power is the most important factor in any communication—whether between parent and child, teacher and student, employer and employee, friend and friend, or husband and wife.

When Lord Acton said, "Power tends to corrupt," he meant, as we understand it, that power affects the listening of people—that positions of authority tend to desensitize those persons to the feelings of others, that probably the need to get to the top in an aggressive culture breeds a certain unawareness in the men who compete. Moreover, in order to retain power, a person at the top has to listen for the weaknesses of the men who would displace him, thus learning how to handle them. What we are saying is that power separates a man from others in his immediate life, indeed even from those who would support him in power, for he must listen to his supporters suspiciously, too, in order to determine the limits of their loyalty. So corruption for the man in power is this: that his listening must conceive of those around him as either enemies or as tools for his own advancement. As a consequence, he is voluntarily starved of love, the emotion most needed in order to grow. His ambitions, it turns out, cut his own lifeline.

What about the listening of those deeply related to the power-hungry man? In the subordinate role, people listen for the emotional needs of the leader. They must hear his needs for unwavering support. And, if they idolize him, there need be no dishonesty on their part. Indeed, it is almost necessary that the closest followers of a power-oriented man believe in him with little or no question, because he can ferret out distrust with remarkable accuracy. After all, the person who gains power does not do so without competencies. But the corruption for the follower does not come in the fact that he trusts his leader; rather, it comes in the fact that he cannot listen to his leader as he is. The follower must hear megalomania, pomposity, ruthlessness, and suspicion in a power-corrupted man as energy, greatness, strength, and brilliance. He cannot perceive the power-driven man as a closed and dying person fighting for self-worth and fulfillment through power. Nor can he see the defenses of the power-hungry man. He must interpret the inscrutable mask of his leader as character and strength. He does not perceive the mystery of the man as a reflection of his inability to hear himself as he is—one unrevealing and unknown. And above all else, the follower must not see that the perfection of the leader, created out of the distortions just described, arises from his own need to have somebody strong to lean on—an escape from the greatest of all fears, a fear of trusting one's own appraisals. Run get the doctor; elect a strong president; tell me, teacher; interpret the news, Mr. Commentator.

While the above explanation may seem a bit too much for some in authority or those who, for whatever reasons, highly respect authority, it seems to us that the struggles between men, between religions, and between nations, and the overriding fear we have of each other as individuals can be explained only by sensing the immense drive for power and prestige among those who perceive their own worth in terms of the control of others, and on the other hand, by observing the vast numbers of weak people whose needs complement and reinforce the needs of the power-hungry few.

Hypotheses about the
Impact of Power on Communication

1. When used between people, power distorts perceptions of what each is saying to the other, causing them to omit, misinterpret, and garble.

2. Power relationships between people restrain them from saying what they would otherwise say, thereby robbing the listener of a chance to assess the unspoken feelings or ideas of the other appropriately.

If complete power completely corrupts, it is because the words said do not openly convey the meanings that maintain the power relationship.

Let us examine some of the ideas and data that make such hypotheses seem reasonable.

The Voice of Power in a Relationship

As Dr. Paul Watzlawick points out,[4] every communication occurs at two levels: (1) the content level, and (2) the relationship level—the latter often involving power. As observed in Chapter 1, the relationship always takes a bold hand in determining the content. Consider the following common interaction: Two college alumni, who have not seen each other for several years, meet on the campus. The one recognizes the other, rushes over and extends his hand, and after conventional greetings, says,

> I've been with General Motors the last two years, but you know how wild it is in industry these days. I.B.M. has been trying to get me to take an executive post in Seattle, and I had a phone call from another firm just Friday asking whether I would consider a move. . . .[5]

Analysis of the message from the sender's viewpoint:

[4]Paul Watzlawick, *An Anthology of Human Communication* (Palo Alto, Calif.: Science and Behavior Books, Inc., 1964). Much of the material in this section of the chapter is an interpretation of Watzlawick's concept of relationship.

[5]Notice that much of the "meaning" in this message is carried by the information the speaker decided to omit.

Content: I am providing you information about my present location, and I am purposely selecting some (only some) recent events in which I have been involved.

Relational data: I want this renewed relationship between us to be one in which I impress you and thus bolster my ego. You must realize that I have moved ahead very fast in the business world. Our relationship ought to be one in which you listen to me, appreciate me, envy me. I'm not the kid you knew in college. I am a success. Therefore, it is right that you listen to me.

We teach each other on each meeting, says Watzlawick, what the relationship will be at any given moment. The kind of relationship that emerges can be classified into one of two categories.

Symmetrical A symmetrical relationship is one based on a subtle struggle to establish or maintain equality. A college administration makes demands; students make counterdemands. One partner drops the name of an important person he has met recently; the other person drops an equally important name. The teacher asks a question; the student replies with a question about the question. A friend begins some sarcastic banter; his friend matches him. Whatever the situation, the partners to a communication that has been mutually defined as symmetrical make claim to equality.

And although we make much of the importance of equality in our culture, the symmetrical relation is a very unstable and difficult one to maintain. Any move to gain the upper hand is likely to result in an escalation of the effort at mutual influence. Thus, each communicator becomes wary of the other. Garbling develops and the partners either drift apart or grow belligerent. The power is there but undefined, and is thus anxiety producing.

Complementary A complementary relationship is one based on "the acceptance and enjoyment of difference." ". . . there can be no giver without a receiver, no lover without a beloved, no mother without a child."[6] In one sense, most communications can be viewed as "complementary." If there is to be a speaker, there must be a listener, and vice versa.

FIGURE 10 Diagram of a symmetrical relationship

[6]Watzlawick, *op. cit.*, p. 7.

Notice that both types of relationships are basically efforts to solve the power problem. In a *symmetrical* relationship it is as though each person is saying, "Whatever you say, I will go you one better. You are not going to control me," In the *complementary* relationship, one of the partners is always saying, "Now look, here's the way it is." And it should be noted that the relationship is just as likely to be engineered by the submissive one as by the dominant one; the submissive one acting in such a way as to say to the other, "I can't solve this problem myself. You will have to help me find an answer. I am dependent on you." The other agrees. Indeed it is the very fact that both parties to a complementary situation define the relationship in the same way that makes a complementary relationship possible.

FIGURE 11 Diagram of a complementary relationship

Instability in Complementary and Symmetrical Relationships
If two persons in an interaction are defining the relationship differently, there will be trouble. This seems to be precisely what happens in many of the "power contests" in communication. A mother and daughter can be almost continuously at swords' points because the mother defines their relationship as complementary while the daughter defines it as symmetrical. Neither realizes the difference, and neither seems willing to make any shift. So they play the same record over and over again until they do not even hear the repetitiveness of their own messages.

Or again, if there is a "runaway" in either kind of relationship, trouble develops. Remember those times when "kidding around" ended in a fight? Those are examples of "runaway" symmetrical relationships. Consider an example of the "runaway" complementary relationship. Rollo May[7] tells of a young intern who was undergoing psychoanalysis because he had severe attacks of anxiety with repeated urges to drop out of medical school. Even when he had completed his medical studies and had received a letter from the hospital directors, praising him for his work as an intern, and offering him a choice position as resident, he was seized with another attack. In his therapy session shortly thereafter he reported this dream:

[7]Rollo May, *Man's Search For Himself* (New York: W. W. Norton & Company, Inc., 1953), pp. 77–78. By permission.

I was bicycling to my childhood home where my mother and father were. The place seemed beautiful. When I went in, I felt free and powerful, as I am in my real life as a doctor now, not as I was as a boy. But my mother and father would not recognize me. I was afraid to express my independence for fear I would be kicked out. I felt as lonely and separate as though I were at the North Pole and there were no people around, but only snow and ice for thousands of miles. I walked through the house, and in the different rooms were signs tacked up, "Wipe your feet," and "Clean your hands."

The relationship was a "runaway" complementary one, as it turned out, between a man and his domineering mother. So completely had her power position been established that, though skilled and competent, he feared his success would injure his relationship at home. In short, he was afraid that if he listened to the voices telling him he had powers, he would no longer be accepted at home.

Symmetrical-Complementary Compromise Our observations suggest that the "runaway" tendency of power in both symmetrical and complementary relationships means that in most longtime stable relationships, a kind of symmetrical-complementary pattern develops. One person is recognized as more powerful—to mutual advantage—in one regard; the other more powerful in another way. In a conference, one person may speak more than another; and yet, if the conference is successful, it must be recognized that the good listener excited the best thinking of the speaker. One friend is best at initiating ideas; the other is better at executing ideas. The church is best at spiritual solace; the state is best at defense. Women are better than men at giving birth to children, though men have their part.

Indeed, who can be parent without his children? Who can be teacher without student, or doctor without patient? These basic observations have caused the authors to recognize their own children as their best teachers. The ultimate acceptance of the dignity of all parties must be communicated in any healthy relationship. Probably the very uniqueness

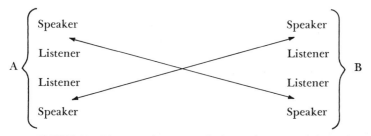

FIGURE 12 Diagram of a symmetrical-complementary relationship

of each person makes all relationships complementary, yet interdependent. So, the ultimate solution to the problem of power in relationships must probably find itself in the sense of union and mutual need, which leads to mutual agreement on the division of power.

Let us summarize what we have said up to this point. Communications have both content and relational elements in them. The relational element is usually, if not always, more significant than the content element. It contains the efforts of both sender and receiver to exercise power. That contest is either symmetrical or complementary, or a mixture of the two.[8]

Theories of the Role of Power in Life

It would be a mistake, as suggested earlier, to talk about power as if it were simply an annoyance in communication, to be eliminated with the right prescription. The urge for dominance is deeply imbedded in animal life, including the human species. We should *expect* to have to communicate with the noise of power cluttering the air waves. Alfred Adler, one of Freud's early associates, broke with Freud because he, Adler, finally came to conceive of all communication disorders as stemming from one's feelings of inferiority, rather than sex. He saw these feelings of inferiority as a consequence of the restraints of the social order on our will to assert ourselves and exercise power.

Robert Ardrey also concludes that dominance (status) is a more powerful basic force than sex.[9] He says that every primate society so far observed can be explained best by examining its dominance system. He shows convincingly how the life of the baboon, water buffalo, cow, gorilla, lion, rhesus monkey, and a colorful variety of other animals, all reveal "pecking order"—individuals in the species "lording it over" other individuals. Konrad Lorenz, the pioneering ethologist, believes that man's class of life is an extension of this animal urge for dominance.[10] His description of life among the jackdaws is frighteningly "human." Desmond Morris, in his book, *The Naked Ape*, needles all of us about failing to face up to our "nature." He points out that, "It is a fact that the most level-headed intellectuals frequently become violently aggressive when discussing the urgent need to suppress aggression."[11] So deep, we

[8]For an illuminating discussion of how this struggle to control relationships works, see Jay Haley, *Strategies of Psychotherapy* (New York: Grune & Stratton, Inc., 1963), Chap. 1.

[9]Robert Ardrey, *African Genesis* (New York: Dell Publishing Company, Inc., 1961).

[10]Konrad Lorenz, *On Aggression* (New York: Harcourt, Brace, Jovanovich, 1966).

[11]Desmond Morris, *The Naked Ape* (New York: McGraw-Hill Book Company, 1967), p. 146.

are saying, is the need of most people to stamp their values on somebody else—often just to erase their own doubts—that a listener can only expect to do most of his listening in the presence of that power.

The Conforming Listener

In any culture perhaps, and certainly in an aggressive culture such as ours, most listening induces conformity. What we are learning about the conformer seems to justify the following conclusions. The use of power in communication (1) makes him more cautious, and thereby leads him to reduce the range of messages he gets; (2) makes him more self-centered in his responses; and (3) renders him more inaccurate in reading the incoming messages. Let us have a look at some of the evidence on which these conclusions are based.

If a listener has a strong need to conform, it follows that he should listen for those things supporting what he is "supposed" to think, and should suppress "undesirable" responses. A study using college students as subjects bears this out.[12]

There is another way, however, in which the conforming listener distorts messages. As suggested earlier, most people learn from early childhood that the *source* of what they hear is more important than the *message*. The source represents for them expertise, wisdom, special knowledge—power. So when they listen they tend to hear primarily those details that will be consistent with the image they have of the person sending the message.[13] Thus, teaching a child to rely on the source of what he hears is the equivalent of urging him to listen for the tones of authority. So the findings of Myron Burger's study with neuropsychiatric patients should not surprise us: the stronger the source, he discovered, the more conforming the responses of his listeners.

Why does it happen with such remarkable frequency that a stutterer can talk fluently to animals? The most commonly accepted explanation holds that the threat of power represented by the judgment of people is the disorganizing influence. If this is so, is it not also reasonable to suppose that the normal speaker, trying to reassert his own significance in the face of an effort by another to control him, should be disorganized in his processes, even though he does not end up stuttering? "Moral threat," Brock Chisholm has said, "is the enemy of imagination." Douglas Heath found that intellectual performance suffered in the presence of

[12]Kay Smith and Barrie Richards, "Effects of a Rational Appeal and of Anxiety on Conformity Behavior," *Journal of Personality & Social Psychology*, 5 (1967), 122–26.

[13]Myron Burger, "Source/Message Orientation, Locus of Control, and Conforming Behavior in Neuropsychiatric Patients," (Ph.D. Dissertation, Purdue University, 1965).

anxiety and that "more disorganization" occurred in those situations and on those issues and with those persons that were the more anxiety-producing for the individual.[14]

The Self-Image of the Conformer But there must be a part of the story yet untold. Is a listener helpless in the face of power? Why doesn't he reject the hand that would cripple him? The answer seems to lie somewhere in his need to defend his ego. When he is trapped in the conviction that he is inadequate, he spends his energies trying, somehow, to affirm himself and, thus, has little chance to interpret incoming messages clearly. Conversely, the better he feels about himself, that is, the less he feels under threat by an authority figure, the better he can perform as a listener.

Consider a case in point. At the University of Michigan, students saw a film and were then asked to write what they had seen and heard.[15] Witnesses who had rated themselves as good witnesses tended to be more correct and covered the material more completely than did those who rated themselves poorly. But the most impressive finding in the study was this: if the person asking the students to respond showed that he regarded them as good witnesses, they usually believed they were good witnesses, and thus performed well. Listeners get more and get it more accurately when the other person is able to help them feel good about themselves. "Runaway" power tends to do just the opposite. Any effort to change (persuade, influence, etc.) another, one writer has pointed out, implies that the other person is inadequate. Built into the desire to control is the assumption that the other person is not taking adequate action on his own. It reflects, therefore, on his quality—and he is quick to sense this.

Almost as if designed to illustrate the point, one of the saddest of stories appears among Robert Frost's letters to his friend, Louis Untermeyer.[16] Frost's only son, Carol, had had a long struggle into manhood with progressive paranoia, becoming increasingly suspicious of people. As his desperation deepened, his father took time out from a lecture tour to go to New England to talk with him. All night they talked, Frost trying to convince his son that he had the capacities to develop a rich and meaningful life. In the rueful letter written later to Louis Untermeyer, Frost notes that the last thing said between them was the son's poignant remark to his father, "You always have the last word." Two days later, Carol shot himself.

[14]Douglas H. Heath, "Individual Anxiety Thresholds and Their Effect on Intellectual Performance," *Journal of Abnormal and Social Psychology*, 52 (1956), 403–8.

[15]James Marshall, "The Evidence," *Psychology Today* (Feb. 1969), 48–52.

[16]Louis Untermeyer, *The Letters of Robert Frost to Louis Untermeyer* (New York: Holt, Rinehart, and Winston, 1963), p. 322.

What makes that story so powerful is that in spite of Frost's sensitivity and insight, his son *perceived* him as the one asserting superiority in their relationship, and apparently learned to listen more and more to the messages that told him of his own vulnerability and weakness—turning away from the messages that spoke of his abilities.

Somewhere in Russian literature is the story of the child who, in his boisterous play, broke a treasured vase. His enraged uncle sentenced him to a period in the closet for punishment. In an eloquent passage that follows, the boy, now alone in the closet, plots all the satisfying ways in which he can get revenge on his uncle, and for that matter, on all adults who hold power over his life.

Such delightful fantasy is not for children alone. The "games that grownup children play" are hidden just as imaginatively. When we have to come to terms with the power of others, we think one thing and say another. Speaking dishonestly, we create dishonesty in the opposition, and thus we feed each other's doubts about both self and the other. Defensiveness soars on both sides and communication worsens.

Communication in the Chain of Command

We have already had a look at the theory that the struggle for dominance is deeply imbedded in all of animal life, and thus in human life. We have tried to show that either getting on top or accepting the inferior role distorts messages, for the self-image must be preserved. All this can be seen in a somewhat different perspective by examining the role of status in human organization—for example, in a business organization. Let us take an oversimplified organizational chart something like the one in Figure 13.

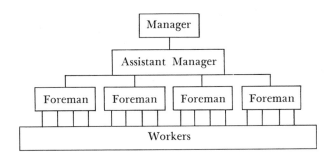

FIGURE 13

Several things are known about the flow of communication in such a structure:

1. Communications will flow laterally (e.g., between persons on the same level —between workers, or between foremen), more readily than either downward to the workers or upward to high-level management.
2. There will be more messages sent downward than upward.
3. Those persons low on the authority ladder will be more cautious about the messages they send upward than will those high on the ladder.
4. Persons high on the status ladder will think they are being heard more accurately than will really prove to be the case.
5. Persons low on the ladder will distort the messages they receive from above in such a way as to fit their purposes.
6. The "lows" will try to move toward the "highs" and away from the lowers."[17]

Take a look at the following chart showing the flow of communication, in each of several media, among forty academic employees in a typical university hierarchy.[18]

Communication Types	Up %	Down %	Lateral %
Telephone	19.7	26.1	54.2
Indiv. Conf.	23.7	49.8	36.4
Staff Conf.	21.4	32.3	47.4
Reading	30.7	20.6	48.7
Writing	26.3	33.3	40.4

Notice that lateral communication is by far the most frequent of the three directions of flow except for individual conferences. People tend to shy away from talking to others on either end of a "power" relationship. Notice, too, that in individual conferences the communication is initiated downward (i.e., by the power holder) more than twice as often as upward. Notice, above all, that the differences in quantity of contact are the greatest where power is exercised directly, by speech, and least where the message-sender has little direct control over the receiver, as in writing. Add this to the above: eighty percent of the communicating done in the business is oral, only twenty percent written.

It is little wonder, then, that a high degree of lateral communication has been found to be associated with poor morale and poor productivity.[19] Apparently, the more communication is cut off between superiors and subordinates the less likely the job is to get done. And conversely, the poorer the job performance, the less superiors and subordinates tend

[17]A very similar list appears in Barnlund's summary of research on the matter. See Dean C. Barnlund, *Interpersonal Communication: Survey and Studies* (New York: Houghton Mifflin, 1968).

[18]Charles Goetzinger and Milton Valentine, "Communication Channels, Media, Directional Flow and Attitudes in an Academic Community," *Journal of Communication*, 12 (1962), 23–26.

[19]Goetzinger, Valentine, *op. cit.*, 25.

to be in communication. Just as the ineffectual human is out of contact with himself, so the ineffectual organization is out of contact with its leaders.

A subordinate, we have noted, talks more to those above him than to those below him. But there is more to it than this. Generally, persons are trying to rise in the organization. The harder they try for higher positions, it has been found, the less accurately they will communicate problem-related information to their superiors.[20] For example, they will communicate more pleasant matters and withhold unpleasant ones. They will talk more about their achievements than about their errors or difficulties. For like reasons, the teacher fails to know his student. Similarly, the parent loses contact with his child.

So, part of the distortion in up and down communication in an organization comes from the selective character of the speech of the person in the inferior role. Discussing defensive management in business, Gibb has this to say:

> Any restriction of the flow of information and any closed strategy arouses energy devoted to circumventing the strategy and fosters counter-strategies that are at least as imaginative and often more effective than the original inducing strategy. A familiar example is the strategy of countering the "top brass" by distorting the upward-flowing data; feelings of hostility are camouflaged by deferential politeness. . . .[21]

If the superior typically recognizes the distortion, and allows for it, it does not, in the end, turn out to be so distressful. But that is not the way it usually works. In a typical study on this question, it was discovered that school administrators, in self-deception for whatever reason, considered both upward and downward communication in the schools over which they had charge more effective than did the teachers with whom they were communicating.

It is probably safe to assert that each person, superior or subordinate, will listen as he must in a hierarchy of organization in order to satisfy his need to be comfortable with that constant companion—himself.[22] As subordinates, we probably have the more difficult time. In the universally famous Charlie Brown of the Peanuts cartoon, we all see ourselves

[20]William H. Read, "Upward Communication in Industrial Hierarchies," *Human Relations*, 15 (1962), 3–15.

[21]Jack Gibb, "Fear and Facade: Defensive Management," in Richard Farson, ed., *Science & Human Affairs* (Palo Alto, Calif.: Science & Behavior Books, 1965), pp. 197–214.

[22]Arthur R. Cohen, "Upward Communication in Experimentally Created Hierarchies," *Human Relations*, 11:1 (1958), 41–54; W. Charles Redding & George A. Sanborn, *Business and Industrial Communication: A Source Book* (New York: Harper and Row, 1964), p. 119.

struggling to cope with our superiors and would-be superiors. We iden-
tify with honest Charlie who somehow seems to survive and escape utter
despair despite his complete absence of the usual human defenses against
power-oriented messages. Low status persons confront a self-esteem prob-
lem every time they listen or speak to a person of higher status, and since
all organizations are pyramidal it is in the nature of things that there
will always be more Indians than chiefs. Thus, most people are subordi-
nates and thus the universal problems of Charlie Brown. As the person
develops his low self-esteem, he becomes more susceptible to persuasion;
or, to put it another way, more vulnerable to the exercise of power by
superiors.[23] On the other hand, if those power figures reward his re-
sponses to their communications, thus ascribing worth to him, he will
think better of himself and will maintain that change for a significant
period of time. But if coercion is used by the power figure, even if it is
perceived as good by the subordinate, his self-esteem drops.[24]

Power Shifts in the Family Hierarchy

If we have been using the business and industrial organization as chief
whipping boy in our efforts to explain the impact of status on communi-
cation, it is not because it is the only place where status is a potent pro-
ducer of distortion. The school is a hierarchy too. And, perhaps most
significant of all, the very structure of the family is arranged on a "peck-
ing order."

But it is also obvious that the pecking order in the home is not what
it used to be, and that, as the bold, contemporary folk song has it, "The
times they are a-changin'," in ways that will reshape all our institutions.
One psychologist theorizes that we can trace a considerable amount of
this status change to the emancipation of women.[25] When the husband
lost control over his wife, says Rudolf Dreikurs, he and his wife both lost
control over their children. As he sees it, the chief reason for the highly
publicized "breakdown of communication" between the generations is
this massive revolt against the old status system of a paternalistic society.
Children are demanding that they be treated more as equals. They vis-
ualize a symmetrical-complementary relationship when they converse
with adults, though the adult world still thinks in terms of the old social

[23]Carl Horland, Irving Janis, and Harold Kelley, *Communication and Persuasion*
(New Haven, Conn.: Yale University Press, 1953), p. 187.

[24]John Schopler, Charles L. Gruder, Mickay Miller, and Mark Rousseau, "The En-
durance of Change Induced by a Reward and a Coercive Power Figure," *Human
Relations*, 20 (1967), 301–9.

[25]Rudolf Dreikurs, *Democracy in the Home and School* (New York: Grune and
Stratton, 1960).

order—a complementary relationship, with adults dominating. We agree with Margaret Mead's recent pronouncement that now not only do children fail to follow the models of parents, but also that now they tend to reject their teachers with whom the culture has tried to replace the parent model. If, in the new situation, a teacher wants to teach with significant influence, he must listen and know young people. It is not that we, the wrinkled ones, are not wanted. The young are desperate for teachers, and they appreciate listening teachers as they have seldom ever appreciated teachers. Without viable models, they are searching for those who will help them find their own identity. But older ones must know that whatever person now evolves, it will not be a copy of the past. The question is: What will it be and will it be cohesive? There is, to put it bluntly, a heaving in the hierarchy.

Power in Early Life

It is possible to live a lifetime without even wondering why we have the impulse to exercise power over others in our communication—or the converse. That urge comes so early in life, so unconsciously, as a consequence of our smallness as a child in a world of large, insensitive, and sometimes frightening adults. Erik Erikson sees each adult as carrying the burden of his childhood:

> Every adult, whether he is a follower or a leader, a member of a mass or of an elite, was once a child. He was once small. A sense of smallness forms a substratum in his mind, ineradicably. His triumphs will be measured against this smallness, his defeats will substantiate it. The question as to who is bigger and who can do or not do this or that, and to whom— these questions fill the adult's inner life far beyond the necessities and desirabilities which he understands and for which he plans.[26]

This situation has its roots deep in our earliest recollections and is more profound than we like to admit. The problem is dramatized by a most devastating example of an excessively powerful father. Adolph Hitler's father was a drunkard and a tyrant who abused and ruled the family. And even though he died while Hitler was only a boy, he apparently set forces in motion in his son that would incite him to listen too exclusively to the messages that set in motion his own devastating power. Hitler says in the first chapter of *Mein Kampf* that no one, not his father "nor any power on earth" could make an official out of him. The irresponsible

[26]Erik Erikson, *Childhood and Society* (New York: W. W. Norton & Company, 1963), Second edition, p. 313.

and abusive power of the father turned, as we all, unhappily, know, to total tyrannical power in the son.

Consider the very opposite example, Helen Keller. Someone has suggested that the reason Helen Keller turned out to be a zestful and vivacious traveler in life, in spite of her "handicaps," was that the people who would have wielded power over her early in life could not get through. She could neither see nor hear.[27] She therefore escaped the power-exposure experience of most of us, and did not have to be defensive. Thus, she became an open, sensitive communicator.

But few of us are deafened early in life. As Erik Erikson says, none of us normal hearers escapes the impact of the power impulses of others. This does not mean, however, that all normal hearers, even those who have had bad communications in the early years, are doomed for a lifetime. Elizabeth Barrett Browning's life is a classic story to the contrary. We present it here as the picture of a highly intelligent woman who misunderstood how she was listening until she was changed with the help of a listening friend. Had it not been for Robert Browning's discovery and courtship of her, she probably would not have found her lilting song; for before she was a famous writer she was an invalid with sinking fortunes —the virtual prisoner of her father. Her father, if historical research is correct, was a tyrant who kept his children under his thumb, even when they were adults.

Mr. Barrett, the father, whose own father, note, had deserted his mother when the son was only two years old, showed kindness and generosity toward his children so long as they obeyed his commands.[28] But he made one unyielding demand of his three daughters; namely, that they must not marry. So when Elizabeth Barrett fell in love with Robert Browning, she was thrown into direct conflict between father and suitor.

At the beginning of her correspondence with Browning, she tries to defend her father and refuses to admit that she blocks out threatening messages from him. She argues that he has responsibilities; that his harshness just seems so to outsiders; that, in any case, she has gotten used to his chains and has her own freedoms within them. At one place she writes:

> But what you do not see, what you cannot see, is the deep, tender affection behind and below all those patriarchal ideas of governing grown up children "in the way they must go!" And there never was a truer affec-

[27]Apparently she had the tactile communication, the warmth of touch, from the beginning of life; otherwise she would not have grown to be the affectionate and concerned person she was.

[28]R. V. Sampson, *The Psychology of Power* (New York: Pantheon Books, 1965), pp. 59–69. In the introduction to the book he offers the startling proposition that, "To the extent that we develop our capacity for power we weaken our capacity for love; and conversely, to the extent that we grow in our ability to love we disqualify ourselves for success in the competition for power."

tion in a father's heart . . . no, nor a worthier heart in itself. . . . He loves
us through and through . . . and I, for one, love him![29]

After fourteen months, Browning dares to bring up the subject in a
letter to Elizabeth. He says, in effect, that he can't imagine a father with
genuine interest in his children who could still deny an invalid daughter
the happiness she might get from the occasional visit of a friend.

Somewhat later, Elizabeth Barrett writes in quite a different vein about
her father. She comes to see his "love" for what it is—the vindictive, de-
manding, manipulating of a man terrified by his own insecurity. She
decides that if she is to know life for herself, she will have to throw off
the tyranny of his demands. Her Rubicon is crossed when she agrees to
elope with Robert Browning. By this time she is ready to steel herself
to the violent consequences. She imagines how she will ask her father to
pardon her for seeking happiness in her own way. And she predicts that
when she does he will show himself as he really is (". . . and he will wish,
in return, that I had died years ago!"). She was, as it turned out, right.
Despite her tenderness and sensitivity, her father refused to forgive her
and broke off their relationship, never to speak to her again.

The story is a parable of the way listening to a power figure early in
life can shape us. Yet, at once, it is a story that tells us that, with the aid
of another, we can escape that tyranny.

At the Most Practical Level

Throughout the chapter we have discussed the impact of power on
communication as it affects the very evolvement of our lives. What we
may have overlooked is the way these power relationships affect commu-
nication in everyday experiences where somebody's error makes us say,
"But why didn't you listen?"

Consider one such case. New employees in a Long Island plant were
trained in the use of the grappling irons they had to use on the job. The
instructor told them that when they needed an iron it could be taken
from the rack on the wall at the left of the forge; that when they were
done using an iron it should be placed on the rack at the right of the
forge, where it would be left to cool. The cool irons would then be
moved to the rack at the left, and would be available for use. One of the
new employees, the story goes, placed his red-hot grappling iron, unfor-
tunately, on the rack at the left. The next man who came along took it
from the rack (where, he had been led to believe, there were only cool
hooks), and it burned him so badly that he could not disengage his hands.
He fainted with the burning iron in his hand.

In the investigation following the incident, the man who had erred

[29]*Ibid.*, p. 7.

vowed no one had told him about those racks. But it was established that he was present at the training session at which all new employees heard the directions, and the instructor recalled that he appeared to be listening intently when the instructions were given.[30]

Many things could have gone wrong here, of course. The worker who made the error might have been sitting at a place where external noise prevented him from hearing the explanation accurately. He could have misinterpreted. He could have been daydreaming at that moment. He could have been fascinated with his new physical surroundings. But he, also, *could have* tuned out the voice of authority. His lifetime experience could have taught him to counter inwardly another person's effort to control him, by simply ignoring the message. In short, his failure to hear the directions about the grappling hooks could have been of a piece with his failure to catch his third grade teacher's instructions for the next day's arithmetic assignment.

There seems to be a remarkable number of instances in which the person who does not hear shows a history of "authority problems."

Possible Solutions

Are we faced with an insoluble problem? How can a person be authentic, be himself, if he is confronted by authority? Yet, on the other hand, do we not have to have authority? How can we escape the evils encased in the words "superior" and "subordinate"?

At least two approaches offer hope: one is a changed attitude toward child-rearing. "We treasure a promise of things to come," says Erikson. "The simple daily observation that wherever the spirit of partnership pervades a home and wherever childhood provides a status of its own, a sense of identity, fraternal conscience, and tolerance results." The other is to increase, by every means possible, opportunities to communicate. *Communication and power are, in one sense, deadly enemies.* Let us illustrate by citing commonly known examples in which power is wielded through noncommunication. The medicine man, in primitive cultures, held all the secrets. As "medical" information began to be communicated, the power of the medicine man faded. Feudal lords could keep peasants in bondage until the word got around that a man's worth is not to be measured by his birth, and that peasants need not remain peasants. In twentieth-century American culture, the power of whites to enslave blacks, the power of parents to dominate children, the power of teachers to make pawns of students—all of these types of power have been reduced

[30]Ralph G. Nichols and Leonard A. Stevens, *Are You Listening?* (New York: McGraw-Hill Book Company, Inc., 1957), pp. 144–45.

through the increase of communication—both about the situation and between the parties involved.

The only alternative to power-over is the power to do. And to be sensitive to one's own feelings is the door to finding one's own talents and powers. It turns out, as the preceding life stories illustrate, that the exercise of power is an evasion of the most difficult of tasks—to listen to one's self, to take the risky road to self-evolvement. It is so much easier to imagine one's own superiority by controlling the growth of those around.

The thrust to project ideas, to control the environment, to organize the social world, to be aggressive, to assert the male side of our nature at the expense of listening, imagining, creating, and nurturing the female side of our nature, is the peculiar imbalance that inhibits our abilities to cope with the peculiar problems of the twentieth century. It is not that power-over is inherently bad. One cannot avoid the power to influence. Even one's silent presence is itself a power. The problem is not to find a way to eliminate power, but to take out of life the desire to exploit one's fellow human beings. As usual, the answer is not an easy either/or proposition. Rather it is a case of walking the narrow ridge, holding in precarious balance all the parts of our nature. To assert power, yes; but to develop the power to do first. Those who develop the power to do, which comes from open communication with oneself, usually find they have influence without subjecting others to their needs.

Summary

Wherever there is power—as there always is—the communicator has his problems. The power signals involved may not be noticed if one looks only at the communication "content," but they exist in abundance when the "relationship" is examined. The relationship can be either *symmetrical* (based on equality) or *complementary* (based on inequality), and is usually more stable when it is a mixture of both. The more either partner is determined to exercise power, the more likely a "runaway" in either kind of relationship will evolve. If that happens, or if the partners refuse to accept each other's way of defining the relationship, the quality of the communication will be seriously affected.

In the presence of power, certain things happen to a person: (1) the range of messages to which he is open is reduced; (2) his responses as a listener become self-centered and insensitive; (3) his accuracy in reading incoming messages is reduced. More basically, connections can be seen between the exercise of power on persons and a thwarting of their development as persons.

If the effectiveness and clarity of communication is to be improved,

attitudes toward child-rearing will have to put more emphasis upon helping the child find, and believe in, his identity. In a free environment, as one learns the power to do he is less driven to exercise power over others.

OBJECTIVES

The purposes of this chapter are:

I. To recognize that the power drive is universal.

II. To increase your awareness of the significance of power.

III. To suggest how you may use power in a relationship for mutual growth.

EVALUATION

1. If you have taken the *Personality Orientation Inventory* note your score and percentile on the acceptance of your aggression. Write a commentary on the significance of this in the light of your understanding of the chapter.

2. If you have taken the FIRO-B test note the scores on control.* Write a commentary on this in the light of the chapter.

3. If you have kept a journal analyze your entries from the beginning in terms of your changing sensitivity to your impact on other people, and the changing impact of others on you.

DISCUSSION QUESTIONS

1. *Objective I* "The exercise of power is not compatible with good communication, but communication unrelated to the exercise of power is of no use." Discuss this statement in the light of the chapter and your understanding.

2. *Objectives I, II & III* Discuss the role of power in the educational system.

*FIRO B is one form of the Fundamental Interpersonal Relationship Orientation Inventory published by Consulting Psychologists Press, 577 College Avenue, Palo Alto, California. Among other things it measures both expressed control and need to be controlled.

3. *Objectives I & III* "The symmetrical relationship appears to be compatible with freedom, whereas, in fact, the compromise between a symmetrical and a complementary relationship is more likely to produce freedom in the relationship." Discuss this statement in terms of your experience.

4. *Objectives II & III* Explain how power isolates a person.

5. *Objectives II & III* Explain how power distorts communication.

6. *Objectives II & III* Explain how the use of power makes it difficult to appreciate the feelings of others.

EVALUATIONS

1. *Objective I* Write a paper or make a journal entry in which you explain the difference in the tension level when you are alone and when your roommate is present though silent.

2. *Objective I* Arrange to be alone for a day in order to sense the meaning of eliminating the power impact of another person's presence. Write a paper or make a journal entry about the experience.

3. *Objectives I & II* Explore a relationship in your life in which you think there is no exercising of power on the part of either of you. Give a talk on your observations and conclusions.

4. *Objective II* Describe the power relationship with your roommate. How is the power exercised? Is it a mutually agreeable relationship?

5. *Objective II* Give a talk describing incidents in which you have enjoyed teasing people. Discuss this in terms of the use of power.

6. *Objective II* Think of a relationship in which you use humor which has as its target the other person. Talk about it.

7. *Objective II* Humor was once thought to be exclusively tension reducing. More recent research shows that jokes are tension building if one person or group is an object of the humor. Analyze your favorite jokes for the power content.

8. *Objective II* Divide into groups in which you discuss any agreed-upon problem, the solution to which will be compared with that of each other group. After fifteen minutes of discussion decide which member of your group shall be asked to join a different group for the remainder of the assignment. Discuss the power dynamics which emerge in excluding the person.

9. *Objective III* Talk to the class, sitting on the floor. Then stand, so now you tower over the class; continue your talk. Place a desk between you and the class and continue. At the close discuss your different feelings about yourself and the class in the three different physical modes.

10. *Objective III* Write a paper or make a journal entry or tell the class

about the power relationships between you and your father, mother, sisters and brothers. Listen carefully to the comments your classmates make.

11. *Objective III* In order to increase your awareness of the way power messages are sent nonverbally identify (a) a relationship in which you see yourself as operating on a level of equality with the other person, (b) another relationship in which the other person is dependent on you, and (c) still another relationship in which you are dependent on the other person. Observe such things as the following about the nonverbal behavior of each person in each of the three relationships: the freedom to touch the other, the ease of looking into the eyes of the other, the freedom to interrupt, the division of time to talk.

12. *Objective III* Come to class prepared to talk about a situation in which you consciously dominated another person. What was the effect on both you and the other person?

13. *Objective III* Explore your life for incidents in which you have been forced to think and behave in accordance with another person's influence. Evaluate the impact of these incidents on your daily behavior. Talk to your class about this and note the class response.

14. *Objectives II & III* Form groups of six or seven and choose one member to report to the class. The reporter will discuss the selection process. Did the reporter vie for leadership? Did he compete with others? Did others assume leadership and force the reporting role on the one chosen? What was the character of the humor? Who avoided the discussion? How did he do it?

15. *Objective III* Discuss the leadership patterning that has emerged in your class. List three people who have exercised the strongest leadership. List three who you would most prefer as leaders. List three who have made considerable impact but have said little. List three who have frightened you by their behavior. List three whose leadership has irritated you. Report your observations in a paper, journal entry, or talk.

16. *Objective III* List the people in your life who had the greatest influence on you. List those who have had the greatest influence on your growth. List those whom you love the most. List those for whom you feel a rather prevailing hostility. Compare the names on the four lists. What conclusions do you draw? Write a paper, make a journal entry, or give a report to the class.

17. *Objectives I, II, & III* Make a speech about power and American society.

18. *Objectives I, II, & III.* Make a speech on power and race in America.

10
From Monologue to Dialogue

Every man is a potential adversary, even
those whom we love. Only through dialogue
are we saved from this enmity . . .
 *REUEL L. HOWE**

If you and I were to change places,
I could talk like you . . .
 THE BOOK OF JOB

A girl amused the other students in one of our classes by telling about meeting a "guy" at a folk festival who was the best conversationalist she had ever known. It turned out that she couldn't remember anything in particular that he had said or that in fact he had even talked very much. She had been the one who talked and she really didn't remember what she had talked about. But she yearned to meet this person again and feared that she would not as it was one of those events where people came from long distances. "I have never been as free and as exhilarated in my talk with anyone. And you are wrong, I only had one drink all night. I ranged free and easy. I was so fluent and said things that were meaningful. My life seemed just right that night. There was no show-off —and that's not me. I knew he understood and that we understood much together. There was a strange intimacy—and yet there was no intimacy

*From Reuel L. Howe, *The Miracle of Dialogue.* By permission of The Seabury Press, Inc.

at all. This is one of the most beautiful and most precious memories of my life."

It turns out that occasionally complete strangers quickly develop openness and intense relationship, largely perhaps because they know that they will not meet again and thus entanglements and commitments are not endangered. This may be what happened here. But it is well that the girl remembers the incident cited for she will know that moment when she is met, confirmed, and listened to in depth only a few times, even if she lives to be an ancient lady. Many many times she will talk to impress and her auditor will indulge her, especially if he is male. (She is an extremely attractive female.) Many times she will argue and be caustic. (She is an aggressive female too.) How much of her verbal demand is the consequence of hungering for a person who understands her, one can only speculate. How many people never know what it is to be listened to at all and spend their lives talking to themselves in the presence of other people?

The levels of interpersonal communication exist on a continuum between self-talk, at the one end, and a depth of understanding of others— real dialogue—at the other. This chapter concerns those levels.

Even the most superficial exchange, however,—in which one or both persons are talking almost entirely for their own benefit—has some awareness for each, of his involvement with the other. The diagram below (Fig. 14) is an inaccurate perception of the way interpersonal communication works.

FIGURE 14

The diagram fails to account for the basic ingredient of communication, a relationship. This last chapter, exploring in depth the perspective of the first chapter, concerns that ubiquitous and enveloping, if vaporous, feature of communication, added in the diagram below (Fig. 15).

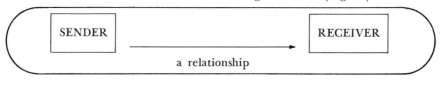

FIGURE 15

Perhaps the significance of human relationship to the way we talk and listen is best borne out by studies of the likenesses and differences among

the several schools of psychotherapy. In discussing this, Barnlund says, "relationship is therapy."[1] By relationship he means the affective state, the emotions aroused by the communicants, which, as suggested in Figure 15, determines the level of the communication. We have discussed the role of emotions in communication back in Chapter 5. In this chapter we refer to the emotions only insofar as an examination of them lets us see into the character of the differences in the levels of communication. Or to turn it another way, the level a person seeks in a communication is the consequence of his emotions aroused in the communication, ranging as they do over the continuum from indifference to the other person to deep concern for him.

The conceptual framework of this final chapter may be visualized as in Figure 16.

MONOLOGUE

Communication marked by indifference for the other person results in a speech in which the intended receiver is the self. The other person serves almost exclusively as a stimulant. Just as an amputated leg or arm can be experienced as a phantom limb, so another person can be experienced as a part of one's own communication system—a kind of phantom.[2] And

The Communication of:

Monologue Technical Dialogue	Resistant Communication Confrontation	Dialogue
Relative Indifference	*Anxiety and Negative Emotions*	*Positive Emotions*

Depth
of
Involvement

FIGURE 16

[1]Dean Barnlund, *Interpersonal Communications: Survey and Studies* (Boston: Houghton Mifflin Company, 1968), p. 673.

[2]Ludwig von Bertlanffy, "The Mind-Body Problem: A New View," in Floyd W. Matson and Ashley Montagu, eds., *The Human Dialogue* (New York: The Free Press, 1967), p. 233.

this is what happens in monologue, a kind of communication we learn early in life.

The Russian psychologist A. R. Luria found that children talk six times as much in the presence of others as when alone. Apparently, internal speech is excited by the presence of another child. Internal speech, or *verbal thought*, if you like, develops as the child internalizes the partner who is not present, a feat which depends upon, as a first stage, imagining he is talking to another person—best done when he has somebody present. In this way a child turns himself into the recipient of his own message. Recently we asked a four-year-old girl to repeat a comment that was unclear. She looked startled for a moment and then replied, "Oh, I was talking to myself."

But children are not the only ones who do this. Professors, the better ones, who are essentially our more mature children, behave similarly quite often in their lectures. Their faces may go vacant, eyes lose focus, perhaps the head will tilt back while they explore some thought just at the edge of awareness. All creative people have this self-orientation. While monologue, by definition, means a minimum of involvement with the other, the self-listening is at a maximum and it is extremely valuable as above suggested.

Narcissistic Monologue

However, the listening of monologue may be for the purpose of self-adoration, rather than for the exploration of one's thoughts. When this happens a self-reflective smile (the dead giveaway) dominates the speech, especially at the end of sentences. The articulation of such speech, almost always unduly precise, expresses language to match, likely ornate. This behavior is all highly infuriating to others, often arousing caustic response.

However, we all do this "face work," and when it is half hidden it is socially acceptable.[3] Indeed one's feelings about himself, his position with his conversants, and his status at large, are always involved in his communication. One may lapse into silence, overrespond, joke, mimic, argue, ignore, belittle, bitch, praise, blame, or laugh in order to draw attention to himself. It is inevitable, for we are all self-conscious, one of the chief accomplishments of language. The laws of human interaction do not rule out "face work"; they can and do order it into the background.

Yet some people insist upon talking openly for their own amusement and amazement, and it is this that is infuriating. If one does this in most of his interaction he gradually evolves into a socialized isolate, that is, he

[3]Erving Goffman, *Interaction Ritual* (New York: Doubleday & Company, Inc., 1967), pp. 5–45.

spends much of his time with people, actually alone. Any honest emotional exchange initiated by another causes him to grow silent or flippant, in some way to evade the relationship suggested by conversation.

Narcissistic monologue is largely self-destructive, but exploratory monologue has its important value for both the individual and society, as noted above.

TECHNICAL DIALOGUE

The listening of technical dialogue is more fully alert to the presence of the other person than is that of monologue. Indeed the interaction is mutual, as it is not in monologue. One person speaks, the other answers, to which the first makes a rejoinder. Each recognizes that "it takes two to tango," that without the other person the communication intended is incomplete. As one might expect, the content of technical dialogue has two basic elements which characterize it: (1) the topic of discussion concerns objective things; and (2) the emotions expressed concern relationships with things, not the other person.

Concerning the former, the topic, we humans live in a physical and social environment which, of necessity, must command much of our attention. Hence the talk about weather, crops, taxes, the price of automobiles. Considering man's inescapable need for food, clothing, and shelter, economic discussion is basic and fundamental to all other needs. As much as we may deplore materialism, exploration into the flights of man's spirit is not possible or sensible when the conditions for existence are distressing or out of order. Even the most spiritually oriented person recognizes the significance of technical dialogue to civilization. And, indeed, it has been man's ability to accumulate technical information that has led to the Industrial Revolution beginning in England about 1760 and reaching its peak in automation of recent years. Thus the plethora of goods of the western world. Advertising, which is much of the stimulant for technical dialogue at this point in history, keeps us all alert to the latest improvement in electric stoves and the multitude of other things, some valuable. Of course, it is scientific dialogue beneath the technical advance that gave us not only the comforts of our age but, unhappily, atomic bombs, deadly germs, and devastating gases. The development of these kinds of destructive goods shock the student of communication into recognizing the limitations of technical dialogue to hold the world in one piece.

But that is not its purpose. Technical dialogue exists primarily for the purpose of accumulating information about the environment so that men may deal with it to their common advantage. Both the Brown-Carlsen and the Educational Testing Services STEP Test of Listening, as

well as the Science Research Associates tests and others, are designed to measure one's ability to participate effectively, as a listener, in technical dialogue. Indeed, man's phenomenal success in mastering his physical environment is the consequence of an educational system, the listening tests an example thereof, almost exclusively designed to improve one's capacity to participate in technical dialogue. As early as the fourth grade the reading tests are constructed to see how accurately the child remembers the specific data in the story or the essay. The lecture, the teaching machine, even the book, which dominate our educational scheme, are designed in the interest of developing the power to participate in technical dialogue. Tests and examinations measure one's ability to listen to technical dialogue. Thus it is the skill of listening, not intelligence, or reading, that correlates most highly with the capacity to make good grades in school.[4]

Competence in technical dialogue is indispensable to an industrial culture.

Second, as noted, the emotions expressed in technical discourse are associated directly with things, only indirectly with other people. Many, perhaps most social relationships evolve out of the exchange with people with whom we work and the friendships are based on the mutually agreeable feelings aroused by conversations about the work. Take away the work and the people are strangers to each other. Where technical dialogue dominates a person's communication it becomes extremely difficult for that person to understand himself and even the members of his family.

Harold McCurdy compares the communication between most people with man's efforts to communicate with some likely intelligible life on some far-off planet in some galaxy eighteen or perhaps eight hundred light years away.[5] Let us take that imaginary trip in the interest of getting a feel for the reason people depend so much on technical dialogue to care for their need to relate to others.

Sebastian von Hoerner calculates that perhaps six percent of the planets of the universe have conditions similar to our own and therefore it is likely our intelligence is matched or surpassed by some creature on some far-off planet. But at least, if so, physical contact is impossible. Only by messages traveling at the speed of light can we reach some intelligent being in outer space, and even then the persons on earth who might send such messages will have aged and died before answer can return. Perhaps unknowingly we are even now receiving such messages from halfway out there in space, initiated before Columbus discovered America. Some basic code known to all forms of intelligence, perhaps mathematical, is the

4Charles T. Brown, "Three Studies in the Listening of Children," *Speech Monographs*, 32 (June, 1965).

5Harold McCurdy, *Personality and Science* (Princeton, N.J.: D. Van Nostrand Company, Inc., 1965), Chapter 6.

only possible way of saying "hello" across cosmic space. This may all seem somewhat odd and irrelevant to a discussion of the emotional involvements in technical dialogue unless one senses that what McCurdy is trying to say, by analogy, is this: that within the human family the ability to reach across psychic inner space is as difficult as reaching across outer space. So much of each man's meanings consists of private translations for which there often seems to be no code. This is why, at least in part, we place such a burden for our well-being on technical dialogue. A discussion of the new colors of the latest automobile models is safe, easy to make oneself clear about, and gives some feeling of belonging.

RESISTANT COMMUNICATION

By resistant communication we refer to that communication dominated and directed by objections to what the other has said. If the relationship between the people involved is essentially affectionate the resistant exchange fastens upon facts and rational argument: "I don't see why you insist upon seeing France as the ideal democracy. A really democratic president seldom stays in power there for more than a few months. Only a dictatorial personality like De Gaulle . . ." And the other person answers, "Now wait a minute. The French instability of government is the perfect reflection of democracy. If a people are free their government must change as they change. . . ." The listening of resistant communication, at the most rational level, is a search for the logical weakness in the other person's argument. It is much like the listening of technical dialogue (focused at language levels 3 and 4), differing in that it does not share in mutual observations, but presents the other person with the differences in their logic and information. If one or both of the conversants is open and calm but alert, one or both may alter his position. If emotional resistance comes into play the arguers usually cease only when exhausted, both of the same opinion still.

We all know the urge to criticize. It characterizes the mid-level of communication, the ambivalent state between the extremes of indifference and total involvement. If technical dialogue is man's most common way of relating indirectly, resistant dialogue is our most common way of relating directly. Here we are, each unique and treasuring his uniqueness, yet needing so badly to be related to others. Half knowing we shall change if we listen, we talk to change the other person for the sake of that needed relationship. Usually it does not work, for the other person has the same needs and uses the same strategy. Thus we are all highly threatened by listening to views different from our own. Should the reader feel we make too much of the threat of open listening let us re-

mind ourselves that the only way some anthropologists find cultures alike is in the terrible resistance each has for the messages of the other. And the social disease of war, organized resistance against the way of "those others," is society's mirror of the individual's fear of listening to another person of different view. Each of us learns through work in a decision-making committee dealing with a controversial issue—shall we abolish grades, dormitories, the R.O.T.C.—to sense how difficult it is to find agreement or even compromise. It is common knowledge that eighty per-cent of all problems in social organizations—whether in industry, educa-tion, or government—are personnel conflicts, conflicts of judgment, ob-servations, motivations. More than one-third of the couples who marry part in conflict. Resistant communication is that level of involvement halfway between indifference and acceptance. It is the state where we "can't live with them or without them"; it is a consequence of people being unable to listen to each other.

Each of us in fulfilling his needs wants to be accepted by others whom, in turn, he wants to influence. Here may be the basic source of conflict. We want to help others, but also to be helped by others. We wish to assert ourselves but also to comply to the wishes of others. We need to esteem ourselves, but we hear the criticism of others, which we cannot completely ignore or negate. We have to involve ourselves with the lives of other people, many of whom in many ways we cannot trust. Somehow each person must resolve all these conflicts in order to feel united, not anomic. No wonder we resist, for every consequential message upsets the delicate balance within. As it turns out, when one settles into resistant listening he usually searches out and joins up with other persons of the same disposition, listening appreciatively to those of similar complaint. Thus the unstable resistant internal order is confirmed. Misery loves company.

The speech of the persistently resistant communicator is marked by interruptions, corrections, vocalized pauses—um, ah, un—repetitions, pe-riods of silence, changes in loudness, jerky spurts, and fast talking.[6] For the person who persists in resistant listening the muscular tension even-tually results in stiffness of body and posture, awkwardness in gait, clenched jaws, a thin red line of lips, and a face of "immobile mask, frozen in false smile or anxious frown or counterfeit dignity."[7]

Resistant communication settles for the negative side of the emotional scale. Thus behavior is aggressive, dominating and critical.[8] Yet as earlier

[6]Dean Barnlund, *Interpersonal Communications: Survey and Studies* (Boston: Houghton Mifflin Company, 1968), p. 367.

[7]Sidney M. Jourard, *Disclosing Man to Himself* (Princeton, N.J.: D. Van Nostrand Company, Inc., 1968), p. 49.

[8]Gay Boyer, "Over-30 Despair: The Reality Gap," *Careers Today* (February, 1969), 69.

suggested, the state is basically unstable. It is likely, therefore, to retreat to technical dialogue or to move even more negatively to confrontation with those who send the disturbing messages.

CONFRONTATION

When we confront a person the messages we have been receiving from him are so upsetting that we wish at last, at least, to stop them. "I've had enough, shut up!" If our feelings about the other person are a mixture of love and hate, we are moved to persuade him in order to change him into a more acceptable person. If, however, our feelings are essentially hateful we hear the other person as evil, someone to be thwarted, punished, or exterminated symbolically or even literally.

While the persuader in resistant communication hopes to win the other person to his side, the confronter hopes to embarrass or, in one way or another, to destroy the other person. Confrontation is excited by intense passion which controls the communication. And note this: The most important character of such passion is the complete identity of self-behavior and self-ideals. This takes away the source of our more usual restraints. At once, we perceive a complete incompatibility between the other person's behavior and his avowed ideals. Thus the purpose of confrontation, conscious or otherwise, is to force the other person to confront himself, to see himself as he is. With such intent, one can listen only to that which reinforces his own absolute perfection and his unquestioned judgment. Hence the vindictiveness and lack of restraint, indeed the affirmation of passion. As is demonstrated every day in the street and seen on the evening telecast, the vicious talk of angry people in confrontation often leads to physical violence, imitating behavior much like that ascribed to the person they want to destroy. How often we hear the young radicals of our day, who cannot accept the existence of the violence condoned in the present law, justify their own tactics of violence as the only effective way to correct violence. And how often we hear and see the preservers of law and order committing acts of violence, in response to dissent![9] When confrontation is the order of the day violence is met by violence, and the irrationality of the situation comes about because each

[9] Professor Robert Seltzer (in a paper presented at the Michigan Academy of Arts and Sciences, March 24, 1972) described the tactics of "disruption" as a political tool in process of change. The tactics of confronters in the presidential campaign of 1968 were designed to dominate the opposition. Speakers were booed to silence as in the case of Governor Rockefeller in Miami. Police response as in Chicago at the Democratic Convention led to bloodshed. Since then both confronters and confrontees are searching for new strategies. Few confronters are willing to pay the price in possible injury for trying to dominate completely. In turn speakers are finding ways to keep control by anticipating and capitalizing on the challenger's methods.

side sees in itself an identity of self-image and self-ideal, but, at the same time, distrusts the relationship between the behavior and ideals of the other. One has no way of hearing and thinking correctively when his words are chosen by vindicated passion.

Relationship in Confrontation

As contradictory as it may seem, when a person confronts another he has a deep need for relationship with that other. Though highly preoccupied with his own goals, his own future and his own value scheme, he sees his future as highly threatened by the other. Thus he cannot withdraw as he does in monologue and technical dialogue. He must find his relationship with those very people he is in struggle with. As might be expected he is highly accepting of his own aggressive desires and thus tends to try to control others. To this objective he asserts himself, joins up with people of like position, woos the undecided, and indulges in argument with those who oppose.

The Distortions of Confrontation

One of the most peculiar characteristics of the resisting and confronting communication is that as emotions arouse one to speak out he loses his ability to see the "good" and the "bad" in others. Rather he perceives people as essentially good or essentially bad. To do this he must select and hear in bits and pieces. "Semantic hang-ups" become the order of the day. Arguments go on for hours centered around the meaning of some one word or small incident. In international conflict the contestants may spend months deciding the shape of the table at which the participants shall agree to talk. The ability to hear in perspective is almost absent in the listening of conflict.

"What I said was . . ."

"No, what you said was . . ."

"But what both of those statements say is the same thing."

"No, the *peculiar* emphasis now you are making is quite different. The *emphasis* you made before was . . ."

But all this play on words and intonations is beside the point. In the communication of confrontation the focus of attack is against the other person's morality, his honesty and good faith. "He does not see himself as he is."

The Process of Confronting

There are essentially three stages in the process that leads to destructive confrontation. First, as already suggested, a person closes his ears to

any messages from the other except those conceived as evil.[10] Thus he gradually gathers the data that permits him to perceive the other person as intolerable. Second, he begins to badger the other person, though unconsciously in many instances; he does those very things that elicit the behavior he hates. Students occupy a building, disrupt classes, sit in the middle of a street. The blacks set fire to the ghetto or attack a group of whites. Thus the confronter creates the self-fulfilling prophecy: the "establishment" tries to preserve order, but, eventually angered, it overresponds. The confronter, having aroused the anger and the behavior he condemns, thus has proved his point.

The process cannot run its course unless the confronted responds in the predictable fashion. If, however, the confronted will not react, usually the confronter becomes increasingly irritated, at least unconsciously knowing that in all people there is a point at which patience is depleted. As it turns out, then, toleration for the challenge of the confronter only emboldens the confronter—and all patience has its limits. There is one, nonaggressive way out of the bind, as we shall see in the following explanation.

Conditions That Lead to Confrontation

It is difficult, given the self-righteousness and the imitation of the very acts condemned, to make a just case for confrontation. Yet one must examine the conditions that lead to confrontation too. A person's listening must have been "shut off" for confrontation to develop. Freud, long before the recent history of student and black confrontation, observed that aggression usually has its roots in a lack of or a deprivation of social contact (Liebersnerlust). Real dialogue, real talk has failed because people did not even meet. Laws have been made, orders have been sent. Indirectly or directly messages have been sent. But the opposite, the returning message, has not been provided for. The defensive and hostile human has not been listened to. He did not just grow up hostile. Or, if you like, the confronter has the feeling of nonexistence in the presence of the powers that affect him. The black man in America has been the invisible man. For centuries he has been a field hand, a sex object, a humorous

[10]"One who sees faults in another and dislikes him for them is surely possessed of some of these very faults in his own person. The pure and good man can see only the goodness in others. . . . Rebuke thyself first for seeing faults, and thus being to a degree impure; then thou wilt not hate thy brother, but feel love toward him. If thou rebukest him, it will be in the spirit of love. He will become attached to thee, joining the goodness within him to thine own goodness, and all his faults will disappear. If he should refuse to listen to thee . . . and abuse thee, he shall thereby lose his goodness to thee and remain wholly evil." From *Hasidic Anthology*, translated, selected, compiled, and arranged by Louis I. Newman (New York: Schochen Books, 1963), pp. 390–391.

clown, a musician, and in recent years an athlete, but not a brother, not a human of equal respect and equal opportunity. In like fashion, a student, while getting more and better information in recent years, has never been an enfranchised person in the educational system. The administrative design of classes where *individuals* move in lock-step groups, manipulated by grades, promotions, marks, examinations, fixed subjects, and report cards (instead of a design where acceptance of the interest of the learner is the basic concern) has proved its failure by the pervading hatred of learning and the forty percent dropout rate characteristic of our schools.

> Consider a few twelve-year-olds and their mastery of baseball. This hideously complicated game involves a long list of skills, a collection of concepts, and a good deal of content that the interested child may swell to encyclopedic scale. Yet this impressive learning achievement results from wildly random exposure. Were baseball taught from second grade on, it would be broken down to 'logical' sequences. Great debates would ensue on whether base-running should be taught before fly-catching. Base-running would then be reduced to terminology, theory, projects, and drill. A textbook would be needed, of course, which would further embalm the 'only proper order.' In time, oldsters would insist that kids don't learn baseball like they used to, because the 'fundamentals' aren't taught first, with lots of 'discipline.' Also, of course, boys would hate baseball, and play only under threat of a zero or complaint to their parents.[11]

It is not our business here to discuss the teaching that works, nor the cultural influences that burden the black man, but to suggest the conditions that produce confrontation. We are trying to see how the listening of those who have the upper hand leads to confrontation. Confrontation evolves out of what is perceived as exploitive behavior on the part of those in charge. One is perceived as exploiting when he does not listen to the confronter as the confronter wishes to be heard.

The peculiar result of this non-listening is that it gives the "speaker" a feeling of non-existence, the most frustrating and infuriating treatment we humans can receive, and non-existence ultimately leads to despair. "Baby, it don't mean shit if I burn in a rebellion, because my life ain't worth shit."[12] Confrontation grows out of a persistent "have not" therefore "am not" perception. As Scott and Smith point out, confrontation evolves from a great despair mixed with faint hope:

[11]Leslie A. Hart, "Learning at Random," *Saturday Review*, 63 (1969); Carl Rogers and B. F. Skinner, "Some Issue Concerning the Control of Human Behavior," *Science*, 124 (1956), 1057–66.

[12]Robert L. Scott and Donald K. Smith, "The Rhetoric of Confrontation," *The Quarterly Journal of Speech*, 55 (1969), 6.

a. We are dead.

b. We can be reborn.

c. We have the stomach for the fight, you don't.

d. We are united in a vision of the future.

The underlying feeling which takes over and demands action when conditions evoke confrontation is that of claustrophobia. Every animal, human or otherwise, has its territorial space and it will fight to guard against its transgression. No animal can be herded too closely without trouble. But the herding of humans goes further. It is not that they lose life space alone, but worse, they lose, as a consequence, a sense of personal significance. The packing in school, in the ghetto, in the army, the standing in line, the lack of privacy irritates, but it does much more. It robs the person of his sense of importance. A healthy person has his own awareness of his own dignified existence. To deny by the conditions of existence is to challenge the belief in his existence and thus meaning for his life. Not to listen, to ignore a person's need for significance is to provoke his screaming, designed—though perhaps unconsciously—to gain recognition and thus to verify his existence. And when a given segment of society screams and acts out the violence it condemns in its oppressor, investigation will show it is responding to the failure of the oppressor to hear and respond with recognition.

. When a person or group feels relatively free, though oppressed, it will usually flee the presence of the oppressor. But when one's feeling that recognition of his existence is being denied, the critical distance has been reached.[13] Either he gives up hope and sinks into some form of non-existence, or he sees some hope in which case he confronts.

All this is difficult to understand for those persons in one way or another associated with the "haves" and deeply identified with the "establishment." Perhaps the following illustrations will help. In confrontation the language used is designed, though perhaps unconsciously, to antagonize the perceived oppressor. And that language which becomes the earmark of the confrontation has a symbolic relation to the basic issue involved. In recent years, for example, blacks and students have resorted to obscenity because they have perceived that "straight" society has become insensitive to its own obscenity—its toleration for sick cities and brutal prisons, while spending freely for space and military research and adventure. The story is told of a well-known black speaker's use of four-letter words in a speech at a college chapel. The faculty assembled

[13]Konrad Lorenz, *On Aggression* (New York: Harcourt, Brace, Jovanovich, 1966).

later to discuss the incident and future policy. Indignation was expressed. Finally a young English professor arose and said quietly, "We don't understand the context, I fear. This language is obscene, and it offends my ears too, but it is the natural response to the obscene conditions we are willing to tolerate. You note the speaker referred to Senator X's statement after he toured the seething ghetto of Washington, 'I didn't know it was like this.' What we don't seem to recognize is that for a representative of the people, after years of uprisings, to say this is for the militant black the ultimate obscenity."

It is what authority figures say unconsciously, deeply offending their listeners, that arouses confrontation. It is this insensitivity that lets the other know he does not exist for the person from whom he requests a hearing. The provocation is usually lost in an analysis of a statement because it exists more in the manner of speech than in what is actually said.

"I don't know what the kids are hollerin' about."

"The well-educated black has more opportunity than I do."

"Let it be understood we must have law and order. We cannot tolerate anarchy."

Each of these statements involves a perspective that denies existence to a voice that has been saying over and over and over that which is born of deep hurt. If we seem to be putting too much responsibility on "the establishment" in this discussion of the conditions that provoke confrontation it is because we find it difficult to blame followers for conditions. The language of leaders is in itself one of the most deceptive causes for confrontation. As Sidney Harris suggests, the language of leaders always points in the direction opposite the cause: delinquent children, student unrest, the black problem, poverty. It is an amazing thing that parents rear children but their children become the problem. A delinquent child is not a "problem child," but the consequence of a "problem parent."

Thus confrontation is the product of a kind of non-listening on the part of both parties to the conflict. The original provocation, covert and hidden, is that failure of those in power to listen. The original provocative act is initiated by the insulted ones. As the night must follow the day the insulted ones are led to act out the behavior they are insulted by —without hearing it. To be reared in an environment that does not listen is to be denied the power to listen to oneself.

The Accomplishments of Confrontation

The consequences of confrontation are these: (1) recognition comes to the person who has not been listened to; (2) emotional turmoil ensues; (3) objectives are clarified; (4) new leaders evolve; (5) changes take place.

The relatively invisible person gains recognition for his existence by his very act of confrontation. The labor movement and women's suffrage are historical examples to the point. And of course the blacks and students are recent examples of the way those in the background gain a place in the foreground of attention. The chapter on emotion explains in some detail the role of emotional turmoil in changing what is heard. If the contestants are reasonably well matched the language becomes increasingly exclusive and abusive. Listening deteriorates, and verbal abuse leads to physical violence. Ultimately, out of the chaos some semblance of order arises after exhaustion on one side, or the other, or both. In the struggle objectives that were clouded become clearer. Frustration changes perception. In the end, as things improve, one will note that the listening indicates understanding of the position of the other.

DIALOGUE

In a day when we lean so heavily on attack and denunciation in social interaction, let us make clear at the onset of an examination of dialogue that dialogue is not some ideal that belongs to a nonexistent peaceful world. Even the gentle Martin Buber said that he often struggled with his partner in order to alter his view.[14] Dialogue goes directly and honestly to the difference between "me and thee," and this requires an immense toughness of self—for it does combat without going on the defensive. And so there is considerable difference between the struggle of dialogue and that of confrontation. In confrontation the purpose is the humiliation of the other person. When, however, conflict develops between people in dialogue the other person is confirmed. He is looked upon as responsible and competent though he may not be persuaded.[15] Even downright rejection of a view can still stay within the framework of dialogue. To reject ideas or behavior in another while confirming him as a person is, of course, difficult, requiring a deep faith in self. And yet this is the true test of one's ability to carry on dialogue. It is one thing to feel in such a way as to say, "I don't like you" and quite another thing to say, "I am getting angry with you." The former judges you and excludes you and initiates the termination of dialogue—the work of anxiety. To say, "I am getting angry," however, makes an authentic statement about one's feelings, recognizes the status of the relationship, and musters the courage to continue in dialogue. It does not cover up as in the distortion "I like you" (when actually I don't), nor does it polarize the feelings of the two conversants, as is likely, when one openly attacks

[14]Martin Buber, *The Knowledge of Man* (New York: Harper & Row, 1965), p. 179.
[15]Sidney Jourard, *op. cit.*, p. 123.

the other. The upshot is this, that the deepest level of human interaction has a profound faith in the intentions, and the ideal self-concept of the other person—attained when things and events are seen as he sees them.

Why is this empathy difficult to achieve in the face of conflict?

Above all else the need of every person is to be confirmed as he is. How else can we hope to be more? Without a future what is hope? And what is life without hope? But no person is capable of doing his own confirming. Indeed his confirmation rests in his impact upon others; again, a human self is a social satellite, not an independent planet. In our search for confirmation, however, we deceive ourselves if we dare not differ with others, for we are different. Only as we are confirmed in our uniqueness are we confirmed at all. Thus our greatest assurance depends upon support for what we are when we dissent from the other's opinion. But as Buber points out this is probably the Achilles' heel of the human race.[16] Almost all humans are stingy with support except when they are agreed with—when they themselves are confirmed. So the great moments in dialogue are not those nice exchanges between people when they agree with each other. We are talking about the nature of talk where the listening senses the deep differences with the other and yet trusts the other implicitly. Let it be clear we are not saying that people have to be in conflict with each other in order to have dialogue. Good exchange can take place when there is no conflict to threaten the listening. What we are saying is this: (1) we really have no test of the ability to carry on dialogue if the talk has no threat in it, and (2) that actually one does not know the deepest level of dialogue except when he is comfortably related to a person from whom he differs greatly.

The first point should be obvious. The test of anything is its ability to endure under stress. The second point is not so obvious. Let us approach it with a comment on the command of the ages, "To love thine enemy." This command is not basically a moral injunction but an invitation to know the deepest experiences in relationship—drawing heavily on one's courage. The ultimate in *self-confirmation*, thus, takes place when one trusts his enemy—an "untrustworthy" person. The Western movie has much of its appeal in the fact that it melodramatically explores this relationship when it pictures the hero talking calmly to an enraged man who has him covered with a cocked pistol. We, the audience, are entranced because we know the hero is saying to himself, "Circumstances call for me to calm this man. If I panic he will fire. If I put my trust in his stability and this I can do so long as I do not threaten him I have a good chance of surviving this encounter. I could be wrong. He may fire without provocation. That's the chance I take. Everything considered I choose

[16]Martin Buber, "Distance and Relation," *Psychiatry*, 20 (1957), 97–104.

to take the chance." If one can command himself to do this he learns several remarkable things at once:

1. That he has the capacity to face death calmly—and death is a reality each person must one day experience.
2. That, as a consequence he can probably face any experience calmly.
3. That he has attained a maximum command of himself.
4. That he has also attained the maximum in human freedom—for freedom is that internal state which permits choice among the choices made available by conditions.
5. That he has achieved the ultimate in self-confidence for he has achieved the minimum in self-hate, therefore the minimum in self-doubt.

In the end there is not hate except hate of the self; no anger, except anger with the self. All *our responses* toward other people are proofs of our potentials which others have but stimulated. All feelings are self-reflexive. Whether one panics or remains calm in the face of danger, the stimuli are the same. It is the self that is different.

Thus most talk and listening between nations in conflict—to illustrate the view—is not dialogue because the parties do not have the courage to experience dialogue. By definition the defensive posture is the acceptance of self-doubt. The political leader who insists "we shall bargain only from a position of strength" reflects his fears, not his strength. The perception of the self as strong when one is weak is a deception that comes because one blames the other for his feelings. He conceives of the enemy as wholly distrustful, thus freeing himself from responsibility for his own feelings. If he really wants to talk openly and defenselessly with his enemy he must develop sufficient trust in himself to stir responsible behavior in the other—which means he faces possible treachery, having dropped his guard. Conversely, by maintaining his guard, he excites the defensiveness of his enemy and thus insures the failure of dialogue—unless the enemy is actually the stronger person of the two, and creates the conditions for dialogue.

Perhaps the hardest of all lessons to learn is that defensive listening (which, as we all know, establishes pseudo dialogue) is irresponsible behavior. Defensive behavior insists that the responsibility for one's feelings is in the other person. Let it be clear. The lowering of our defense, especially once mutual defense has developed, may be a miscalculation. But then the escalating of our defenses may be, too. There is no guaranteed safe path for people in conflict. The question is, shall we depend upon our capacity to survive in dialogue or in defense? Defense and dialogue are mutually exclusive behaviors, and there is danger in either course because no person has complete control over the other person.

We have cast this discussion, by our example, in the frame of the international conflict in order to highlight the mutually exclusive differences between dialogue and defense. But we should not limit ourselves to that frame of reference. The basic character trait of the effective psychotherapist, for instance, is his ability to trust his own health while listening to his sick patient. And this he can do only if he believes the relationship will stir the potential health of his patient. Two swim as one only as each gives up one swimming arm to embrace the other. Yes, the therapist confirms the sick man and thus initiates the healing, but this is not achieved without risk. And so the great test of the professional listener is his capacity to maintain the relationship when his partner is sinking.

In similar fashion, the great test of a marriage is the ability of partners to listen to each other when in conflict. Can the one embrace the other when differences arise? Each is tested. "Do I have enough tolerance for myself to embrace a person whose very being I learn stimulates my awareness of those qualities I dislike in myself?"

The capacity of a person to carry on a dialogue with a politician, a policeman, a teacher, a teenager, a foreigner, a whore, a homosexual, a thief, a murderer, or an insane man is the capacity to tolerate the feelings about the self aroused when we identify with that other person—to understand life from his point of view. After all, life can be lived in his way. It is the fear aroused by contemplating that prospect that cuts off the dialogue.

Abraham Maslow asserts that safety holds priority over growth, which means that in the presence of threat defense is inevitable. One can hardly argue with him in the face of the evidence. But this is the reason that few humans experience much dialogue in the course of a lifetime.

Dialogue, then, above all else, is based (a) on faith in the self (b) entrusted to the other person in the exchange of communication. It does not necessitate full acceptance of the other person as he is. It does necessitate sufficient confirmation of the other as he is to entrust, to make oneself vulnerable to him.

Second, it means the one has a deep concern for the other person.[17] If dialogue exists between two people, each maintains an I-thou relationship with the other, that is, each holds the other as an inviolate entity, a person to be concerned about. Neither will use the other for his own personal gain. The relationship is prized above any control or advantage. It is the break in such a relationship, when romantic, that is the source of all sad love songs, expressing the sickening emptiness when a deep faith in a relationship with another has withered. The relationship of dialogue

[17]Milton Mayeroff, *On Caring* (New York: Harper & Row, Publishers, 1971).

is one where each assumes responsibility for the relationship, and indeed, for the other.

Third, in dialogue *we walk at the edge* of our knowledge and our security, for to trust an unstable relationship is to let a phrase flow freely, to invent, to question, to challenge, to explore—to test an idea in the saying.

Fourth, in dialogue one reveals himself as he is, and as he is affected by the other. If he does this he is open; to be open is to listen.

The purpose of our dialogue is to try our values in social practice, to nurture our value scheme, to put our ideals to the test, to translate between language level six (where we order our values) and language level one (where we feel the experience of living them.) In dialogue we make our life complete, give ourselves our sense of meaning. A common consequence of real dialogue is the response, "I didn't know you were like this. I never really knew how you felt." Then perhaps to the self, "He is changing, and so am I." Hasidic wisdom adds this:

Faith should not rest in the heart; it should also be expressed by word of mouth. The utterance of faith strengthens a man's faith.[18]

Dialogue strengthens faith and faith is the source of dialogue.

The Language of Dialogue

In this description of dialogue we have used scattered examples of the language of dialogue. To fix the concepts and to initiate the attitudes of dialogue it may be helpful to speak further of the role and quality of the language. In so doing we should be careful to recognize that there are no gimmicks that work; the language that works is that guided by appropriate intent.

Yet the language that works is a guide to us in those moments when dialogue is threatened. We had a call from a man this morning whose first response to a proposed meeting was "Well, it is a little premature. You and I have not yet discussed ———." In our urge to maintain the best of relations we responded, "Perhaps I have forgotten something that should be taken care of first. What do you think we ought to do before the meeting?" This response was guided by the need to preserve the dignity of our conversant. Thus the language was, we hope, appropriate. We have noted that the language of people who are able to talk to many people at deep levels is replete with phrases such as: "I may be wrong, but here is the way I see it . . . It could be . . . What would you think . . .

[18]Louis I. Newman, *Hasidic Anthology* (New York: Schocken Books, 1963), p. 104.

I think what I am trying to say . . . Isn't there something missing here . . . What you say might just be so . . . I don't think I know if . . ." The statement is tentative, open to alteration. For some people these phrases seem unsure and in direct opposition to the description of the courage of dialogue. But the peculiar thing about the language of confidence is that on the surface it sounds weak. It is tentative in order to insure accommodation for the other person. Conversely, language that says "This is the way it is. There are no ands—ifs or buts . . ." on the surface sounds like it comes from the mouth of a strong man. Such sure language allows if possible only one interpretation. But, again, it is the flexible man, seeing the possibility for several or many interpretations, who is strong, strong enough to accommodate, perhaps, his less flexible conversant.

Yet we hasten to add, strength is not wishy-washy accommodation to anything. It is not fearful confusion. And this should be added: the fearful conformist may use the language phrases of the strong man as a camouflage. "I really don't know what to think" may mean the speaker cannot tolerate the responsibility for taking a position—in which the nonverbal cues give us our best clues—but it is also the language of the man who truly has an open mind willing to listen and to find a position necessary to preserve a healthy relationship. When we are too sure of our words we are not listening to them or the words of others. We are listening to the fears which are demanding firm and legal definitions. Legal language is abstract, logical, and technically correct. But the language of dialogue is spontaneous, free, noncritical, tentative, reflective, searching—based on faith and tolerance. When people meet in dialogue, their language is not an analysis of the rights and privileges of each other, but a mutual participation of the lives involved.

Telling Back Carl Rogers has lifted into prominence the value of telling back to the other person what we, the listener, think he has said. It is a way of giving the speaker a chance to correct our listening impressions, of correcting communication as the communication proceeds. But this takes courage for always our own first interpretations come from our own needs. In changing the language to fit the needs of our conversant we are changing ourselves—because to speak, as we discovered in Chapter 3, has a self-hypnotic effect. Yet, if we can restate the other person's statement to his satisfaction we tell him we are trying to listen as he wants to be listened to and thus out of appreciation, he in turn becomes sensitive to his listener's needs and tries to make no greater demand than his judgment tells him his partner can stand. So, in effect, careful restatement by the listener creates in both parties the conditions for dialogue.

This telling back technique has been developed and discussed most

widely in connection with psychotherapy. It is, however, an equally valuable instrument among healthy people in conflict—and most particularly where the conflict has hardened into confrontation.

A friend of the writer tells of an occasion when his teenaged son, in the course of a disagreement called him "a phoney." The father replied calmly, "You say I am a phoney."

"Yes," said the son.

"This is not pleasant to hear, but if that is the way you see me, I can understand why you don't want to go on vacation with me. But I don't know why you see me as a phoney."

The son began to explain, "You try to press your damned middle-class values on me. You've booby-trapped me into needing to live on a luxury income."

"You're saying I am a phoney because I am exposing you to a way of living that will put you into the rat race. You would like to be free."

"Yes," said the son softly, with relief, knowing he was understood.

"I am sorry, and I don't know what to do about it. I almost feel like I am condemned for existing. I don't know how to make you entirely free of me . . ."

On the son's choice the two went on vacation together—and a good one, the turning point in a deteriorating relationship. In the young man's search for independence he had come to perceive his father as "the enemy." For the father to state this in language that confirmed the son helped both to understand each other better.

As anybody who has tried this knows, the emotion of the restatement is highly important. It would have done no good if the father had said vehemently, "Don't call me a phoney . . ." This would have been defending against the blow. The son would have struck again, or if frightened would have searched for cover. But the calm and perhaps sad, "You say I am a phoney . . . I don't know how to . . ." was an acceptance of the intent of the son—the way the son had to be heard if he was to be understood. In return for being understood the son's defenses against the father were lowered and in his new openness he perceived the father as the father perceived himself.

He also saw how the father could accept himself confronted by the label "phoney," the implicit challenge in every confrontation: "I am going to make you see yourself as you are." To be understood and accepted by a person we attack is to create the conditions in ourselves to understand the other. These are the magical results of the restatement. But once again the magic becomes a fraudulent gimmick unless the language is guided by the intent to confirm and respect the one who is attacking us. The magic is our real, not feigned, confirmation of our confronter, confirmed even as he attacks us.

When all is said and done in that search for the way we poor humans thrash about for understanding of each other it comes down to this: that the madness in our effort is generated by that desperate doubt about our own worthiness. Conflict in a dialogue stimulates this basic anxiety. Depending, as we must, upon language to be human we build a life out of a stack of abstract values by which we direct ourselves. Thus, we rest our lives on our values, the vaporous wings of a prayer. These values must be confirmed by others or they die and we die. Research has demonstrated time and again that each of us is unique in our perceptions, there being no more alikeness among friends than among strangers or enemies. Friends are united and confirmed in their common ideals. Society exists in common aspirations. Therefore dialogue between people both develops and depends upon trustful openness among people in search for common ideals and hopes. There is the human story, or as a student might say, "there is where it's at."

IN SUM

Faith has a contempt for fear and is therefore risk-taking. In monologue risk-taking involves deep trust of the self, but little risk with others. As alienation from others decreases we pass through the stages from technical to resistant to confronting communication. When we risk full involvement with another we enter into dialogue with him.

OBJECTIVES

The purposes of the last chapter are:

I. To sense the different levels of relationship involved in communication.

II. To improve your ability to engage in healthy confrontation.

III. To improve your ability to engage in dialogue.

EVALUATION

1. Have your classmates each evaluate you on a seven-point scale (one being most, seven least) on the degree of courage you have demonstrated in your communication in class during the semester.

2. Have your classmates do the above on your degree of self-confidence.

3. Have them do the same on your trust in the others of the class.

In all three of the above evaluations you might add the following dimension. Have the students mark each scale as they saw you at the beginning and at the end of the semester. The three scales then would be marked each with a "B" (beginning) and an "E" (end). The beginning and end appraisals may be the same or different.

DISCUSSION QUESTIONS

1. *Objective I* Discuss the role of narcissism in communication on campus.

2. *Objective I* What are the values of monologue?

3. *Objective I* Define and discuss each of the five levels of communication.

EXPLORATIONS

1. *Objectives I, II, & III* In the next week engage in a conversation restricting yourself to one of each of the five levels of communication. After each conversation write a statement or make a journal entry concerning the experience. Make an oral report concerning the five experiences noting particularly the sense of well-being felt in each of the experiences.

2. *Objective II* Think of a relationship in which you have been tempted to confront a person. Confront the person, trying to make the experience as healthy as possible for both yourself and the other person. Report the results. It is quite obvious that this is an assignment with possible injuries. However, our experience has been that cool and collected confrontations are not the ones that have got us into trouble, but rather those in which we confronted each other in uncontrolled anger. When we confront without anger we have no desire to destroy and thus the person usually feels that he has been helped by the confrontation.

3. *Objectives II & III* List the people who have been most meaningful to you in your life. Discuss these people in terms of the words "confrontation" and "dialogue."

4. *Objective III* Report your experiences in risking trust, both successful and unsuccessful.

5. *Objective III* Discuss the theme: the worst things that happen in our lives involve a breach of faith.

6. *Objective III* Discuss the theme: every failure in a human is, in the end, a break of faith in oneself.

7. *Objective III* In Chapter 3 we discussed as the highest achievement of language, moments of identification or "peak" relation with a person, nature, some thing or idea. Report a peak experience then explain it in terms of the concept of trust.

8. *Objective III* Identify a close relationship that has flattened out or deteriorated. Over the period of the next week try some specific contacts with that person intended to renew the relationship. Analyze the experience. Report to the class, or write a paper, or make a journal entry about the experience.

9. *Objective III* Form dyads in class and discuss any matter of mutual concern. Try to be as completely present to the other person as you know how to be. In more usual language, try to give the other person your undivided attention, your most empathic attention. Exchange your feelings about the results.

10. *Objective III* Do the above assignment with a trusted friend or a person in distress who wants to talk with you.

11. *Objective III* Make a speech in which you discuss the national political climate in terms of trust and distrust.

12. *Objective III* Analyze a campus confrontation in terms of the discussion in the chapter. Make a report.

13. *Objective III* Discuss a modern movie in terms of the concepts of confrontation and dialogue.

14. *Objective III* If equipment is available make a movie on the theme of the most significant concept you have developed in the course.

Selected
Readings

ARDREY, ROBERT, *The African Genesis* (New York: Atheneum, 1961).

The book makes an effort to show how the behavior of the highest order of apes might be revealing of the aggressive interpersonal behavior of humans. The hypothesis requires accepting Man as a direct descendant of the apes. Once that is accepted, a case can be made, Ardrey believes, for the concept of Man as a predator, driven more by the urge to establish and defend his own territory than by anything else.

ARGYLE, MICHAEL, *The Psychology of Interpersonal Behavior* (Baltimore, Md.: Penguin, 1967).

Argyle is a British social psychologist with a special interest in the way what he calls "social techniques" determine interpersonal responses. His book contains some interesting examination of nonverbal signals, as well as understandings of communication available in the observation of small groups.

BARNLUND, DEAN C., *Interpersonal Communication* (Boston: Houghton-Mifflin, 1968).

> An excellent collection of empirical and theoretical studies on communication is presented here. The book is significant as a source because the items in it were chosen out of a "meaning-centered" view of communication.

BENNIS, SCHEIN, BERLEW, STEELE, *Interpersonal Dynamics: Essays and Readings on Human Interaction* (Homewood, Ill.: The Dorsey Press, 1964).

> For the most part the essays collected in this volume are written from the context of humanistically-oriented psychotherapists. Sections in the book are devoted to emotional expression in interpersonal relationships, some interpersonal aspects of self-confirmation, and various avenues to personal change involving interpersonal relationships.

BERNE, ERIC, *Games People Play* (New York: Grove Press, 1964).

> Intimacy in human interaction is seen, in this book, as rare. The next best alternative, the author thinks, is to engage in communicative "games" (transactions). Berne explains how "parent," "child," and "adult" ingredients function in each person. The hope of the book is to raise the reader's level of awareness concerning the "games" he uses. It can also serve as an introduction to transactional psychology.

BUBER, MARTIN, *I and Thou*, 2nd ed. (New York: Scribner's, 1958).

> This is Buber's classic statement of what he considers to be the highest relationship conceivable between human beings. It is an important item in the bibliography because it describes communicative relationship in terms that go considerably beyond the usual view of communication as a superficial mechanistic process.

D'AMBROSIO, RICHARD, "No Language but a Cry," *Good Housekeeping*, August, 1970, p. 64ff.

> The article reports a therapist's struggle, over a period of years, to help an autistic child break through the wall of silence into a world of oral communication. The importance of the report lies in the clues it provides for an understanding of what produced such compulsive silence in the child. Everyone exhibits a degree of silence in communication. Perhaps the factors at work in intensive form here are also at work, to a lesser degree, in "normal" communication.

DAVITZ, JOEL R., *Communication of Emotional Meaning* (New York: McGraw-Hill, 1964).

> A collection of empirical studies involving examination both of how emotional messages are sent and how they are received is presented. Such questions as, "What sort of communicator is best able to read emotional messages accurately?" and "Is there any relationship between the capacity to express emotion and the capacity to interpret it?" are examined. The research presented is unique.

EISELEY, LOREN C., *The Immense Journey* (New York: Random House, 1957).

> An anthropologist would not seem a logical choice for inclusion in a bibliography on communication, but Eiseley belongs for at least two reasons: (1) His book is itself a demonstration of the way poets, and exceptional prose writers, can unlock the language so it reveals what was hidden before, and (2) The book discusses the ways in which a person can find an identity with the distant past, with the future, and with the unifying experiences available in life.

ELLIS, ALBERT, *Reason and Emotion in Psychotherapy* (New York: L. Stuart, 1962).

> The psychotherapist, in Ellis's view, can work most successfully if he helps the client identify the statements he makes to himself which form the basis for the emotions he experiences. Once identified, the statements can be judged more or less "rational" and, through this new awareness, the client can gain healthy control over the emotional dimension of his life. The book is unique in its effort to tie together silent speech and emotion.

ERIKSON, ERIK, *Childhood and Society*, 2nd ed. (New York: W. W. Norton, 1964).

> Part 4 of Erikson's book is entitled, "Youth and the Evolution of Identity." Along with the chapter which precedes it, on the development of personal identity, it represents a provocative picture of the ways in which communication and identity are related.

ERIKSON, ERIK, *Identity: Youth, and Crisis* (New York: W. W. Norton, 1968).

> As the title suggests this book flows out of the one cited above with particular emphasis upon crises in the search for identity.

FRANKL, VIKTOR, *Man's Search for Meaning* (New York: Washington Square Press, 1966).

> Frankl's book is included in the bibliography because (1) it is an unusual sample of a human being verbalizing his own experience, (2) it poses a view of life in which "the search for meaning" is central, and (3) it is a demonstration of the power of inner-speech (listening to self).

GIFFIN, KIM and PATTON, BOBBY R., *Fundamentals of Interpersonal Communication* (New York: Harper & Row, 1971).

> The book is designed as a text for the beginning course in interpersonal communication. It reflects a strong orientation toward conceiving communication as a problem in relationship. There are, therefore, very useful sections discussing interpersonal perception, ways in which communicative relationships are defined, the bases of trust, and similar topics.

GOFFMAN, ERVING, *The Presentation of Self in Everyday Life* (New York: Doubleday, 1959).

> Goffman studies the events of interpersonal behavior from a sociologist's point-of-view. He concentrates, in this book, on the idea that in any effort to communicate each person involved "defines" himself

as he wishes the other to see him. People are rarely aware that they are doing this, he thinks, but it can be clearly seen when one analyzes communicative experience. Goffman's book goes into detail in describing how those definitions are made and what effect they have on the interaction.

GRIER, WILLIAM and COBBS, PRICE, *Black Rage* (New York: Basic Books, 1968).

Two black psychiatrists draw heavily on case histories of blacks struggling to establish their personal identities in a white society in this unusual report. The reader becomes aware of the intensity of the impact of the environment on what an individual says to himself, and on how he interprets the messages from outside him.

HALL, EDWARD T., *The Silent Language* (Garden City, N.Y.: Doubleday, 1959).

Hall explores, from the viewpoint of an anthropologist, the non-verbal clues which supplement spoken language. He calls attention to physical signs and attitudes, profoundly meaningful, usually overlooked in human communication. His material, more extensive than could be found in most sources, is drawn from both interpersonal and intercultural contexts.

HARTLEY, EUGENE and HARTLEY, RUTH, *Fundamentals of Social Psychology* (New York: Knopf, 1952).

Interpersonal and small group interaction is almost impossible to study without giving attention to the elements of communication involved. The Hartley and Hartley volume, therefore, touches, as expected, many of the dynamics essential to an understanding of interpersonal communication.

JOURARD, SYDNEY M., *The Transparent Self* (Princeton, N.J.: Van Nostrand, 1964).

Out of his background as a clinical psychologist the author discusses the experiences that have convinced him that revealing oneself to another person is a doorway to an understanding of the self. Some of the book is addressed to nurses, and some to professional counselors, but the early chapters are provocative for anyone trying to understand the communication process.

JOURARD, SYDNEY M., *Disclosing Man to Himself* (Princeton, N.J.: D. Van Nostrand, 1968).

Jourard develops further the idea he introduced in *The Transparent Self*, namely, one only becomes known to himself when he is able to allow himself to be known to another. Self-knowledge, then, becomes in part a social experience in which those who invite revelation by the other play an important role.

KENISTON, KENNETH, *The Uncommitted* (New York: Harcourt-Brace Jovanovich, 1965).

What sort of influences, discernible in the life history of college students who have "dropped out" of society, have proven to be most influential in shaping the decision of those students? Keniston culls through an imposing number of in-depth interviews and question-

naires and draws some conclusions of special interest to anyone try-
ing to understand how communication (or the lack of it) plays an
important formative role.

KENISTON, KENNETH, *The Young Radicals* (New York: Harcourt-Brace Jovano-
vich, 1968).

> In contrast to those college students who "drop out" of society (and
> described in *The Uncommitted*), there are those who are motivated
> to take an active role in reform or revolutionary movements. Kenis-
> ton sought, again, to identify the forces in the early life of these
> young people which turned them in the direction of involvement. In
> the process he sheds additional light on the role of communication
> in human development.

LANGER, SUZANNE K., *Philosophy in a New Key* (Cambridge, Mass.: Harvard
University Press, 1942).

> This is a philosophy with language at its core. Langer argues that
> Man has an "organic need" to symbolize. Symbolizing, in her view,
> does not simply fulfill social purposes, nor is it a secondary function.
> Man needs it, she says, to make sense of his world. Without it, all
> would be chaos. The major part of the book ties various symbol
> systems into that over-arching idea.

LORENZ, KONRAD, *On Aggression* (New York: Harcourt-Brace Jovanovich, 1966).

> Perhaps the best known of all ethologists writes here a book show-
> ing how pervasive and basic aggressive behavior appears to be among
> many types of animals. He goes on to conjecture that Man's class of
> life may be a defensible analog to what is being found in animals.
> If so, he implies, there are things we can learn about why and how
> men use power in their interpersonal experiences.

McLUHAN, MARSHALL, *Understanding Media: The Extensions of Man* (New
York: McGraw-Hill Book Company, 1965).

> A profound change in the destiny of Man took place, as McLuhan
> sees it, when the electronic media ushered in an age of instant com-
> munication. This book describes the fundamental features of the new
> age as he sees them and discusses the revolution in communication
> which he anticipates.

MASLOW, ABRAHAM H., *Religions, Values, and Peak-Experiences* (Columbus,
Ohio: Ohio State University Press, 1964).

> A number of books exist in which Maslow explains his theory of
> self-actualization. This is one of them. He deals particularly, here,
> with those "unifying," transcendent experiences that come unpre-
> dictably to self-actualizing people. And a part of his analysis has to
> do with the role of inner-speech and inner freedom in making the
> transcendent experience possible.

MASLOW, ABRAHAM H., *Toward a Psychology of Being* (Princeton, N.J.: D. Van
Nostrand, 1962).

> The book is especially useful to anyone probing the relationship be-
> tween values and interpersonal communication. Maslow makes an

effort to identify the values, and the levels at which they must be satisfied, if a person is to reach self-actualization.

MAY, ROLLO, *Man's Search for Himself* (New York: W. W. Norton, 1953).

Here a psychologist takes a look at the development of a sense of self. And he gives special attention to Man's capacity to communicate himself to himself.

MAY, ROLLO, *Psychology and the Human Dilemma* (Princeton, N.J.: D. Van Nostrand, 1967).

To the student of communication, two sections of this book are of special interest. In one May discusses the forces in our culture producing a loss of personal identity; in the other he traces the roots of anxiety.

MAYERHOFF, MILTON, *On Caring* (New York: Harper & Row, 1971).

This is an extended, informal essay on the effect of "loving" ("caring") in interpersonal relations. The author concludes, essentially, that "caring" means you are concerned both for the growth of self and the growth of the other. Implications for communication are abundant.

MEAD, GEORGE HERBERT, *Mind, Self, and Society* (Chicago: The University of Chicago Press, 1934).

This has become a classic statement of the view that "meaning" is a social phenomenon. Mead asserts that one must call out in himself the same "verbal gesture" that he calls out in the other before meaning can be assumed to exist in the interaction. The role of "I" in human thinking is explored more fully than is usual in the literature.

ROGERS, CARL, *On Becoming a Person* (Boston: Houghton-Mifflin, 1961).

This collection of essays contains a number of chapters dealing with the problems anyone faces in the effort to come to believe in his inner world. It asks, "How can a person deal with the expectations others have for his life in such a way as to enhance his growth in the process?"

ROKEACH, MILTON, *The Open and Closed Mind* (New York: Basic Books, 1960).

Rokeach and his associates develop a series of hypotheses related to the characteristics of people who exhibit "open" orientations and those who exhibit "closed" ones. The functions of belief systems and disbelief systems are integrated into the theory Rokeach presents. Both the hypotheses and the experiments reported are unique in the study of psychological openness.

ROKEACH, MILTON, *Beliefs, Attitudes, and Values* (San Francisco: Jossey-Bass, 1968).

This is a continuation of the research done as a basis for *The Open and Closed Mind*, with special attention given this time to the development of a way to measure hierarchies of values and to theorizing about the impact of value choices on human behavior.

ROSENTHAL, ROBERT and JACOBSON, LENORE, *Pygmalion in the Classroom* (New York: Holt, Rinehart and Winston, 1968).

> How do the expectations of superior regarding the behavior of subordinates affect the self-image of those subordinates? Much has been theorized on that topic. The authors of this book offer documented evidence to support the conclusions they regard as valid. The book speaks directly to the issue of the effect of power exercised by the teacher in the classroom.

SAMPSON, RONALD V., *The Psychology of Power* (New York: Pantheon Books, 1966).

> An English psychologist takes a look, here, at the effect of power used in interpersonal relationships. He hypothesizes that such power stands in antithesis to "love." A special feature of the book is the author's analysis of the role power played in the formation of John Stuart Mill and Elizabeth Barrett Browning.

SARGANT, WILLIAM W., *Battle for the Mind* (Garden City, N.Y.: Doubleday, 1957).

> A fascinating examination is made, by Sargant, of various forms of psychological suggestion. Chiefly the emphasis is on studying religious ecstasy, the background of "conversion," mass evangelism, etc. Out of such a study come some hypotheses about what kind of psychological states produce optimum "openness" and what kind of overload make it hard for the individual to handle incoming messages. This is a book about "brainwashing."

SCHUTZ, WILLIAM C., *The Interpersonal Underworld* (Palo Alto, Calif.: Science & Behavior Books, 1966).

> Schutz searches out the forces which seem to dominate the silent world of people in interaction. He identifies them as the desire for (1) inclusion, (2) affection, (3) control. His book is devoted to explaining how these forces affect interpersonal responses, and how they are related to each other.

SCHUTZ, WILLIAM C., *Joy* (New York: Grove Press, 1967).

> This book extends the author's theory involving inclusion, affection, and control as factors in interpersonal exchanges. It becomes a handbook explaining how those factors can be opened up for individuals through modifications of the encounter group approach.

SHOSTROM, EVERETT L., *Man, the Manipulator: The Inner Journey From Manipulation to Actualization* (Nashville, Tenn.: Abingdon Press, 1967).

> This book separates and analyzes the power-to-be and the power-over behaviors in all of us.

SPITZ, RENÉ, *The First Year of Life* (New York: International Universities Press, 1965).

> Spitz, and his collaborator, Godfrey Cobliner, have made in-depth studies of the first year in the life of human infants, with the focus on what kinds of communication seem to occur between mother and

child. Understandings about early life as a source of either security or fear in the communicative experiences of later life emerge from the studies.

SULLIVAN, HARRY STACK, *An Interpersonal Theory of Psychiatry* (New York: W. W. Norton, 1953).

Sullivan develops his conviction that human growth and the psychological illnesses that beset Man can best be understood in terms of human interaction. His book makes a special contribution when it theorizes about how anxiety is implanted in the life of an individual, what effects it appears to have on human interaction, how it influences the learning and adapting process, and especially how it is associated with the effort to communicate.

WATZLAWICK, PAUL; HELMICK, JANET; and JACKSON, DON D., *Pragmatics of Human Communication* (New York: W. W. Norton, 1967).

This is a pioneering book in that it sees communication as a problem in relationship, and explores the impact of such relationship on the development of the person. The communicative relationships defined are analyzed in some detail, using Edward Albee's *Who's Afraid of Virginia Woolf* as a sample of interaction.

WIENER, NORBERT, *The Human Use of Human Beings* (Boston: Houghton Mifflin, 1950).

One of Wiener's major contributions to an understanding of communication is in what he has to say about feedback and self-correcting systems. He discusses both of those concepts in this book which is an effort to apply the principles of cybernetics to human behavior.

Index